DECOLONIZE MUSEUMS

Forthcoming from *Decolonize That! Handbooks for the Revolutionary Overthrow of Embedded Colonial Ideas*
Edited by Bhakti Shringarpure

Decolonize Self-Care by Alyson K. Spurgas and Zoë Meleo-Erwin
Decolonize Multiculturalism by Anthony C. Alessandrini
Decolonize Drag by Kareem Khubchandani

DECOLONIZE MUSEUMS

SHIMRIT LEE

OR Books

New York · London

The *Decolonize That!* series is produced by OR Books in collaboration with *Warscapes* magazine.

Published by OR Books, New York and London

Visit our website at www.orbooks.com

All rights information: rights@orbooks.com

First printing 2022

Cataloging-in-Publication data is available from the Library of Congress. A catalog record for this book is available from the British Library.

Typeset by Lapiz Digital Services.

paperback ISBN 978-1-68219-315-0 • ebook ISBN 978-1-68219-316-7

CONTENTS

EDITOR'S PREFACE

Back in 2008, I was at a Super Bowl party where I met some young veterans who had returned from fighting in the 2003 Iraq war. I was regaled with all kinds of stories, and I tried my best to hum and haw and stay clear of unleashing my views about American imperialism or the nation's addiction to perpetual war. But one story finally put me over the edge. One of them figured out I was a cultured type who liked art and books, and bragged to me about the day the Iraq Museum in Baghdad was destroyed. It was chaos, he said, everyone was grabbing whatever they could, and he couldn't resist making off with a trident. He even managed to bring it back home to Oklahoma where it proudly hung in his basement. Above the TV. "But why, how could you, it's not yours" … it all fell on deaf years. Don't get upset, the Iraqis didn't care about it, he assured me. They don't care about such stuff. Violent desecration of cultural heritage served with a side of racist mansplaining. Why was I surprised? It was Super Bowl Sunday, after all.

Looting, theft, war and imperialism are not simply side effects but the foundation upon which museums are constructed. I write this in May 2021 as bombs rain down on Gaza, and Israel has ramped up a barbaric campaign of ethnic

cleansing in occupied Palestine. Footage of babies being pulled out of the rubble and buildings crumpling up in a heap airs in real time before our eyes on social media, and a letter titled "Free Palestine/Strike MoMA: A Call to Action" is making the rounds. The letter implicates several Museum of Modern Art (MoMA) trustees with funding and reinforcing projects of settler-colonialism and racial capitalism not just in Palestine but worldwide. These words are particularly sharp and timely: "Given these entanglements, we must understand the museum for what it is: not only a multi-purpose economic asset for billionaires, but also an expanded ideological battlefield through which those who fund apartheid and profit from war polish their reputations and normalize their violence." This makes clear that these violent histories are not a thing of the past but the very mode through which massive public institutions like museums sustain, grow and thrive.

*

Many of us instinctively feel discomfort around museums; we notice that in the dioramas of "primitive" peoples, the figures are usually dark skinned; that the huge pillars from the Persian city of Susa displayed in Paris' Louvre, or those taken from the Temple of Dendur exhibited at the Metropolitan Museum must have cost a fortune to bring over from those

countries, why were they allowed, and how did they even do it; that there's a diversity problem in the art world and massive, high-profile art exhibits tend to showcase white artists, some of whom make balloon animals; that exhibit openings in stark white spaces are fancy and exclusive. In fact, such events will make you fuss about your look, your accent, your address, your wallet size. If you're not white, wealthy, posh, well-traveled or cultured, are you meant to be on the other side of the glass? The question echoes in that oft-regurgitated comment from visitors to the "messy" and "cluttered" museum in Cairo: "they," the Egyptians, cannot be trusted to be custodians of their own heritage. You can apply this comment liberally to other places: Burkina Faso, Benin, India, Congo, Indonesia . . . and coincidentally, this exercise will also vomit up an old colonial map of Europe's old glory days.

Behold the sleazy logic of museums: first comes the plunder, and the plunder is then dressed up as charity, conservation and care.

In *Girl, Woman, Other,* Booker Prize-winning author Bernadine Evaristo has a portrait of a Black woman called LaTisha Jones, a high school dropout who grew up in grim council housing in London. Now a mother of three living paycheck to paycheck, LaTisha recalls that her parents took her "to all the free museums in London. Mummy said children who did well in life had parents who took them to

museums." No distinction is made between a natural history museum or a science museum or an art museum. It's just museums, any museum will do.

What strikes a melancholic chord in the passage is the intuition that museums can give you cultural capital: that imperceptible *je ne sais quoi*, that scent of social class you can't shed. This also explains the recent trend in reclaiming museum spaces within Black popular culture. We saw Beyoncé and Jay-Z rent out the Louvre to film their music video "Apeshit." Despite the feeble critiques of their centering of capitalist excess, the sheer pompous "buying out" of the museum is not only an excellent fuck-you to the institutional white supremacy that the Louvre represents but also a gesture of ownership over a space that continues to be uncomfortable for non-white people from a range of social classes. The French series *Lupin* also played with these significations. In the show, protagonist Assane Diop (played by Omar Sy) is a Black Frenchman son of an immigrant father exploited, framed and killed by traditionally wealthy, art-collecting, art-dealing, and trafficking white employers. In order to avenge his father, he plots an exquisite jewelry heist. Diop plays with the museum staff's perceptions of a Black nouveau riche class and makes off with a historic diamond necklace right under their noses, disguised as a reclusive tech billionaire yet unknown to

a "woke" white French society. Pop culture, more and more, is routinely exposing this intuition about class, race and museum culture, and Shimrit Lee's *Decolonize Museums* also uses such references to shine a light on these core connections.

★

Whether it's through references to Indiana Jones's exciting looting exploits in *Raiders of the Lost Ark* or the subversive heist by *Black Panther's* Eric Killmonger, Shimrit's book reminds us that the ties that bind museums, theft, knowledge production, and resource-hoarding have never really been hidden, but somehow they have been idealized. We continue to revere museums and refuse these truths. We choose instead to believe in the reformation of such institutions that pretend to be offering a public education and upholding patriotic national agendas through cultural conquest. We think diverse curators and diverse artists and asking disenfranchised communities will do the trick. But the violence that undergirds museums is not a vague colonial violence of cultural memory, or an erasure of heritage. It is a specifically settler colonial violence that is ongoing and underway. Museums are an extraordinary force of gentrification. First comes the museum, then the high-rise buildings, then the sushi and brunch spots, then

the yoga studios . . . you get the drift. Along the way, dispossessed populations get brutally uprooted and shoved out into peripheries.

Shimrit's book is a rigorous and urgent introduction to the history of museums and the kerfuffle around "decolonizing" them. However, this book is not an extended argument for returning a Benin bronze or a Chadian funerary staff, but an exposé of the quagmire of racial capitalism, greed and imperial savagery that allows the institution of the museum to thrive today. *Decolonize Museums* is constructed deftly and straddles a difficult balance between taking the reader through repulsive colonial histories and keeping us focused on the present-day injustices practiced by museums.

Yes, this book contains horrifying stories from the past: there's Austrian anthropologist Felix von Luschan, who wanted Herero and Nama bones shipped to Berlin during the genocide in Namibia in the early twentieth century. "Herero women were forced to use shards of glass to scrape away the flesh from the corpses of their loved ones for this purpose," Shimrit writes. This collection of human remains and skulls ended up in the American Natural History Museum in New York. But then, we were recently treated to a contemporary version of such grotesque acts with the revelation that Penn Museum has held the remains of the victims of the MOVE bombing in Philadelphia since 1985.

We also learn about unionized workers demanding better pay and benefits as well as the relentless gentrification. Shimrit reminds us that attempts to infuse "new life" into cities through the creation of a cultured bourgeoisie class of museum goers simply means that "urban renewal results in urban removal."

Decolonize Museums is the second book in our series "Decolonize That: Handbooks for the Revolutionary Overthrow of Embedded Colonial Ideas," which attempts to grab the current, ubiquitous #decolonize imperative by the horns. The call to #decolonize appears to be everywhere these days; while it remains central to "land back" and Native sovereignty movements everywhere, it is also popping up in all kinds of diversity initiatives at institutions or is part of the daily, micro-rebellious activism proliferating in memes and social media posts. Our series tracks various sites and topics; some tongue-in-cheek, some grim and sobering like this one. *Decolonize Museums* illustrates the limitations of "decolonize" as a revolutionary frame. Decolonizing museums is certainly an excellent starting point because it means reckoning with barbaric histories, and the commodification of bodies and their objectified remains. It also means slowly moving towards saying NO to art and an art world that nourishes such institutions. But decolonizing is certainly not enough. There is a litany of words we need to add to support collective action

against this mammoth institution: defund the museum, strike against the museum, boycott the museum, abolish the museum . . .

This book did me in and it will most likely do the same for you. I'll never set foot in a museum again. Perhaps, you will be moved to do the same.

—Bhakti Shringarpure
March 2022

INTRODUCTION

In one iconic scene from the 1981 film *Indiana Jones and the Raiders of the Lost Ark,* adventurer Indiana Jones overcomes a booby-trapped temple in Peru to retrieve a golden idol, leaving a bag of sand in its place. In another scene, he must free an ancient Hebrew tabernacle from illegal Egyptian possession before the Nazis find it first. Steven Spielberg's portrayal of "Third World cultures" draws from a laundry list of colonial tropes. The Egyptian people, for example, are just as oblivious to the historical treasures right under their noses as they are to the colonial presence that dominates their lives.[1] Only the archetypal American explorer is capable of grasping the significance of ancient archeological objects that must be "salvaged" from the chaos of non-European landscapes.

Dr. Jones may trample across precious archeological sites across the globe to snatch up artifacts that don't belong to him, but at the end of the day his signature phrase—"That belongs in a museum!"—redeems his profession as one of preservation, knowledge-production, and above all, rescue. At the end of the film, he turns over the spoils of his adventures to the fictionalized National Museum of Washington, D.C., where the violence of Western imperial adventure becomes even further removed from view—absorbed into

curated displays or placed into warehouses for study by "top men."

However, the concept of the museum as an extension of colonial endeavors goes beyond Hollywood storylines.

What is a museum? For decades, anyone who was interested in an answer to that question could turn to a steady, reliable source: The International Council of Museums (ICOM). Since the 1970s, ICOM—Paris-based network that represents more than 20,000 museums—defined a museum as a "non-profit, permanent institution in the service of society" that "communicates and exhibits the tangible and intangible heritage of humanity and its environment for the purposes of education, study and enjoyment." The definition is broad enough to encompass natural history museums as well as museums of science and technology, fine arts, and ethnography.

Sounds pretty straightforward, right? It was—for a while, anyway.

In 2016, ICOM set up a committee to examine whether its definition needed changing. After speaking with hundreds of ICOM members and reviewing nearly 300 suggested revisions, the committee settled on a new definition to bring to the wider membership. The proposed update defined museums as "democratizing, inclusive and polyphonic spaces for critical dialogue about the pasts and the futures," which could

"work in active partnerships with and for diverse communities" in order to "contribute to human dignity and social justice, global equality and planetary wellbeing."

As advocates saw it, the new definition presented a utopic framework for what museums *could* become, and didn't require any immediate changes to museum protocol. Nevertheless, the proposal caused an eruption in the organization. Several ICOM members resigned in protest. At ICOM's 2019 conference in Kyoto, after an intense four-hour debate, 70 percent of delegates voted to postpone the question indefinitely.

Their critiques varied. Some disapproved of the omission of words like "education" and "collection," which they felt were critical to a museum's mission. Others felt that the new definition didn't do enough to distinguish museums from cultural centers or libraries. Many of the strongest voices, however, expressed deeper concerns, condemning the definition as a "statement of fashionable values" and objecting to its "political tone."[2]

In those latter denunciations, there was an unmistakable note of fear. As increasing numbers of protest movements against imperialism, racism, and colonialism have landed at museum doors, many top museum officials have been reluctant to take explicitly progressive stances on political and social issues out of a concern that such positions would expose their institutions to further examinations of their legacies of

violence. In hopes of preserving their authority and avoiding scrutiny altogether, officials abiding by this view of cultural institutions have hoped to keep their heads down and stick with the supposedly passive tasks of collecting, conserving, and exhibiting. As of this writing, ICOM has still not resolved its definition debate. Regardless of the outcome, it's fair to say that proponents of a timid, defensive vision of the museum, free of conflict and controversy, have already lost. Why? Because that vision has never reflected reality.

History shows us that museums have *always* been simultaneously beloved and contested spaces—"both the hand that feeds and the citadel to be stormed," as Lucy Lippard put it. Contemporary protest movements like the #J20 Art Strike and Strike MoMA are just the latest chapter in a long and rich story of grassroots activism that has activated the museum as a site of struggle. In the 60s and 70s, groups like the Art Workers Coalition and the Guerrilla Art Action Group mobilized against the Vietnam War. Beginning in the late 1980s, A Day Without Art/Visual AIDS spotlighted the AIDS crisis. And for decades, groups including the Black Emergency Cultural Coalition, the Ad Hoc Women Artists' Committee, and the Guerrilla Girls have protested racist and gendered exclusionary practices in the art world.

This story goes back centuries and spans continents. In 1792, for instance, revolutionaries stormed the Tuileries

Palace, the home of Louis XVI. Under the newly established republic, the royal collection was transferred to a new, public museum—the Louvre—designed to represent the identity of the newly transformed state. During the 1917 Russian Revolution, Bolsheviks stormed the Winter Palace, declaring it to be part of the public Hermitage Museum.

That museums are today seen by many as "neutral" is a testament to the extent that the histories of museum spaces have been buried by their modern operators. To examine those histories is to know that museums are really *crime scenes*–to use a metaphor proposed by Wandile Kasibe of IZIKO Museums of South Africa—spaces that house the memories of atrocities committed during the colonial period, including theft, murder, and genocide. The Louvre may have revolutionary roots, but its Egyptian antiquities collection is composed of artifacts taken by the French during Napoleon's conquests in the Middle East. Likewise, the British Museum owes much of its collection to Sir Hans Sloane, a collector who financed his expeditions from his wife's earnings as the owner of a slave plantation in Jamaica.

Today, it is impossible to find a Western museum that doesn't hold some amount of cultural material from Africa, Asia, Oceania, or Native America—an enduring sign of the devastating afterlives of colonial rule. Wall texts often tell neutral, authoritative narratives of the objects displayed, but

that passivity fails to reckon with the extractive nature of colonialism by which most of the Global South was robbed of culture, resources, and people in plain sight. This violence is not over for Indigenous and Black people who continue to suffer under regimes of economic and political inequality, and experience macro- and microaggressions on a daily basis. The museum, with its white walls and white lights, aids in historical amnesia, tricking visitors into believing that this violence only exists in the past.

This fantasy of forgetfulness, driven by the same skittishness that characterized the opposition to ICOM's new museum definition, has become increasingly untenable. More and more, museums are beginning to hear what formerly colonized people have been demanding all along: They want their cultural heritage back, and they want control over their own history and its interpretation.

These demands have reached a fever pitch in recent years alongside a slew of other movements grounded in the belief that neutrality is indeed a fiction and always has been. In 2014, for instance, students at the University College London founded a campaign called "Why Is My Curriculum White?" to challenge an academic curriculum that centers whiteness and makes Blackness invisible. A year later, South African students belonging to the Rhodes Must Fall movement successfully removed a statue of the racist colonialist Cecil Rhodes

at the University of Cape Town. Then, in the wake of the murder of George Floyd at the hands of Minneapolis police officers in 2020, demonstrators across the globe toppled or defaced dozens of monuments to historical oppression. In the U.S., figures of Christopher Columbus and Confederate generals were beheaded, toppled, or forced into storage. In Belgium, a bust of Belgian King Leopold II was painted red. In Bristol, protestors tore down a 125-year-old statue of the seventeenth-century slave owner Edward Colson and threw it into the city's harbor.

Will museums be next to topple? While activist groups like the International Imagination of Anti-National Anti-Imperialist Feelings (IIAAF) want to "dismantle" museums like MoMA altogether and replace them with an alternative "controlled by workers and communities, not billionaire and their enablers," there are those who see a path to meaningful, transformative reform within existing institutions.

Whichever way things pan out, one thing is clear: The museum as it's been traditionally defined—that is, the museum rooted in colonialism—can't hold much longer.

Towards Decolonization

In the past few years, some museum workers have begun to re-evaluate their relationship to their collections and the communities they claim to serve. But what exactly does it

mean to decolonize a museum? For some institutions, decolonization has meant simply expanding the perspectives they portray beyond those of white colonizers. For others, the word has meant working with local Indigenous communities in efforts to conserve, exhibit, or repatriate human remains and objects.

These efforts have not been without their critics. For Simone Zeefuik, founder of the hashtag #DecolonizeTheMuseum, the museum's current urge to change is partially rooted in the fear of becoming "less and less relevant, which will ultimately result in selling less and less tickets." Others have pointed out that the word "decolonization" has become somewhat of an overused buzzword. The problem with buzzwords, of course, is that they can mean many different things or nothing at all.

In their influential article "Decolonization Is Not a Metaphor," scholars Eve Tuck and K. Wayne Yang warn against co-optation, whereby words like "decolonize," "decolonial," and "decoloniality" are superficially absorbed into the language of institutions that have no intention of unsettling the status quo. Rather than a generic term for social justice, they argue, decolonization requires the material repatriation of Indigenous life and land.

This material interpretation of decolonization harkens back to 20th century national liberation movements across

the Global South. Writing in the midst of the Algerian rev-
olution, Frantz Fanon argued that decolonization must go
beyond the simple withdrawal of imperialist flags and police
forces from colonized territory; it must also involve a recog-
nition that capitalist powers have grown wealthy by extract-
ing resources from the colonies. For this, he demanded, "they
must pay."

Alongside his insistence on reparations, Fanon also rec-
ognized the mental, spiritual, and emotional processes of
decolonization, a sort of "self-liberation." Today, there is no
blueprint for museums looking to reach institutional decolo-
nial liberation. It requires a constant questioning of one's own
relationship to ongoing forms of colonial erasure. Thus, it has
become commonplace for institutions to publicly acknowl-
edge the Indigenous land on which they were built as well as
the continual displacement of Native people by the United
States. Such language, however, is not always accompanied
by meaningful commitment to Indigenous voices and causes.
As Amin Husain and Nitasha Dhillon of the MTL Collective
point out, to be an accomplice to colonized people can mean
both "resistance, refusal, and sabotage, on the one hand, and
economies of love, care, and mutual aid on the other."

Decolonization can—and should—be unsettling for
institutions. Reckoning with Indigenous land claims, legacies
of slaveries, and ongoing forms of dispossession and erasure

isn't easy, feel-good work. But, done correctly, it can also be a creative form of knowledge-production that leads towards collective liberation. By highlighting intersections between global and historical struggles without collapsing them, the work of decolonizing museums can generate new forms of solidarity benefitting museums, visitors, and decolonized people alike. But it can't be undertaken lightly—or quickly. If, as historian Patrick Wolfe declared, settler colonialism is "a structure, not an event," then the work of decolonization can never really be over.

Evidence: Four Chapters

From its very inception, the museum as we know it today has worked to naturalize imperial domination. Each of this book's four sections describes a different aspect of this colonial crime scene –*the collection, the gaze, the narrative*, and *the money*.

In the first chapter, I investigate museum collections. Today, museums across Europe and North America continue to hold an immense stockpile of treasures pilfered from former colonies and Indigenous communities around the globe.

Calls to repatriate stolen cultural objects grow louder every day. In 2017, French president Emmanuel Macron delivered a landmark speech in which he pledged that France would return "African heritage to Africa." Three years later,

on November 4, 2020, the French Senate finally cleared a path to that goal, approving a bill that would return twenty-seven colonial-era objects in museum collections to Benin and Senegal within a year. These were artifacts that were plundered in an 1892 raid by French troops in present-day Benin and are currently held at the Musée du Quai Branly in Paris, alongside thousands of other contested items.

By delving into the historical, political, and legal dynamics of these repatriation battles, including the steps that have been taken (or not) since Macron's bombshell speech, this book attempts to answer questions such as: Why have museums been reluctant to return stolen artifacts? What kinds of ethical questions come into play when it comes to the return of human remains from former colonies or conquered peoples? Can repatriation alone heal the deep wounds inflicted by colonialism? Or, as Malian scholar Manthia Diawara argues, must restitution only come after reparations?

In the second chapter, I travel back in time and ask: How have museums served as historical extensions of colonial projects? How have processes of display and classification upheld a logic that views Europe, and European man, as the ideal image? How have museums enfolded the violence of conquest and colonialism into a supposedly neutral aesthetic, one that ultimately upholds a glorification of whiteness? To answer these questions, I fuse the histories of museums with those of empire.

For the imperial nation, processes of collection, display, and knowledge production have always gone hand-in-hand with conquering and colonizing. These intersections manifested in the early cabinets of curiosities that formed the foundation of modern European and colonial collections; the rise of natural history and typology for exhibiting both non-Western objects and human remains; the development of professional anthropology in the museum; and popular forms of ethno-spectacle, including nineteenth-century fairs and exhibitions, which, like the museum, were based on principles of specialization and classification that bolstered Eurocentrism. The "showing and telling" at the heart of these institutions aimed to generate consent to the existing political order, namely overseas imperialism.

By exhibiting colonized people and their belongings as "exotic" specimens, world's fairs and museums illustrated and popularized theories of racial hierarchy.

Calls for decolonizing museums must therefore go beyond the desire to settle long-pursued claims of reparations and repatriation. In the third chapter, I examine initiatives that position the museum as a space where these colonial histories can be addressed. For example, since 2016, the group Decolonize This Place (DTP) has taken over the American Museum of Natural History (AMNH) in New York on Indigenous Peoples' Day (also marked as Columbus Day) to

highlight how legacies of white supremacy, settler coloni-
alism, and heteropatriarchy are monumentalized in the dis-
plays, language, and aesthetics of the museum. Like many
ethnographic museums, AMNH organizes, categorizes, and
displays the cultures of non-European peoples in ways that
reify outdated cultural hierarchies that have their origin in
nineteenth-century colonial science. DTP has requested
that the museum establish an independent Decolonization
Commission to assess the impact of these offensive rep-
resentations. Their demands, which extend to other museums
across the city, also involve the diversification of curatorial
staff and executive leadership and the territorial acknowl-
edgement of Indigenous land occupied by cultural institu-
tions, among other things. As groups like DTP push cultural
institutions to reckon with histories of slavery and genocide,
as well as ongoing forms of white supremacy, is a revolution-
ary museum possible? Or will the museum always end up
serving the interests of the nation-state?

I carry the work of DTP into the fourth and final chapter,
which looks at the ethics of museum funding. In the last dec-
ade, museums have become highly visible centers of protest,
with actions often aimed at museum sponsors. Activists have
drawn attention to institutions that accept sponsorship from
oil companies, weapons manufacturers, and private prisons,
among other toxic sectors that use their association with the

arts to polish their public image. Cultural workers bypass the authority of art institutions again and again, acting on their own accord without institutional permission.

Their political aims are more urgent than ever. Even as some museum leaders seek to posit their institutions as neutral spaces that serve the liberal public sphere, grassroots protests have provided an effective counterweight, forcing a conversation about what is possible within the cultural sphere. Even the #J20 Art Strike, which called on the art world to protest the inauguration of Donald Trump in 2016, went well beyond a refusal of Trumpian white supremacy, xenophobia, and militarism. In fact, in a mission statement, organizers with Occupy Museums point out that the advent of fascism is not representative of a single administration, but is rather a symptom of "living in a house with a flawed foundation built on slavery, stolen labor, and bloodshed; maintained through the normalization of systemic injustice." Indeed, as Fanon argues in *The Wretched of the Earth*, fascism is just colonialism coming home after a long journey abroad.

Decolonize Museums investigates the flawed foundation of the museum, which has upheld or whitewashed colonial-era crimes and injustices for centuries. It also investigates how that scaffolding is beginning to fail. My analysis touches upon a range of museums, with a focus on art museums as well as anthropology or natural history museums. And while I do

take into account the origins and political histories of museums in the Global South, I focus considerable attention on museums in the United States and Europe.

This book is by no means meant to be comprehensive. Just as the work of decolonization is never complete, neither is the work of learning about colonialism's deep, far-reaching, and ever-mutating legacy in our cultural institutions. Those who take on decolonial work must always continue to learn—and continue to act.

Chapter 1

RETURNING THE COLLECTION

The 2018 film *Black Panther* may be best known as the first Black superhero blockbuster, but it offers plenty of lessons for students of decolonization. Early in the film, the villain Erik "Killmonger" Stevens (played by Michael B. Jordan) stands in front of a glass museum display, examining a selection of African artifacts inside. He is approached by a white curator, who condescendingly offers to tell him about the display. As she explains that the exhibited war hammer was made in the seventh century by the Fula tribe in Benin, he quickly contradicts her: "Nah."

"I beg your pardon?" she inquires.

"It was taken by British soldiers in Benin, but it's from Wakanda," he says, referencing the fictional sub-Saharan African country. "I'm gonna take it off your hands for you."

When the curator tells him the items aren't for sale, Killmonger confronts her: "How do you think your ancestors got these? Do you think they paid a fair price? Or did they take it . . . like they took everything else?"

Just then the curator, poisoned by her coffee, collapses on the floor. Killmonger and his team smash the glass display case and take off with the hammer. While this is fiction, it's representative of the very real issues in museums

today. Killmonger's very presence in the museum as a visitor of color is noteworthy, given that just over six percent of visitors to U.S. museums are Black.[1] As Lisa Ragbir points out in *Hyperallergic*, Killmonger's co-conspirator, disguised as a museum cafe worker, points to the hierarchical divisions between a museum's "diverse" service workers and a predominantly white curatorial staff. The scene also raises questions about the retelling of colonial narratives, and who gets to tell these stories. Above all, it brings up the issue of unethical acquisition practices, which fits into a long history of colonists robbing African artifacts to put on display for European consumption.

The scene is set at the "Museum of Great Britain," a thinly veiled reference to London's British Museum, which has long been embroiled in its own debates over acquisition and repatriation. The institution currently faces calls from Nigeria's National Commission for Museums and Monuments to return the Benin Bronzes, which British soldiers looted in an 1897 raid.

Recently, a real-life episode reminded me of this scene from *Black Panther*. On June 13, 2020, Congolese activist Mwazulu Diyabanza wrested a nineteenth-century wooden funerary post from its fixings in Paris' Musée du Quai Branly while declaring to a livestream audience on Facebook: "No one has the right to take what belongs to the African people

because it is our heritage." Together with four other activists, Diyabanza triumphantly carried the post through the museum shouting, "We're bringing it home!" Museum guards eventually stopped them, but their point had been made. Even before he went on trial, Diyabanza sued the French state for the same crime he allegedly committed: theft.

Some museum conservators viewed Diyabanza's act as a reckless incident of vandalism. Others, however, viewed his act as a demonstration of radical visual protest, a reclaiming of African cultural heritage that had been forcibly taken during the colonial period. The tension between these two views is emblematic of the clashes between museums and formerly colonized people when it comes to questions of repatriation—that is, the return of stolen cultural materials to their countries of origin. Those complex, ongoing debates are the subject of this chapter.

Macron's Promises

Why was Diyabanza driven to rip the post from the museum with his own hands instead of pursuing legal means? To begin to understand the answer requires rewinding a few years—specifically to November 28, 2017. Speaking to a group of students at the University of Ouagadougou in Burkina Faso, French President Emmanuel Macron pledged that within five years, France would begin the "temporary

or permanent [return] of African heritage to Africa." As a first step in this process, Macron commissioned a study to determine the amount of African art in French museums. The 2018 report, co-authored by Felwine Sarr and Bénédicte Savoy, found that over 90 percent of the material and cultural legacy of sub-Saharan Africa remains housed outside of the African continent. Diyabanza's funerary post, originally from a region that now comprises Chad or Sudan, is one of an estimated 90,000 objects seized from Sub-Saharan Africa during the colonial period and held in French collections. More than a third of these objects are at the Musée du Quai Branly.

Elsewhere in Europe, countries had slowly begun to acknowledge their own bloody histories. It took Germany over 100 years to apologize to the Hereros, the people of present-day Namibia who suffered genocide under German Colonial Law. In 2008, Italy apologized for the "deep wounds" inflicted on Libya during its colonial rule between 1911-1943. After a long juridical battle, the United Kingdom formerly apologized for the bloody repression and torture it inflicted upon the Mau-Mau of Kenya throughout the 1950s. On June 30, 2020, King Philippe of Belgium wrote a letter to the president of the Democratic Republic of Congo to express his "deepest regrets" for his country's past. (The letter did not include an apology.)

Macron's statement, like those of his contemporaries across the continent, can be read as a rather radical departure from the decades of denial, whitewashing, and even nostalgia that characterizes Europe's relationship with its imperial history.

And yet, as of 2019, two years after Macron made that bombshell announcement, France has taken little concrete action. The Benin treasures, robbed by French missionaries in 1892–93 from the Kingdom of Dahomey (now known as the Kingdom of Benin), had not been returned. In fact, as I write, only one object—a nineteenth century sword returned to Senegal—has been *loaned* to Dakar's Museum of Black Civilizations. Under French law, national collections are protected with "inalienable and imprescriptible" rights, prohibiting museums from permanently handing over accessioned objects. But the situation is changing. On October 7, 2020, the National Assembly of France passed a bill that would bypass the current restrictions and allow authorities to return 26 looted artifacts to Benin within one year.

Other European countries have since followed Macron's lead. In February 2021, the Dutch government approved a plan to unconditionally return objects looted from former colonies—a policy that has put the Netherlands at the forefront of European repatriation efforts. A month later, Germany entered into historic talks to restitute its holdings

of Benin Bronzes to Nigeria. Pressure for European nations to restitute their colonial holdings continues to mount. Even as I complete this manuscript, the domino cascade of breaking news persists—most recently with repatriation announcements from Scotland's University of Aberdeen and the National Museum of Ireland. These pledges by countries across Europe— have been praised by some as important "first steps" in the repatriation process.[2]

But for some, the progress has, understandably, not been swift enough. It certainly wasn't swift enough for Diyabanza and his associates, who decried France's years of foot-dragging and silence. The activists instead chose to take matters into their own hands, addressing the public directly through militant *Black Panther*-style action, while declaring to their livestream audience: "This belongs to us. It *deserves* to be taken home."

The Scramble for Africa

How did vast amounts of African cultural heritage end up in Europe? The looting of cultural heritage began before the colonial period and continued after the independence of most colonized nations. But I begin this story with the Berlin Conference of 1884. It was here that European leaders set the stage for the so-called "scramble for Africa." Although the invasion, division, and colonization of African territory was

already well underway, the Berlin Conference established the *rules* for its conquest and partition. By setting up the continent as an amusement park for Europeans, the Conference opened the door for Africa's cultural and natural heritage to be plundered and transferred to Europe.

Today, few museums lack some material trace of European conquest. Consider the Africa Yoruba masquerade costume taken from a shrine in Nigeria in 1948, now in the collection of the Brooklyn Museum. Or the Gweagal Shield, seized from Aboriginal Australians by Captain James Cook and his men, now on display at the British Museum's "Enlightenment Gallery" with no mention of its violent acquisition. Or Tippu's Tiger, an eighteenth-century wooden instrument forcefully taken from the Kingdom of Mysore by the British East India Company to be displayed at the Victoria and Albert Museum. (You can purchase miniatures of the piece at the museum gift shop for £17.50!)

One of the most well-known cases of colonial plunder is that of the "Benin Bronzes"—a group of more than a thousand metal plaques and sculptures that once decorated the royal palace of the Kingdom of Benin in what is now Nigeria. In 1897, the ruler of the kingdom, the Oba, imposed an embargo on exporting palm-oil products into British-controlled territory. In response, the British sent in a mission to depose the Oba and bring Benin under British

control. The Benin army decimated the expedition, leaving only two British survivors. A few weeks later, the British sent in what they called a "punitive expedition" to avenge the dead and carry out the conquest. After three days of fighting, the forces had burnt down Benin's capital city.

Here is a photograph of the Oba in shackles, just before he was sent into exile. The image is rich in information. The Oba's flowing velvet robes are perhaps a last-ditch effort to maintain dignity in the face of a humiliating defeat. The soldiers behind him, trained members of the Niger Coast Protectorate Force, are a stark reminder of those Africans who played the "game of collaboration" with colonial forces, as Fanon put it.[3] Then there's the man behind the camera—West African photographer J. A. Green—whose work for British colonial officers was used in the process of empire building. The image, a hand-painted, colored collotype, circulated as a postcard at the time. Other postcards from the expedition depict triumphant British soldiers kneeling next to piles of ivory and artwork looted from the Oba's palace.

If "empire follows art," as William Blake wrote at the turn of the nineteenth century, postcards like these staged the colonial space as one ripe for plunder. Indeed, following the expedition, the British confiscated all of the Oba's royal treasures. Two hundred of the pieces were taken to the British Museum, while others were purchased in auctions by

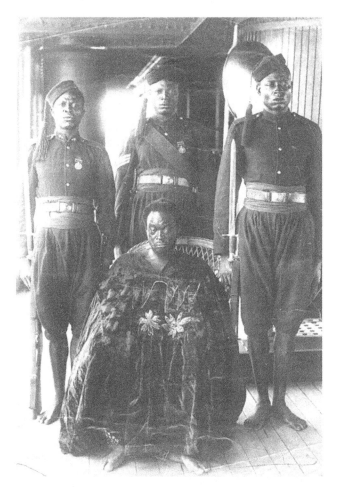

Photograph taken on board the S. S. Ivy, a British Government vessel, as the Oba was exiled and sent to Old Calabar in eastern Nigeria. Source: British Museum.[4]

other European museums and private collectors. Such theft was justified and explained as a "right of conquest" under the terms of the Berlin Conference. Yet even after twenty-four European nation-states signed the 1899 Convention with "Respect to the laws and Customs of War on Land," which made the "pillaging and plundering of cultural artifacts during military campaigns" an illicit act, the looting of African objects by European powers continued. The colonial desecration of Africa needed no legal justification.

Anthropologists, meanwhile, invented their own justification: "salvage anthropology." Often associated with Franz Boas, who was obsessed with recording "vanishing" Native American cultures, salvage anthropology is premised on the notion that Indigenous cultures were doomed to disappear, and therefore were in desperate need of permanent preservation. In 1903, the director of the Ethnologisches Museum Berlin, Felix von Luschan, advocated for the forceful acquisition of cultural objects from people that European ethnologists considered to be close to extinction. In the same year, British anthropologist and director of the Halifax museum Henry Ling Roth argued that the practice of extracting objects from Benin was crucial. Congratulating himself for his role in transferring great works of art seized at Benin City by the British expedition of 1897, he wrote:

> Unlike the Tasmanians or Ancient Peruvians, the West African
> will never be wiped off the face of the earth, but intercourse with
> the white man alters his beliefs, ideas, customs, and technology,
> and proper records of these should be made before we destroy
> them.[5]

Roth's use of the term "we" to refer to destructive Europeans is rare. Those who desired to "salvage" the culture of the colonized rarely contended with the colonial violence that decimated those same cultures in the first place.

A sober examination of history, however, cannot ignore the connection. Indeed, across time and geographic space, conquest and looting have sustained one another in a continuous feedback loop. The perceived need to "rescue" treasures from those humans damned for extinction resulted in the immense transfer of financial and material wealth from Africa to Europe, from colonized to colonizer. Oftentimes, as in the case of the Benin bronzes, this wealth was used to finance the expedition and pay for future excursions.

Legislating Theft

The sheer scale of the Benin punitive expedition remains incomprehensible. The number of Africans killed is unknown, as is the number of sacred objects looted from the Oba's palace. No formal procedures informed the handling and distribution of the loot. It was a chaotic act of vandalism,

in which sailors, soldiers, and colonial officials grabbed whatever they could hold.

Yet this method of "every (white) man for himself" didn't characterize all forms of colonial theft. Archeological looting in Iraq, for example, was carried out through the legal oversight of the Antiquities Law of 1924. This was the legislative baby of Gertrude Bell, the British adventurer, archeologist, and mountaineer who has been described as the female Lawrence of Arabia. Bell's law, drafted as an attempt to curb the looting of Iraq's archeological ruins, granted the Director of Antiquities the power to closely monitor excavation sites and determine which objects would remain in Baghdad. It is no coincidence that throughout the 1920s, Bell herself occupied this position, serving as an intermediary between British officials and Iraq's King Faisal. In this role, she threw herself into the creation of the National Museum of Iraq, which she variously referred to as the "Mini British Museum" and "*my*" museum. Likewise, she called the Antiquities Law "*my* law," as it effectively gave her the authority to decide which Iraqi artifacts would make their way to Iraq's National Museum, and which ones would be exported out of the country by Western archeologists.[6]

When it came down to deciding the fate of Iraq's cultural heritage, Bell's decision-making process was often arbitrary.

In a letter she wrote to her father dated March 6, 1924, she recounts a long day of dividing up archeological spoils:

> Before 9 we started the division (it began by my winning the gold scarab on the toss of a rupee) and we carried on till 12.30, when I struck. It's a difficult and rather agonizing job, you know. We sat with our catalogues and ticked the things off. But the really agonizing part was after lunch when I had to tell them that I must take the [Sumerian] milking scene. I can't do otherwise. It's unique and it depicts the life of the country at an immensely early date. In my capacity as Director of Antiquities I'm an 'Iraqi official and bound by the terms on which we gave the permit for excavation. J.M. backed me but it broke Mr. Woolley's heart, though he expected the decision. I've written to Sir F. Kenyon explaining. (By the way, this is confidential, Mr. Woolley values it at £10,000, at least. I'm not going to tell the 'Iraq Govt lest they decide to sell it and thereby blacken my face and theirs. But you'll agree that it's a responsibility to decide the fate of objects of such value …)[7]

Bell's letter shows that she saw deciding the fate of Iraq's cultural heritage as her own unique responsibility. Yet ironically, Bell identifies *herself* as an Iraqi official, even as she decides to keep the Iraqi government in the dark concerning the value of the country's artifacts. Each excavated piece faced a trial like this one: Less a negotiation between equal parties than a transaction based on Bell's individual gut feeling, or the toss of a coin.

Bell certainly played a significant role in building up Iraq's national museums, and even broke some Western hearts along the way. Yet the Antiquities Law ultimately allowed for

a significant amount of excavated material to leave the country. Just two years before writing that letter, Sir Charles Leonard Woolley—the British archeologist who had been vying for the Sumerian milking scene in Bell's story—led an expedition to Ur in Mesopotamia. There, his team uncovered the Copper Bull, a sculpture which dates from 2500 BC, as well as the Bull Headed Lyre, one of the first string instruments ever discovered. Under Bell's law, the former was sent off to the British Museum, while the latter made its way to the Penn Museum.

Not everyone was on board with Bell's authority. Even before the Antiquities Law was passed, influential Arab nationalists like Sati' al-Husri and Yasin al-Hashimi attempted to introduce a different law that would restrict exports by foreign excavators. Bell eventually thwarted their efforts. But the idea that Iraqi antiquities should belong to the Iraqi people had already taken hold. Archaeology became an integral component of national identity as well as a platform where nationalistic battles would be fought.

Today, Iraqi law requires that anything found in Iraq must stay in Iraq. Unfortunately, that has not always held up. In April 2003, in the midst of the Iraq War, Baghdad fell to coalition forces. As U.S. troops stood idly by, looters ransacked the Iraq Museum, stealing over 170,000 antiquities. At the time, the *Associated Press* reported that "[everything] that could be carried out has disappeared from the museum."

It was pure chaos—a scene reminiscent of the pillaging of the royal palace in Benin over one hundred years earlier.

Some attribute the destruction to built-up anti-government resentment on the part of the Iraqi public, which viewed the museum unfavorably as a government symbol.[8] Most likely, however, those who stole items from the museum were driven by economic incentives, desperate to receive an illegal source of income—a small relief from the war-time inflation, sanctions, and high unemployment rates that were crippling the Iraqi economy.

It is unclear what happened to the milking scene that Bell had insisted on keeping in the Iraq Museum all those years ago. Many other Sumerian artifacts were funneled from Baghdad into the Western art market—a market that is unfortunately well-equipped to receive trafficked antiquities from smuggling routes. Since 2003, some of these ancient Mesopotamian artifacts have been recovered and returned. Others, however, have been swept up in the global antiquities market. On sites like "Live Auctioneering," anyone with a spare $200 and some decent Wi-Fi can purchase a terracotta fragment or a stone bull.

Uprooted Objects, Displaced Meanings

Susan Vogel's 2011 film *Fang: An Epic Journey* recounts the century-long journey of a wooden reliquary figure made

by the Fang people in Gabon. The story—a work of fiction based on real events—begins in Cameroon in 1904, where a German rubber trader (based on German explorer Günther Tessmann) recounts the capturing of the idol as he carefully paints an acquisition number on its side. So begins the object's transformation into a category of "art" for Western consumption. From there, the Fang sculpture travels through curio shops, art dealerships, artist studios, and academic offices, before landing at its final destination: the museum.

Many African objects followed a similar trajectory. These objects, violently plundered from the colonies, were first "decontextualized," or extracted from the context of their original use, and then "recontextualized" in the sense that they were inserted into new settings. Different modes of contextualizing ethnographic objects coexisted and often contradicted each other. Some museums, like the Pitt Rivers in Oxford, placed stolen ethnographic artifacts on a yardstick designed to measure each culture's level of civilization. Other museums, like the Musée de l'Homme removed Indigenous objects from their original ritual or communal contexts, and instead rebranded them as pieces of "universal art."[9]

This "rebranding" involves relegating imperial violence to the background—an open secret not to be explicitly named. Instead, as theorist Ariella Aïsha Azoulay argues, a range of

professional procedures and skills convert these objects into pure works of art. Protocols and regulations surrounding practices of collection, handling, displaying, and purchasing these objects ultimately "[transform] world-destroying violence into a decent and acceptable occupation."[10]

A quick search for "Benin bronze" on the auction house Christie's website becomes a case study in how to whitewash imperial crimes. A posting for a sixteenth century Benin Bronze plaque, which sold at $388,300, lists the formal qualities of the object, including its height, shape, and color. Its listed provenance traces its origins to Dorset, England, 1898—a year after the infamous raid on Benin. More recently, Christie's July 2020 auction listed a Benin sculpture of a fish, originally crafted to symbolize the Oba's qualities. In both cases, the website didn't mention how these items ended up in a private collection. Instead, the sculpture was absorbed in the sanitized language of the art market—a "neutrality" that erases the ugly history of colonial plunder.

Such reframing not only hides an object's violent acquisition; it also denies it a pre-imperial existence. Azoulay references the example of a sculpture that the Pende people of Congo made to commemorate a revolt against Belgian colonial rule in 1931. The piece, which depicts a Belgian tax collector whose murder sparked the rebellion, might have been used by the Pende as a symbol of resistance to the

colonial system. In the 1970s, members of the community sold the statue to the Virginia Museum of Fine Arts to raise funds for sending village children to school.

In the catalogue accompanying the sculpture's display in the museum, curator Richard Woodward points out that the statue could be sold out of the community because the Pende do not believe that their objects should last forever. For this reason too, they avoid making statues out of permanent materials. So what happens when this statue—created to be deliberately ephemeral and inaccessible—enters a Western museum where it is conserved and displayed as a piece of fine art?

First, there is a process of forgetting. The Pende statue becomes a unique art object when the museum erases its pre-imperial function as well as the story of its violent acquisition. Second, there is an element of disrespect at work when curatorial or scholarly "experts" scrutinize communal codes, values, and practices that are not meant for outside audiences. Finally, a process of aestheticization repositions the statue as "art" and allows it to be both decontextualized and commodified.

The Virginia Museum of Fine Arts acquired the Pende statue at a time, in the 1970s, when "primitivism" was uncritically celebrated as an aesthetic form capable of introducing new visual vocabularies into Western art. But Western romanticism of African art goes back decades earlier.

In Vogel's film, artist Georges Braque is represented in his studio in 1907 as he attempts (and fails) to paint the Fang idol. The walls behind him are covered in African masks and artifacts. This scene is typical of the time. Beginning in 1906-1907, avant-garde artists in Paris began integrating these objects into their visual repertoire, despite having no knowledge of the African artists who had made them. In 1907, for instance, Picasso had a moving encounter with a collection of African tribal masks at the Musée d'Ethnographie du Tocadéro, which inspired his "periode nègre" (black period) or African period. It also turned him into an avid collector of African masks and sculptures, which greatly influenced his work.

There's something to be said for Picasso's own philosophy that "good artists copy, great ones steal." Artists are always recontextualizing, remixing, and mashing up existing work to create something new. Yet even as Picasso developed an intimate relationship with African objects, he had no interest in African people as producers of culture. His first encounter with Black people had been with colonial Africans on display at the Parisian Universal Exhibition of 1900—an experience that did not make a strong impression on Picasso's consciousness because it didn't directly serve his aesthetic interests.

While colonialism deprived people like the Pende of their cultural objects and the means to produce them, their works

were being integrated into the repertoire of Western art by individual artists like Picasso who were hailed as "geniuses."

In 1984, the Museum of Modern Art (MoMA) in New York held an exhibition called *Primitivism in 20th Century Art: Affinity of the Tribal and the Modern.* The show displayed 200 tribal objects alongside modern art from Paul Gauguin, Paul Klee, and other artists who were influenced by tribal forms previously thought of as crude and inferior. Here, another separation takes place, in which abstract modernism appropriates the visual language of primitivism, while severing tribal works from their original sources. Artists like Picasso could therefore turn towards Africa for its "magic and art" while avoiding the problems of its colonized people.[11]

Restitution, Repatriation, Return: A Legal Story

So far, I have used the terms restitution, repatriation, and return interchangeably. Indeed, there is a blurry line between them. Yet each term is tied to a specific legal regime of values, and it is worth pausing to delve into each of their historical and political genealogies.

"Restitution" emerged as a hot-button issue in the 1960s. At the time, illicit trafficking of antiquities from South America, Africa, and Southeast-Asia (referred to "source nations") to North America, Western Europe, the Gulf States and Japan (so-called "market nations") was rampant. In 1970,

in an attempt to curtail these illegal transfers, The United Nations Educational, Scientific and Cultural Organization (UNESCO) adopted the Convention on the Means of Prohibiting and Preventing the Illicit Import, Export and Transfer of Ownership of Cultural Property.

The Convention was the first body established to handle restitutions. Over the years, its successes have been substantial. Take the case of the Euphronios Krater, an object which was illegally excavated in Italy in 1971 and purchased by the Met in 1972 for $1.2 million. In 2006, under the terms of the UNESCO Convention, the museum restored ownership of the object to Italy. The Convention also handles the ongoing restitution of artworks that were stolen or confiscated by the Nazis from museums and Jewish collectors. The collapse of communism in 1989–91 opened up the possibility of restitution of much of this property, which had been illegally transferred between Iron Curtain countries.

There are, however, a couple of weaknesses that limit the scope of the UNESCO Convention. First, the Convention is based in the legal language of property rights, whereby property must be clearly owned by a source nation, and then clearly stolen or illegally transferred to a market nation. This bars the recognition of claims by non-state legal parties, such as unrecognized states like Palestine. Indigenous groups are also left out.[12]

Second, the convention cannot be applied retroactively; it only applies to cases that took place after 1970. This leaves out many postcolonial nations who have been pleading for a return of their cultural objects long before 1970. Throughout the 1960s, as newly formed African countries achieved independence from their European colonial rulers, claims for restitution of cultural heritage began pouring in. In 1960, for example, the newly independent state of Zaire asked Belgium to return a number of treasures that were stolen during the colonial period. In 1968, Nigeria submitted a restitution claim to various Western governments to return stolen items from the Kingdom of Benin to fill a new National Museum in Benin City. Neither case received a response. In 1969, the Organization of African Unity drafted the Pan-African Cultural Manifesto, which insisted on the recuperation of art seized by colonial powers.

By starting the clock at 1970, The UNESCO Convention does not acknowledge these historical realities. Christie's is able to sell off the Benin fish sculpture without consequence precisely because the piece was stolen between 1968 and 1969—a year before Britain would be subject to the Convention. It is these loopholes that have led many activists to call for an expansion of the legal instrument.[13]

Here's where the concept of "return" comes into play. Under the mandate of the 1978 Intergovernmental

Committee for Promoting the Return of Cultural Property to its Countries of Origin or its Restitution in Case of Illicit Appropriation, claims on material looted before 1970 could be made. And yet limitations remained. Claims could still only be filed by state actors. Second, contrary to restitution, which is upheld by property law, the debate concerning return lies outside of the law. Instead, return disputes are typically settled through behind-the-scenes negotiations.

Perhaps the most well-known (and ongoing) case is Greece's unanswered call for the return of the Parthenon ("Elgin") Marbles from the British Museum. The Marbles were stolen—or "rescued," as the British put it—from the Acropolis by Lord Elgin in the early nineteenth century. The Acropolis Museum of Athens, built in 2009, includes a specially designed space to house the marbles if and when they are returned to Greece. But without the teeth of legislation, the British Museum can continue to refuse all requests to give up one of its most popular exhibits.

And then there is "repatriation." Unbound by the state-centric, property rights frameworks of the other terms, repatriation is more ideologically and symbolically driven.

Repatriation is not only about returning objects; it's about restoring the dignity of a people, and allowing them to re-establish ties with their culture and their past. Both states and local communities within a nation-state can make

repatriation claims to a wide range of cultural artifacts: works of art, religious relics, manuscripts, musical instruments, and so on. Repatriation is also used in reference to the restoration and reburial of Indigenous human remains.

The concept of repatriation expands the conversation around stolen property to encompass issues of human rights, sovereignty, and culture. The refusal to give back stolen cultural property, journalist Kwame Opoku contends, violates the right to access culture under the Universal Declaration of Human Rights (1948), the International Covenant on Economic, Social and Cultural Rights (1966) and the International Covenant on Civil and Political Rights (1966). As long as people are deprived of their cultural heritage, he argues, they are unable to exercise the full array of rights guaranteed under these instruments.

Perhaps even more importantly, repatriation activates the concealed memory of colonialism, particularly for younger generations who are inheritors of that history. Depriving African youth of their artistic and cultural heritage, for example, means prolonging the trauma of colonialism. As long as the cultural resources inherited from Africa's past are stored in institutions outside of the continent, African youth will remain unaware of the richness and creativity of their past. Alongside legal and national rights, a moral right emerges— the right to one's inheritance, and a right to admire the

ingenuity and creativity of those who came before. The 1969 Pan-African Cultural Manifesto recognizes this right to culture, linking the recovery of cultural heritage to national progress and development. The right to one's culture, the Manifesto declares, is the right to one's "soul" and "history."

Repatriation, therefore, goes beyond decolonizing the museum; it's a call to decolonize access to knowledge, culture, and history. Why have so many Western museums been allergic to it?

i. Purchasing Power

Perhaps one of the most frequent arguments against repatriation made by Western museums and collections is that many objects, at the time of their acquisition, were legally obtained. Like the Pende sculpture sold to the University Virginia Museum of Fine Arts in the 1970s, it is true that many artifacts from Africa, Asia, and Oceania, were traded, purchased, or obtained with the permission of the individual or community that crafted the object.

But it's really not so clear-cut. As Chip Colwell argues, many purchasing agreements were procured with "the threat of violence, without consent and in ways that violated cultural traditions." Transactions often resembled forced and erratic purchases.[14] Under these conditions, it's largely impossible to determine a sense of legitimate consent among the targeted

population, let alone the actual amount of money paid during transactions. Often, the amounts paid were laughable. For example, in 1931, a zoomorphic mask was purchased by a French exhibition in Dakar-Djibouti for 7 francs ("the equivalent price for a dozen eggs at that time") at a time when it could easily sell at an auction for 200 francs.[15]

Sometimes, colonial powers insist, the removal of a piece of cultural property wasn't a financial transaction *or* a clear-cut case of theft, but instead an instance of *collecting*. British Museum Director Hartwig Fischer, for example, once described the taking of the Parthenon Marbles as a "creative act." These feats of linguistic gymnastics served to reframe looting as a simple act of accumulation. In his account of an 1896 British expedition in Kumasi, Major Robert Stephenson Smyth Baden-Powell (who also happens to be the founder of the Boy Scouts) describes the raiding of the African king's palace like this:

> Here was a man with an armful of gold-hilted swords, there one with a box full of gold trinkets and rings, another with a spirit-case full of bottles of brandy, yet in no instance was there any attempt at looting.[16]

Baden-Powell, like many of his European associates, clearly believed that the removal of treasures under the orders of a British officer was a legitimate transfer of property—and therefore a good reason to keep that property in British hands.

Likewise, many museums refuse repatriation because they insist that they purchased objects *legally* from the art market. This attitude is reflected in a statement by Lord Donaldson of Lymington to the British House of Lords on March 8, 1977. Addressing the British Museum's consistent rejection of Nigerian requests for temporary loans of Benin artifacts, Lymington declared: "I should like to make it emphatically clear that any such objects which are in the national collections were legally acquired and properly paid for at the time."

Similarly, when faced with demands by the people of Benin to repatriate the Benin bronzes from the Ethnologisches Museum in Berlin, the German government has historically argued that these items were acquired through purchases and gifts from Britain—the nation directly responsible for criminal practices of looting. Opoku writes that such assertions of "indirect" responsibility are preposterous, noting that it was German enthusiasm for Benin bronzes that "prompted British institutions to increase their own stock."

Christie's uses the same language of "indirect" or "legal" acquisition to auction off morally questionable items. In addition to the Benin bronzes, the auction house is selling off a number of sacred sculptures removed from Nigeria in the late 1960s in the midst of the Biafran war. They point out that the sculptures were legally acquired by French collector Jacques Kerchache between 1968–69, and then "properly exported"

to Christie's through a Belgian dealer, Phillipe Guimiot with the help of Nigerian locals.

Art historian Chika Okeke-Agulu writes that the expropriation of these objects from his homeland is incredibly painful. He calls these objects "blood art," because like "blood diamonds," nobody should be selling them. In an Instagram post, Okeke-Agulu took aim at Christie's, stating that "these artworks are stained with the blood of Biafra's children." A petition to stop their sale uses the hashtag #BlackArtsMatter to remind the public that "it is not just the black body, but also black culture, identity and especially art that is being misappropriated." The commercial art market—a surging colonizing force driven by money and cultural capital— adds an additional layer of complication to the already fraught field of repatriation.

ii. Restitution Contagion: Fear of Precedence

Many cultural institutions in the West fear that repatriating one object will open a Pandora's box of additional claims, leaving museum shelves empty. Take this speech given by former French president François Mitterrand, thanking Helmut Kohl for the restitution of twenty-seven paintings stolen by the Nazis, in which he declared:

> I hope that this evening, the custodians of our countries, those
> responsible for our grand museums, experience a bit of anxiety.

Will this become generalized? I don't think it's much of a risk on my part, thinking that this example will remain very singular and the contagion will be squashed out rather quickly.[17]

This contagion anxiety—a mix of "political prudence and museum dread," as Sarr and Savoy put it—showed up again in 2005, when the British High Court ruled that the British Museum was barred from returning four Old Master drawings stolen by the Nazis. While for many, including for the British Museum itself, it seemed like an obvious moral choice to return the drawings to the family of its original owner Dr. Feldmann (who was tortured and murdered by the Nazis), the British government worried about setting a precedent. If the drawings were returned, the logic went, the door would open up for Greece to pursue its claims to the Parthenon marbles.

Curator Dan Hicks insists that such arguments drive a popular misunderstanding that pits restitution against "the spectre of empty galleries." In reality, he maintains, museums have returned some pillaged property—generally artifacts without a direct connection to colonial histories. Currently, the British Museum is overseeing the return of more than 158 looted ancient artifacts to institutions in Iraq and Afghanistan. The objects had been smuggled out of heritage sites during recent wars. The museum is also working collaboratively with experts in Egypt and Sudan to return 700 artifacts to

those nations. Within the past five years, the J. Paul Getty Museum of Art and the Met have returned a slew of artifacts to the Italian and Greek Governments. As Hicks reminds us, "Restitution is not subtraction." It is not a zero-sum game. If each looted object represents an unfinished event, as he argues, repatriation presents a unique opportunity for museums to serve as sites of reconciliation and healing.

iii. The Fallacy of the Universal Museum

Many proponents of repatriation claim that certain objects qualify as "cultural patrimony"— the property and product of a culture. The tight link between cultural patrimony and cultural identity, they argue, renders such property inalienable, or non-transferrable.

Opponents of repatriation fundamentally reject this idea. Ghanaian-American scholar Kwame Anthony Appiah, for example, rejects the notion of cultural patrimony on the grounds that such claims are the product of a relatively new phenomenon: nationalism. Much of what is considered cultural patrimony was made by members of societies that no longer exist. These objects, Appiah argues, should not be considered the property of modern nation-states, but rather that of humankind. He urges poor countries to drop repatriation claims and instead allow Western museums to be the guardians of what he calls the "cosmopolitan enterprise of

cross-cultural understanding." Like the Sistine Chapel and the Great Wall of China, he insists, the Benin Bronzes should belong to the world.

This is an oft-cited defense against the return of looted objects. Neil MacGregor, the former director of the British Museum, has claimed that the Parthenon sculptures are a part of the heritage of all mankind, rather than the cultural property of Greece. He described the British Museum as a "museum of the world, for the world," a sentiment repeated by the Museum's current director Hartwig Fischer, who described the institution as one of the few so-called "encyclopedic museums." The museum's job, Fischer says, is "to take the long view, to observe the whole of human history." Therefore, returning the Elgin Marbles to Greece is, in his view, out of the question.

For Tristram Hunt, Director of Britain's Victoria and Albert Museum, the acquisition of objects by Western museums serves to communicate a "nuanced understanding of empire"—one that emphasizes the "cosmopolitanism and hybridity" brought by the mixing of cultures. In a 2019 article for *The Guardian*, he argued against the return of the collection's Maqdala crown to its original home in Ethiopia because "to decolonize is to decontextualize."

This view of the museum is widespread. In 2002, 18 major museums, including the Met, the Getty, and

the British Museum, signed onto a "Declaration on the Importance and Value of Universal Museums." The text declares that knowledge should be prized above nationalism, and that "museums serve not just the citizens of one nation but the people of every nation." (Never mind that all of the museum signatories were located in the Northern Hemisphere, with almost all holding onto material from the sacking of Benin City.)

As soon as the Declaration was issued, it faced a barrage of criticism. Kwame Opoku described it as a pitiful attempt by Western powers to proclaim immunity from repatriation claims. Geoffrey Lewis, then Chairman of the ICOM Ethics Committee called it "a statement of self-interest, made by a group representing some of the world's richest museums." And philosophers Tapuwa R. Mubaya and Munyaradzi Mawere identified it as a tool for "naked diplomacy" used to evade the topic of repatriation altogether and legitimize the continued exploitation of African cultural property. Considering that "universal" museums are based exclusively in Europe and America, they argue, the majority of the world's people (especially those in the Global South who have been alienated from their cultural property) don't actually benefit.

In defending the British Museum's unwillingness to return the Benin Bronzes to Nigeria, Chris Spring, the former curator of the museum's Africa galleries, went so

far as to argue that "London is a global African city, argu-
ably the biggest African city in the world." While it may be
true that London is one of the most ethnically diverse cit-
ies in the world—and home to many African immigrants—
the museum's board of trustees is overwhelmingly white,
wealthy, and male. Museum audiences are also largely white.
In the UK, in 2018, 51.1 percent of white people had visited a
museum or gallery, compared with only 33.5 percent of Black
people and 43.7 percent of Asian people.[18]

The harmful impact of the concept of "universal her-
itage" goes beyond the historical evasion of repatriation
claims by Western museums. It is also tied to contemporary
political dynamics. In his book *The Brutish Museums*, Hicks
contends that it is no coincidence that the *Declaration* gained
coherence during the build-up to the Iraq War. Alongside
grand ideas of democracy and women's rights, liberal val-
ues of multiculturalism and global exchange were wielded
by the Bush administration as justifications for the so-called
"war on terror." Just as the sacking and looting of Benin City
had been driven by Enlightenment ideals of encyclopedic
knowledge production, the invasion of Baghdad was framed
as a liberal project, one that would help realize Bush's vision
of a "new world order." As Hicks writes, "*The Declaration of
the Importance and Value* of objects looted for rubber and palm
oil was made hand-in-glove with the Declaration of War

for oil." Decolonizing the museum involves recognizing the myth of universalism as a "weapon" that has been loaded and reloaded across time and space.[19]

iv. The Ghost of Salvage Anthropology

Alongside arguments for "universal" institutions is the idea that Western institutions are best equipped to *preserve* the world's heritage. Appiah, for example, urges poor countries to drop repatriation requests in order to ensure the survival of ritual objects for later generations. Under this assumption, certain communities lack the resources or the will to properly care for their own cultural property.

In the case of the Parthenon Marbles, Lord Elgin (who plundered the Acropolis) believed that he was *rescuing* the treasures from further damage. The Turks, he claimed, had been grinding down the statues to make mortar. Today, the British still argue that giving the marbles back would irreparably destroy them. But, as anthropologist Sally Price succinctly explains, "'Give it back and it'll only be stolen' is the universal motto of the thief."

Anthropologists in the nineteenth century furthered imperial projects by "salvaging" artifacts as a means to preserve cultures before they went extinct. Today, these cultures continue to exist, but Western governments and museum officials deny their ability to "salvage" their own heritage. Artist

and activist Bayryam Mustafa Bayryamali has called these conservationist concerns "orientalist," as they are based on the assumption that objects taken out of colonized communities can be best taken care of in the "hands of the colonizer."

They also contain echoes of the fascist logic of *Kunstschutz*—the German principle of preserving cultural heritage to keep it safe. Consider the Nazis' Museum of the Extinct Jewish Race, built to house confiscated Jewish artifacts and art from the Theresienstadt concentration camp, as well as the storage of Jewish "degenerate" art by the Nazis in Paris's Musée du Jeu de Paume. The latter contained more than 22,000 confiscated works of modern art from the collections of notable French Jewish families. Although the artworks were banned in Nazi Germany and condemned as an "insult to German feeling" by Hitler himself, the Nazi second-in-command, Reichsmarschall Hermann Göring, took a great interest in the Jeu de Paume warehouse, personally selecting hundreds of artworks for his own collection.

Perhaps this entire debate—about the desirability of so-called "universal museums" that are equipped to care for so-called "universal heritage"—is a distraction. To truly decolonize the museum, as Lewis argues, we must center the "ability of a people to present their cultural heritage in their own territory." To wit, there are more than 500 museums in sub-Saharan Africa that await the return of artifacts. Some,

like the Museum of Black Civilizations (MBC) in Dakar, contain state-of-the-art facilities equipped with climate and humidity controls. Many of its galleries are empty rooms, awaiting the return of African artifacts currently held in European institutions. "[W]e can no longer say that Africans are not ready to receive new works," said Abdoulaye Camara, researcher at Cheikh Anta Diop University in Dakar to *Smithsonian Magazine*. "We now have all the cards in hand if works from Senegal, for example, were to be returned."

In March 2021, the Nairobi National Museum launched an exhibition series titled "Invisible Inventories" which included ten empty display cabinets meant to represent objects that Kenya wants back. The exhibition is accompanied by an ongoing research project carried out by the International Inventories Program (IIP) to build a digital database of Kenyan cultural objects located in Western collections. The National Museums of Kenya—an institution that manages Kenya's museums, historical sites, and monuments—is overseeing the project, which they see as a crucial step in the reclamation process. There are 32,000 objects in the database to date.

The continued insistence on "preserving" objects in European institutions not only ignores contemporary institutions that are ready to house such treasures; it also looks past a rich history of conservation in Black and Indigenous

communities. In most instances, colonial incursion destroyed Indigenous systems of preservation and care. Dynastic treasures were held in protected spaces within the Oba's Palace in Benin City before the site was looted by British officials. The Ethiopian emperor Tewodros II (1818–1868) created and tended to what could be considered a collection of "modern libraries." And European explorers were shocked to "discover" the massive libraries of Timbuktu that safekept precious manuscripts and sacred objects for centuries.

Once again, we must heed Azoulay's call to remember the pre-imperial moment in which such objects existed and found meaning. These objects were cared for long before Europeans deemed non-Western communities incapable of preserving them. Those communities could—and should—preserve them once more.

Towards a "Fourth R"

Macron's speech, full of promises to return African heritage back to Africa, begged the question of whether France would also financially support the necessary infrastructure to conserve these objects in African museums. While many museums in formerly colonized lands do, indeed, have the capacity to expertly house delicate objects, there's no question that their efforts would be enhanced by material support

from European nations. Indeed, many have argued that repatriation must not only involve a return of objects; it must also include the financial costs required for preserving such objects for future generations.

Mubaya and Mawere, for example, connect poor levels of security in African museums to U.S. sanctions that have slammed many African countries. They contend that all objects should be returned back to their respective original countries *and* that Europe and America should "provide the financial resources required to conserve and secure such objects by their original countries or peoples." A return of African cultural objects would boost tourism to the African continent, which in turn would support local economies and provide the means for more financially secure cultural institutions. Similarly, in cases involving the return of human remains to Indigenous communities, many have argued that repatriation must be accompanied by financial support to cover the costs of reburial and associated ceremonies.

Calls for a more expansive notion of repatriation arose in talks surrounding the 2023 opening of a new Royal Museum in Benin City, which is expected to house at least 300 Benin Bronzes. The initiative is organized by the Benin Dialogue Group, a group comprised of Nigerian representatives and European museum officials. Through its Benin Plan of Action, the group has agreed that as part of a repatriation

plan, European museums must assist with funding, expertise, and training for curatorial education at the new museum. However, despite its collaborative framework, many have criticized the Benin Dialogue Group for skirting the issue of permanent return; instead, the museum is designed as a rotating display of some of Benin's most iconic pieces, which will be loaned on a *temporary* basis from European institutions. Opoku has called it a "ridiculous and insulting proposal." The situation might be changing soon, with Germany now negotiating the full repatriation of over 500 Benin objects.

In a letter to President Macron, cultural theorist Manthia Diawara cuts past these complications of restitution—including unsatisfying dialogue, loopholed compromises, and unfilled promises—to demand a so-called "fourth R": *reparations*. Forget the restoration of African heritage, he argues. The more urgent problem is a neoliberal economic structure that continues to reward inhabitants of the U.S. and Europe, while relegating Africans to a state of poverty and endless debt:

> ... restitution does not feed anyone in deep Africa, nor does it reconcile continents and races, nor does it put an end to the emigration of Africans to the West (which is in part generated by the theft of Africa's natural resources over the past four centuries) How much of Africa is there in Europeans' and Americans' daily consumption?

The urgent need for reparations before repatriation is reflected in the Q&A segment that followed Macron's speech at the University of Ouagadougou. One after the next, college students in attendance raised concerns not about the meaning of repatriation, but about the lack of electricity and air conditioning in their classrooms. A flustered Macron, unprepared for these questions, lashed out at a student: "It is like you are speaking to me as if I was still your colonial master. But, I do not want to be dealing with electricity supply in Burkinabè universities! That's your President's job!"[20]

Or is it? Certainly, Macron *is* at least partially responsible for the crumbling infrastructure in Burkina Faso. After all, his country has benefited from the extraction of Africa's material natural resources for centuries. Reparations, many have argued, are in order. Diawara for one, has proposed a hypothetical "Macron Plan for Reparations," essentially an economic support package for the African continent funded by European and American taxpayers. Such a plan would not be "charity, paternalism, nor band-aids," but rather the bare minimum necessary to "reconcile Africa with itself" and the West.[21]

The Battle over Human Remains

Up until now, I've mostly discussed repatriation as it relates to the transfer art or artifacts from western museums or art

markets back to former colonies. But the term "repatriation" is also used in reference to the restoration of human remains back to the contemporary descendants of the cultures from which they were originally removed.

Unfortunately, there's a lot of demand for this kind of repatriation. In the nineteenth century, anthropologists and archeologists circled the globe to dig up graves and buy and sell bones from dealers. This was all done in the name of scientific research. Scholars used human remains to explain physical and cultural differences between peoples. The measurements of cranial capacity and skull shape, for instance, helped to prop up theories of white supremacy.

While this kind of behavior was common in virtually all colonies, it was most rampant in settler colonies. Take the case of South-West Africa, now known as Namibia. From 1884 to 1915, German settlers rushed to the region to create a homeland abroad. In response, between 1904 and 1908, the Herero and Nama ethnic groups launched a rebellion, which resulted in what is now considered the first genocide of the twentieth century. Tens of thousands were killed through battle, starvation, and thirst. Many more suffered forced labor, medical experiments, and disease in concentration camps. Germany's intent was to rid the colony of people viewed as expendable, and thus gain access to their land.

In 1906, Austrian anthropologist Felix von Luschan urged the overseers of those Herero and Nama concentration camps to gather bones and ship them to him in Berlin for research purposes. Herero women were forced to use shards of glass to scrape away the flesh from the corpses of their loved ones for this purpose. Luschan eventually sold his entire personal collection of human remains, including skulls belonging to the Herero people, to the AMNH in New York. Henry Fairfield Osborn, the president of AMNH at the time, was eager to obtain the collection in order to advance his own studies of "backward races" based on skull analysis. The purchase doubled the AMNH's physical anthropology collection.

Since 2017, the remains have been wrapped up in legal battles. The AMNH has repeatedly turned down requests by descendants of the victims to inspect the skeletal remains of eight individuals said to be of Namibian descent. And on September 24, 2020, a U.S. federal court in New York dismissed a class action lawsuit that had been filed by the Herero and Nama peoples to demand Germany pay reparations. Despite these setbacks, the Herero and Nama continue their fight for justice.[22]

Yet even if the human remains are eventually repatriated, not all Herero descendants agree on what to do with them. Some want to put the bones on display to demand international recognition of the genocide; others want to see

an immediate burial, so that their loved ones can be laid to rest.[23] Zoé Samudzi, scholar of German colonialism, points out that the incarceration of ancestral remains in museums is a spiritual issue. For many Herero elders, the transition of Indigenous dead from this life to the next cannot take place without the performance of traditional funerary and burial practices.

In another settler colony, the United States, the struggle over human remains continues to be front and center for many Native communities. Much like the Herero and Nama skulls, Native American skeletons became a tool for science, collected in the thousands to corroborate theories of social and racial hierarchies. When archeologists came across a grave of a European person, the skeleton was swiftly buried; Native American bones, in contrast, were deposited as specimens on museum shelves.[24] Walter Echo-Hawk, a Pawnee attorney involved in Native American repatriation cases, put it another way: "If you desecrate a white grave, you wind up sitting in prison. But desecrate an Indian grave, and you get a Ph.D."

Although Franz Boas rejected the hierarchy of races, he nevertheless played a role in the collection of Native peoples' bodies for research. Boas was known for robbing graves after dark while completing ethnographic work on the Pacific Northwest Coast, infamously noting that "it is most

unpleasant work to steal bones from a grave, but what is the use, someone has to do it." Boas collected more than 100 skeletons and skulls belonging to the Kwakwaka'wakw and Coast Salish peoples, which he later sold to the Field Museum in Chicago. Another anthropologist, Samuel G. Morton, actively collected human remains and provided economic incentives for soldiers and settlers to enter Native American graves to collect remains and funerary objects. Many were transferred to the Smithsonian Institution in the 1890s. Others found their way into the Morton Collection—a vast repository of more than 1,300 crania currently held at the University of Pennsylvania's Museum of Archaeology and Anthropology. Today, as journalist Douglas J. Preston put it, anthropology and natural history museums are still "closets of Indian skeletons."

Enter NAGPRA

In 1990, after decades of struggle by Native American communities to protect against grave desecration and repatriate the bodies of their ancestors, the U.S. Congress finally passed codified repatriation into law as The Native American Graves Protection and Repatriation Act (NAGPRA). The Act requires federal agencies and museums (excluding the Smithsonian Institution) "to return human remains and associated funerary objects upon request of a lineal descendant,

Indian tribe, or Native Hawaiian organization."[25] NAGPRA is considered by some to be the most important piece of cultural policy legislation in U.S. history. As of 2019, the law has facilitated the return of some 50,000 human remains, 1.4 million funerary objects, and 14,000 sacred objects of cultural patrimony to Native Americans, Native Hawaiians, and their lineal descendants. Some, like Aboriginal curator Franchesca Cubillo, look to NAGPRA as a model for other settler societies such as Australia, whose lack of repatriation policy, she argues, is embarrassing in comparison.

While NAGPRA has indeed put repatriation squarely on the museum agenda, it has not been without its shortcomings. For one, it distinguishes between secular and religious objects, favoring the latter, even though this distinction does not exist in some Native cultures. The emphasis on "sacred" material is not a coincidence. As historian Steven Conn points out, the legislation was born during the Reagan era's virulent right-wing fundamentalism, where it became tactical to emphasize the religious aspects of political demands. Similarly, as a framework through which collective healing could supposedly take place, NAGPRA fit perfectly into the culture of therapy and self-help that dominated mainstream America in the 1980s.[26]

But how much healing can NAGPRA accomplish when Native Americans continue to face mounting levels of

poverty, substandard education, and a lack of control over natural resources? Colwell would argue that this isn't the right question to ask. NAGPRA itself does not explicitly mandate healing. Healing is a potential side effect, not a legal dictate. In a survey of tribal repatriation workers, Colwell found that most respondents considered repatriation to be a form of justice that could begin to remedy histories of violence and dispossession; some saw it as a tool for intra-tribal healing, whereby ancestors could be properly laid to rest; others viewed it as a first step in rebuilding trust between tribes and museums. A handful of statements suggested that healing could only begin when every object and set of human remains had been returned or reburied. To that end, Native Americans have criticized NAGPRA for being burdensome and slow.

Part of that slowness is linked to NAGPRA's requirement that human remains and sacred objects can only be returned if a genealogical relationship can be established between a tribe and the cultural patrimony they seek. Some have argued that this prerequisite reinforces 19th century notions of biological essentialism. In his article *Decolonizing NAGPRA*, Pawnee scholar James Riding In laments the fact that so many ancestral remains sit in museum storage rooms because institutions have not assigned them a "culturally affiliated status." The logic of NAGPRA, he argues, is tied

to a scientific way of thinking that encroaches on Native concepts of kinship and ancestry. In a direct plea to his community, he asks Native people to bypass these limitations by forming cross-tribal coalitions in order to file "shared group identity" claims to ancestral remains that are labeled as "culturally unaffiliated." For him, the most basic aspect of decolonization requires Native communities to accept "individual and group responsibility" for the fate of their ancestors. This not only involves working cooperatively on repatriation cases to ensure the reburial of ancestral remains. It also requires that Native peoples are well-versed in traditional knowledge regarding the proper treatment of the dead, understand the history of scientific grave looting, and reject contemporary scientific studies based on the violation of burial rights.

Yet the burden to make NAGPRA accessible and culturally relevant should not fall on the shoulders of Native people. Museums must actively engage the public in their own NAGPRA procedures. In March 2021, the Mississippi Department of Archives and History (MDAH) released 403 sets of Native American remains and 83 funerary items to the Chickasaw Nation—the largest return of stolen Native American antiquities in the state's history. As part of the process, MDAH launched a website that features an interactive map of active and pending repatriation cases alongside other

resources, including internship opportunities, tribal histories, and collections updates. Meg Cook, the MDAH's director of archaeology, emphasized the significance of the organization's transparent approach: "The most important part is remembering that these remains are people, and their families want to see that they are reburied."

Beyond NAGPRA: Sovereignty and Stewardship

Repatriation becomes even more dicey when human remains and sacred objects are located outside of the U.S., beyond the scope of NAGPRA. These cases fall under the umbrella of the 1970 UNESCO Convention. But remember: the Convention concerns *states* only; Indigenous people can only make claims if the state is willing to do so on their behalf.

The issue of state sovereignty in repatriation cases gets thorny in the case of the Zuni War Gods, known as Ahayu'da. Each year, members of the Bear and Deer clans of the Zuni (located in present-day New Mexico), carve two War Gods to serve as guides and guardians. These Gods, according to the Zuni, are not inanimate artifacts, but rather powerful living entities that play a crucial role in the spiritual well-being of the tribe. After one year, clan members retire the Gods to hidden shrines, where their natural decomposition is meant to replenish the earth and keep order in the natural world. For decades, however, outsiders have stolen Ahayu'da from their shrines.

In response, the Zunis have launched a powerful recovery effort to retrieve the War Gods from private art dealers and museums. Since the passage of NAGPRA, more than 100 Ahayu'da have been reclaimed from institutions and collections in the U.S.—a campaign described by the *New York Times* in 1990 as a "rare story of American Indians getting back what was taken from them."

Yet the Zuni have not been as successful in Europe, where the same laws of restitution don't apply.[27] Through his travels across Europe, Colwell found that museum officials have often justified holding on to statues of Zuni war gods by arguing that they constitute universal property. "We give all the objects to the world," said an official at the Musée du Quai Branly, insisting that the war god no longer serves Zunis, but museum visitors. (The museum still holds 101 Zuni items, including one Ahayu'da). This view is, of course, patently false. The War Gods remain essential for the Zuni's spiritual well-being and cultural survival.

Since the Zunis don't have a state actor supporting their claim, however, the 1970 UNESCO Convention can do little for them. Unfortunately, their situation is not unique among tribes, whose claims often fail to fit within the Convention's narrow requirements for repatriation. Another requirement, for instance, stipulates that objects must be preserved after

their return—a pointedly Western notion that sometimes directly contradicts Native practices of stewardship.

Take the case of the Ghost Dance Shirt. In 1998, after seven years of negotiation, Glasgow's Kelvingrove Museum finally agreed to return the shirt to Lakota Sioux. The shirt had been worn by a Sioux warrior killed in the 1890 Wounded Knee Massacre, and was believed to have offered protection from the bullets of white men. During the negotiation process, the Wounded Knee Survivors Association, a group comprised of descendants of the victims of the massacre, recognized that some members of their tribe wanted the shirt back in order to properly dispose of it, either by burial or incineration, according to tribal law and tradition. In order to successfully repatriate the item, however, the delegation needed to assure the museum that the Shirt would be preserved in a museum and used to educate the public, as per the Kelvingrove Museum's mission. Additionally, the agreement stipulated that the Lakota acknowledge the role of Glasgow in all displays of the shirt and drop their appeal for four other stolen items associated with the massacre.

The case of the Ghost Dance Shirt exposes a fundamental tension between museums and those seeking repatriation. Indeed, requests for repatriation seem to go against the implicit charter of most museums—to be repositories of knowledge for future generations. Under this logic,

collections are inalienable and objects are intended to be conserved forever. This is the argument used by Hannah Boulton, a spokeswoman for the British Museum, to explain the museum's reluctance to return the Zuni's Ahayu'da: The museum exists "to tell the story of human cultural achievement from two million years ago to the present day," she said, and its trustees want the collection "to remain as a whole." This view doesn't take into account the rights of the descendants of those whose human remains or sacred objects are held captive on the shelves of museum storage rooms. Some groups, like those tribal members involved in the Ghost Dance Shirt negotiations, believe that custodianship can even involve the right to destroy an object.

There are three schools of thought in the debate around stewardship, according to James Riding In. Those who follow "Native concepts of justice" demand the immediate return and reburial of all human remains and funerary objects in museums and federal agencies. In contrast, those in the "scientific establishment" value such material as tools that can be used to study concepts such as evolution, genetics, and migration patterns. According to this group, the production of scientific knowledge should override Indigenous desires for repatriation. A third school of thought lies somewhere in the middle, advocating for a compromise in which unidentified human remains should be scientifically studied before they are reburied.

Rather than a dead-end debate that falsely pits Indigenous people against the production of scientific knowledge, the question of stewardship should open up a much-needed conversation about the ways in which Western science has always been inextricably linked with colonialism. Human material and sacred objects were not freely given to scientific institutions or museums. Whole bodies were plundered from colonized communities and used as research objects to advance the scientific expertise of the colonizer.

Speaking to the scientific establishment's bizarre romance with human remains, Yorta Yorta elder Henry Atkinson asks: "What benefit has this research had for Indigenous people? Our babies still die younger, our youth have less opportunity and our elders live approximately twenty years less than the non-Indigenous population." He recounts visiting a museum as a child and witnessing the tears on his mother's face when confronted with her own ancestors on display. His mother's deep sorrow continues to resonate with him every day, and drives his work in repatriating Aboriginal ancestral remains from around the world so that the spirits of his people can rest at last.

Conclusion: Towards Healing?

Recently, the conversation about repatriation in the United States has expanded to consider the human remains of

enslaved Africans. The Smithsonian, for example, holds the bones of roughly 1,700 African Americans in its storerooms, while Harvard University holds the human remains of fifteen individuals of African descent. In the past two years, groups of students discovered that fifty-three skulls in the Penn Museum's Morton Collection came from enslaved Africans in Cuba, and 14 others came from Black Philadelphians.

In April 2021, the museum announced a repatriation plan to return the crania "to their ancestral communities, whenever possible." While there is no clear legislative approach when it comes to returning the bones of the enslaved, the absence of NAGPRA may offer a liberatory vision for repatriation. A more expansive definition of "ancestor" and "descendent," for example, may serve to quicken processes of reclamation and reburial.

While the Penn Museum may be taking strides to confront the ghosts of the Morton Collection, it has yet to acknowledge its holdings of human remains from the 1985 MOVE bombing—a more recent manifestation of racialized state violence, in which the Philadelphia Police Department bombed a residential home, killing eleven people and destroying an entire city block. The family of the bombing victim whose remains are still housed at the museum has demanded that Penn make a public apology and commit to "some kind of restitution."[28]

Of course, restitution alone cannot heal the deep wounds inflicted by colonialism, slavery, and state violence. As Southern Cheyenne peace chief Joe Big Medicine said, "NAGPRA doesn't heal. But the process does." Repatriation is just one aspect of what must be an expansive effort to revitalize the lifeways and survival of Black and Indigenous people across the globe. For these communities, the wounds of history will never fully disappear.

Yet repatriation struggles do not always involve tears of grief, like those of Atkinson's mother as she confronted what was stolen from her people. Nor must they result in anger, like that demonstrated by Mwazulu Diyabanza as he defiantly removed an object of African cultural heritage from the Musée du Quai Branly. Both of these emotions are valid responses to decades of colonial pillages of art, artifacts, and skeletal remains from colonized people. But sometimes there is joy as well, such as when people are reunited with their material heritage.

Anthropologist Laura Peers describes the moment when a delegation from the Haida people, an Indigenous group from the Pacific Northwest Coast, were reunited with collections of their objects held at the British Museum and the Pitt Rivers Museum. These museums were "not ready" to consider repatriating these objects, but the Haida were nevertheless invited to reconnect with their heritage

in the UK and generate new knowledge about the collections. When members of the group touched objects, they reconnected with their ancestors. As people picked up masks and headdresses, they burst into tears. Sometimes, the objects restimulated parts of the brain that triggered Haida terminology and language that hadn't been used for over 60 years. The museum became a place for song and dance. There was grief and anger, but also immense joy over the revitalized relationships between the community and their ancestors.

Restitution struggles continue. Some result in the return of heritage, others in dead ends. But crucially, these struggles call into question the concept of stewardship. Today, museums are beginning to recognize that it is inconceivable to display Indigenous culture without the participation and expertise of Indigenous communities. And, as the Black Lives Matter movement continues to expand an urgent, nation-wide conversation surrounding racial justice, institutions like the Penn Museum are forced to address the historical exploitation of people of color in their collecting practices. The concept of the "universal museum" seems old-fashioned, as a new generation continues to push major museums to see themselves less as central repositories of knowledge and more as sites of transit and cross-cultural dialogue. Healing is far from complete, but in the words of Savoy, "we must allow ourselves to dream."

Chapter 2

SUBVERTING THE GAZE

"*Has the American dream been achieved by the American Negro?*"
This was the question posed to James Baldwin in his debate
with conservative commentator William F. Buckley at
Cambridge University in 1965. As the moderator introduced
the "star of the evening," Baldwin took to the podium, a glint
of frustration in his eye at having to engage with what he
immediately identified as a "question hideously loaded." He
began by making a rather simple point: that the answer to this
question comes down to one's "system of reality"—that is, it
depends on the "assumptions which we hold so deeply so as
to be scarcely aware of them."

The prevailing system, Baldwin argued, was white
supremacy—an ideology fine-tuned through processes of
European colonialism before migrating to the U.S. where it
justified genocide, slavery, and imperial intervention. Today,
it remains a system that determines whose life is meaningful
or grievable, who will be able to succeed, and who is consid-
ered to be "civilized" rather than "savage"—in short, who
can achieve the American dream.

How, one must wonder, does this logic make its way into
our collective consciousness? How does racial and colonial
violence get enfolded into an aesthetic that renders conquest

natural, even righteous? More broadly: Where do we gain an understanding of our values, goals, and what seems "normal" or "right"? For the young Baldwin, it was history textbooks, which taught him that "Africa had no history, and neither did [he]." There were also "cowboy and Indian" movies—popular forms of entertainment that trained his subconscious to identify with the all-powerful cowboy. "It comes as a great shock to see Gary Cooper killing off the Indians," Baldwin said, "and although you are rooting for Gary Cooper, [realizing] that the Indians are you."

Baldwin's experience underscores the power of the classic Western genre, whose storylines sanitize American history, normalize colonial hierarchies, and screen out the memories and feelings of the weak.

The white supremacist "system of reality" seeps into each of our consciousness in different—and multiple —ways. Some of my own earliest immersions took place in museums. I still remember my first visit to the American Museum of Natural History (AMNH) in New York City as a child, when I saw reproductions of Indigenous people frozen in dioramas next to extinct plants and animals. One scene depicted a peaceful negotiation between Dutch settlers and the Lenape, the original inhabitants of what is now New York.

It was only later in life that I began to reflect on the dangerous narratives embedded in those scenes. Although

the captions have been updated in recent years, the scenes stand as a monument to the myth that Native Americans are vanishing or extinct, and the lie that colonization resembled an equal exchange between parties, rather than a violently enforced cultural hierarchy. They promote an alternative, but related, version of the mythological American Dream— one that crafts a narrative of national greatness by omitting the genocide, land theft, and African slavery upon which it is built.

The AMNH is by no means the only museum to promote such narratives. Under the guise of leisure, science, or education, museums play a crucial role in weaving attitudes and opinions into the fabric of society. Through cultural work, these institutions make certain ideas seem common-sensical, while burying or mystifying others. As the artist Hans Haacke argues, they function in the "vineyards of consciousness."

The work of structuring everyday perception and making profound or controversial ideas seem familiar through simplification and repetition is done all around us, all the time—through movies, monuments, malls, theme parks, bill-boards, advertisements, and beyond. Certain images, words, and concepts surround us so fully that they become the ideological oxygen we breathe. In the nineteenth and twentieth centuries, at a time when the modern museum was birthed

from the blueprints of fairgrounds and cabinets of curiosities, that dominant ideology was colonialism.

In the nineteenth century, major cities in Western Europe and North America were littered with celebrations of empire—from public plaques and monuments memorializing great colonial conquests to churches from which imperial power spread through civilizing missions. Particularly significant among these imperial markers were museums. The history of the modern museum is a story of how imperialism was presented to Western audiences as a project at once humane, aesthetically pleasing, and scientifically important. If we are to decolonize museums as they exist today, we must first understand these colonial roots. We must untangle the "vineyards of consciousness" by which cultural institutions such as museums have historically ordered culture, nature, and society, thereby structuring the way we think about such matters today.

Modern Museums: Between Science and Spectacle

The museum as we know it is a somewhat recent phenomenon, but it didn't arrive out of the blue. In the nineteenth century, modern museums grew out of other forms of display and exhibition, which themselves had deep roots in colonialism. Museums attempted to define themselves in contrast to those forms of display, but they shared the same colonial DNA nonetheless.

Early predecessors to the modern museum were "cabinets of curiosity" or "wonder rooms." These private collections of wealthy individuals, families, or institutions were mostly composed of rare or curious natural objects designed to provoke surprise and intrigue. They did this by reflecting the knowledgeability and worldliness of the elites who created and flaunted them. These extraordinary objects—including plants, exotic birds, and butterflies, as well as preserved organs and skeletons—were often arranged to categorize and tell stories about the wonders of colonial exploration. Take the collection of Hans Sloane, an eighteenth-century natural history collector who funded his encyclopedic collection of Caribbean plants, animals, and artifacts with profits from enslaved labor on Jamaican sugar plantations. Over the course of his life, he continued to add to his collection by purchasing exotica from travelers and settlers across the expanding British Empire.

The first modern museums intended to set themselves apart from the incongruity of cabinets of curiosity by claiming order and rationality. Nevertheless, Sloane's artifacts—alongside other colonial-era collections from the likes of Captain James Cook and Sir William Hamilton—provided the foundation for what would become the British Museum. Once absorbed into the museum, these assortments of books, prints, and zoological specimens were reclassified and catalogued

according to the Linnean taxonomy system to illuminate a scientific view of the world. The museum became a public learning center accessible to a range of European natural historians.

Museums in the U.S. were likewise founded for educational purposes, beginning with the establishment of the Massachusetts Historical Society in 1791. By 1877, there were seventy-eight historical societies across the country. A majority of them included museums with collections of art, history, and documents that chronicled the founding of the new nation. Unlike in Europe, where cabinets of curiosities functioned as private trophies of imperial conquest for a small handful of elite scholars, U.S. historical societies actively promoted *public* learning.

Displays of animals, plants, and minerals in neat rows of glass cases served as "object lessons" intended to help visitors to make emotional connections with the natural world.[1] At a time when Indigenous people were being forcefully relocated to make way for American territorial expansion, these educational enterprises actively propped up the myth of *terra nullius*—the idea that the country was founded on empty wilderness that needed to be tamed, mastered, and systematized behind glass.

In 1846, the Smithsonian Institute opened in Washington, D.C., proclaiming its mission to be the promotion of public

education. George Brown Goode, who oversaw the institution from 1887 to 1896, envisioned it as a "nursery of living thoughts" that would stand "side by side with the library and the laboratory." During the 1870s, in the years following the Civil War, museums across the country multiplied. Some, like the Metropolitan Museum of Art, the Frick Collection, the Museum of Fine Arts in Boston, and the Philadelphia Museum of Art, fell in line with the American museological tradition of public education. These institutions were largely established through donations from wealthy benefactors.

While turning over the contents of their private collections for public viewership, these individuals filled board vacancies with their millionaire friends—a game of power and wealth that continues to haunt prominent cultural institutions. In 1888, for example, J. P. Morgan was elected to the Met Museum's board and promptly stocked its other vacancies with like-minded elitists including Henry Clay Frick and Henry Walter. When he was elected president of the museum in 1904, he developed a new model for the Met—one entirely based on the collecting habits of his millionaire associates.

Other institutions that existed at this time, known as "dime museums," presented debaucherous entertainment that was a far cry from the lofty educational goals of the Smithsonian. The American showman Phineas T. Barnum

had a collection of over six hundred thousand objects—mostly bizarre rarities meant to invoke wonder and shock. For decades, he housed his carnival of curiosities in the five-story American Museum in New York City, and later took them on tour as part of the Barnum Circus, billed as "The Greatest Show on Earth."

The line between these citadels of science and the kinds of depraved freak shows promoted by Barnum was always somewhat blurry. Barnum himself purchased his collections from several museums across the world. Natural history museums throughout Europe and North America, meanwhile, owed many of their specimens to the same network of animal collecting agencies Barnum used to source live species for his various circuses, menageries, and dime museums. These museums also served as storage units for the overflow of colonial exotica that filled cabinets of curiosity, including boxes of flora and fauna, arts and crafts, and pieces of human bodies plundered around the world.

Fairgrounds—disorderly sites for public assembly where visitors could marvel at fortune tellers, burlesque dancers, and freak shows—were also predecessors to modern museums. As a popular form of leisure, fair-going was eventually incorporated into late-nineteenth-century expos—generally referred to as world's fairs in the U.S., international expositions in continental Europe and Asia, and exhibitions in Great Britain.

These sites combined popular forms of fairground entertainment with educational displays—of manufacturing and industrialization as well as people and products from the colonized world. So-called "exhibition mania" was ignited by England's Crystal Palace Exhibition, which took place in London in 1851 and attracted tens of millions of people to marvel at the architectural, industrial, agricultural and anthropological wonders of the world. Soon after, world's fairs spread throughout Europe, North America and the British Empire. On the heels of London's imperial show came the 1889 exposition in Paris, where the Eiffel Tower was the main attraction, followed by the World's Columbian Exposition in Chicago in 1893 which marked the 400th anniversary of Columbus' landfall in the so-called New World.

It was during this time that museums began proliferating across the globe. About 100 opened in Britain in the fifteen years between 1872 and 1887. About 50 were established in Germany between 1877 and 1880. The Musée d'Ethnographie du Trocadéro—the predecessor to the grand anthropological Musée de l'Homme in Paris—was established in 1878.

In 1846, the Smithsonian Institute opened in Washington, D.C., proclaiming its mission to be the representation of "all objects of natural history, plants and geological and

mineralogical specimens, and objects of art and of foreign and curious research belonging to the United State."

While these museums attempted to contrast their commitment to science and rationality with fairground revelry, they were still haunted by these earlier forms of display.

Museums often acquired objects directly from world's fairs and expositions. The Musée d'Ethnographie du Trocadéro was created on the occasion of the 1878 Paris World's Fair to house thousands of artifacts taken from French colonial expeditions across Africa, South America, and Oceania. The Royal Museum for Central Africa in Tervuren, Belgium was originally built to showcase King Leopold II's Congo Free State in the 1897 Brussels International Exposition. Today, the museum still contains remnants from the Tervuren fair, including ivory statues and ethnographic artworks that were looted during Belgian's brutal occupation of the Congo. In London, many of the objects in the Crystal Palace Exhibition were used as the first collection for London's South Kensington Museum, which opened in 1857 and later became the Victoria and Albert Museum. Bringing together material culture from each of Britain's colonies, the collection represented what art historian Tim Barringer called a "three-dimensional imperial archive."

In the U.S., between 1876 and World War I, the Smithsonian Institution participated in dozens of national, industrial, and international exhibitions. In exchange for staff time and exhibition material, managers of world's fairs donated surplus displays back to the Smithsonian, which helped officials make the argument to Congress that more museum space had to be provided. As a result of its involvement in international expositions, the Smithsonian built two new museums.

Modern curatorial methods were also born out of world's fairs. George Brown Goode, who was in charge of the U.S. Smithsonian Institution from 1887 to 1896, considered world's fairs to be "laboratories for developing new techniques in installation and labeling." For instance, at Philadelphia's 1876 Centennial Exhibition, he debuted prefabricated exhibition cases as well as printed labeling techniques for objects—both foundational to curatorial techniques used today. Goode became known as the "titan of taxonomy," and a few years later, the directors of the 1893 Chicago World's Columbian Exposition invited him to prepare a classification system for the millions of objects displayed at their fair. With labels, visitors could be their own guide through an exhibit, rather than relying on the presence of a curator as interpreter.

The classificatory systems and protocols that Goode helped to develop were born out of the need to manage the massive influx of cultural heritage that was plundered in the colonies and siphoned into European and American collections. Conquest brought booty, and booty brought museums. The National Museum of Victoria, for example, was established in Melbourne in 1854 to display a collection of over 16 million objects, including Indigenous Australian artifacts and works of art. The British Museum showcased plundered sculptures from India as well as the bronzes of Benin, while France's Louvre created galleries in the early 1800s specifically to house the many objects nabbed by Napoleon and his entourage in Egypt. Even the term "loot," derived from the Hindi "lut," meaning "stolen property," was appropriated into the English language as a result of British control of India.

In an effort to distinguish itself from cabinets of curiosities and other nineteenth-century collections of novelties, the museum adamantly represented itself to the public as a "classifying house," emphasizing its scientific and instructional qualities. But behind professional protocols of storage, exhibition, and handling, there was a story of theft. As we saw in the previous chapter, the politics of those cultural spoils continues to fuel controversies surrounding their return to Indigenous and formerly colonized people. In this chapter, we'll trace the genealogy of museums in order to reveal how

modes of exhibition formulated and entered colonial ideas of power and place, time and nature, art and fact, into the collective consciousness of the West.

Entertainment, Education, Self-Regulation

Goode imagined museums as spaces for adult education and social reform, comparing them to universities or libraries. He devoted his passion to what cultural sociologist Tony Bennet termed the "exhibitionary complex," a network of world's fairs and museums that provided the cultural and educational underpinnings for the modern nation-state. In Great Britain, the creators of the Crystal Palace realized the potency of fair exhibitions as mass-educators, with one journalist describing them as "more a school than a show."[2] The official guide to the 1874 International Exhibition in South Kensington promised to instruct the public in "arts, science and manufacture, by collections of selected specimens." In the U.S., too, Franz Boas—the so-called father of American anthropology who helped organize Chicago's Columbian Exposition—argued that the fairground exhibition should be a site for intellectual and moral edification.

Despite these scholarly intentions, the masses typically viewed visits to these exhibitions as a kind of holiday, rather than an opportunity for intellectual betterment. At the Imperial International Exhibition held in London in 1909, for

example, a reporter from *The Times* noted with horror that the public preferred rides and spectacles such as "Bi-planes, and Water-whirls, and Witching-waves, and Wiggle-woggles, and Flip-flaps to all the instruction in the world." In France, the tension between education and entertainment was less present. The Expositions Universelles in Paris had a reputation as a raucous festival.

Whether they were managed to educate or entertain, both museums and world's fairs regulated the public. Unlike the tavern, these spaces of public gathering didn't allow swearing, spitting, brawling, eating, or drinking. Relations of space and viewing were designed to have a moral influence, compelling the audience to self-regulate.[3] Like the wide-open promenades of public parks, the architectural design of museums and world's fairs were set up in a way that rendered the crowd visible, both to staff as well as to other visitors. These spaces aimed to craft the modern citizen by inculcating certain attitudes, opinions, and behavioral norms. As spaces of "showing and telling," or viewing and being viewed, they worked to smooth over class differences, while crafting model citizens through modes of crowd control, education, and progressive reform. In this way, they were more than just a reflection of society; they *altered* society.

World's fairs and museums were central to the efforts of American elites to establish their cultural hegemony

amidst an increasingly fragmented society. Chicago's World's Columbian Exposition, for example, served as cultural cement for an era rocked by frantic industrial growth, mass immigration, and class violence as evidenced by the city's 1886 Haymarket Square bombing. At the Exposition, celebrations of technological advancements alongside evolutionary ideas of race muted class divisions within white society while providing a sense of shared national pride and reformist purpose.

These educational and reformist efforts came together to serve one dominant, overarching goal: empire.

Museums explicitly engaged in propaganda for the colonial project, blending politics with aesthetics, and education with entertainment. Architects were tasked with constructing grandiose museum buildings to elevate the status of colonialism alongside other cultural buildings such as concert halls and national libraries. Museums across Brussels, London, Amsterdam and Paris were filled with ornamentation and decor displaying colonial motifs alongside allegorical figures representing the supposed merits of colonialism. France's Musée des Colonies, built in 1931 to accompany L'Exposition Coloniale Internationale, boasted a bas-relief that depicted colonialism as a gift exchange: In exchange for laborers and natural resources, France gave its colonies science, education, and good government.

The imperial propaganda was just as explicit in world's fairs. If, as defenders of the British Empire suggested at the time, England conquered the world in "a fit of absence of mind," then the Crystal Palace Exhibition played an active role in legitimizing these actions after the fact. If, as it is now generally understood, the expansion of British Empire took place with intention and forethought, then the exhibition, and others like it, popularized that political effort in advance. Wherever one stood on this chicken-or-egg question, one thing is clear: Exhibitions and colonialism went hand in hand.

In fact, millions flocked to the fairground to rejoice in the glory of conquest. This celebration took place first and foremost through the spectacle of spaces where the entire world was offered up to be displayed, collected, and consumed. In some of these spaces, the colonized world was evoked not merely in objects but in the kind of vast simulacra you might expect to find in Las Vegas or Disney World. At the French Exposition Universelle of 1900, for example, replicas of the colonies were brought to Paris. Visitors could roam the Rue du Caire—a reconstruction of an urban Cairo environment complete with winding alleyways, Arab style homes, a cafe serving Turkish coffee, belly dancers performing in the evening, and over fifty donkey-drivers imported from Cairo to give people rides. At the Tunisian pavilion, visitors could stroll through a miniature recreation of a

North African colony, including a replica of the Sidi Mahree Mosque in Tunis.

Such hyperrealism became a standard form of objectification in museum displays as well, creating an illusion that the colonized world was present and could be instantly experienced and enjoyed by Westerners. Visitors could taste new foods and beverages from every corner of the globe, purchase arts and crafts, and hear music that they'd never heard before. British author Rudyard Kipling described getting lost as a child in Melbourne's Intercolonial Exhibition in 1867, wandering among "kiosques and pavilions … this great wheel of [color] and smells and sights."

A South Australian visiting the 1884 International Health Exhibition at South Kensington, meanwhile, found the Chinese village "most interesting … [including] tea houses with *excellent* tea and excerable [*sic*] music by the National Bands," and disparagingly concluded that "the Chinese songs are the oddest most uncouth things you can imagine."[4] Like most colonial exhibitions, this one contained raw materials and human beings shipped directly from the colonies. These pavilions displayed the products of capitalism on a global scale, serving to promote unrestricted international trade alongside a mindset that transformed the world into an exhibition.

Even when Europeans were literally present *within* the colonies, they filtered their surroundings into endless

exhibition. Some of the oldest museums in Africa were opened by colonial officials who were eager to apply their impulse to survey, inventory, and categorize the world. There's I.F.A.N., the Institut Fondamental d'Afrique Noire, established by French ethnographers as the French Institute of Black Africa in 1938; Achimota College's Ethnographic Museum in Ghana, founded by British archeologist Charles Thurstan Shaw in 1929; the Nigerian Museum in Lagos, set up in 1957 by Kenneth Murray, the director of the British administration's Department of Antiquities; and the National Museum of Kenya, started in 1910 by a group of British natural-history buffs who set out to document the flora and fauna of East Africa. The list goes on.

These institutions were not just innocent warehouses staffed by curious European scholars. They were, in fact, active billboards for the colonial project. Take the Rhodesia Museum, established in the British colony of Southern Rhodesia (in what is present-day Zimbabwe) in 1902 by British mining magnate and infamous apartheidist Cecil Rhodes. The institution was born out of the need to house the Chamber of Mines' growing collection of mineral and geological specimens that were being extracted from across the colony. It was here where white colonizers could salivate over the spoils of their own conquest. Displays of colonial mining ventures were a form of

educational propaganda that furthered the desire for continued resource extraction.

This kind of project was clearly not made to benefit the local African population. In fact, Indigenous African people were only allowed to enter the museum on designated days, and were never consulted about displaying their natural and cultural heritage. Of course, this all changed when the country officially gained independence in 1980, and the museum was renamed the Natural History Museum of Zimbabwe. In the next chapter, I'll discuss some of the challenges that post-colonial museums like this one continue to face in their attempt to undo modes of colonial museology. In Zimbabwe, for example, the museum's geology exhibit—which houses over 15,000 rock, gem, and crystal samples—is a glinting reminder of the museum's extractive origins.

The Rhodesia Museum's collection of glittering gems housed in glass couldn't have been possible without the philosophical development that preceded it: In the nineteenth century, Europeans had come to view themselves as separate from the physical world, thus enabling them to observe and control it. This separation extended to a whole host of phenomena, including the city, the body, and the landscape, so that everything appeared to be an exhibit. This gap between representation and reality took place most often through the

visual realm, with the visitor occupying the position of the "observing eye" set apart from the world.[5]

The same mental detachment persists in museums today, with "no touching" signs warning visitors to engage with objects with their eyes only. Exhibits are set up as walking tours, or journeys, in which the visitor is in motion, and the objects, by implication, are all lifeless. For this reason, Barbara Kirshenblatt-Gimblet has described museums as "tombs with views." By maintaining a distinction between representation and reality, subject and object, exhibits at world's fair trained visitors to approach the world as an exhibit, something to be possessed and consumed.

The style of recreating "authentic" non-European life has since become familiar in ethnographic curating. I, for one, will always associate it with those frozen faces I saw as a child in the glass boxes of the AMNH's Halls of Asian and African People—now seen by the nearly 400,000 children who pass through the museum in school and summer camp fieldtrips. But this mode of presentation is widespread. Known as contextualism, it was influenced by the work of Boas, who began his career at AMNH. By displaying humans, animals, and objects alike in detailed, simulated environments, curators sought to capture particular cultures and time periods. This act of "viewing culture"— from world's fairs to the museums of today—results in what

Johannes Fabian called a "petrified relation," whereby various non-European societies are perceived to be living in a different historical epoch. Today, these types of exhibitions continue to deny the possibility of shared humanity and connection between visitors and the people whose cultures are on display.

Humans on Display

Europeans who "went East" in the nineteenth century were obsessed with creating representations of what they observed. These depictions generally contained no sign of European presence. Instead, vacant landscapes evoked biblical pastoralism, while scenes of harems or disorderly battles reinforced fantasies of non-Europeans as exotic or uncivil. These representations—filtered through classical knowledge, religious sources, mythology, or previous fictitious illustrations rendered by Western travelers—formed a library of fantasies that Edward Said famously called "Orientalism." As a style that exaggerated and distorted distinctions between East and West, Orientalism rationalized European colonialism.

Colonial exhibits at world's fairs ran with these cyclical narcissistic fantasies, staging the non-European world as backward, uncivilized, and in need of Western intervention or "rescue." Displays of people from the colonized world in their native environments reinforced these views.

At Amsterdam's 1883 "Internationale Koloniale en Uitvoerhandel Tentoonstellin," natives from the Dutch East Indies and West Indies were put on display, eliciting disgust, wonder, fear, sexual fascination, and curiosity among European visitors. The Greater Britain Exhibition of 1899 included an attraction that featured African animals and 174 representatives of several recently colonized South African peoples. At Berlin's Great Industrial Exposition in 1896— which was ultimately transformed into the Germany Colonial Museum in 1899—more than 100 natives from German colonies were present, each group arranged in a simulated natural setting. As prescribed by the logic of Orientalism, the people who made up the living exhibits had to stay within their prescribed boundaries to maintain the separation between civility and wilderness, nature and culture.[6] The natives were forced to call "hurrah" at set times in praise of the emperor and the *Reich*.

Notably, German, Dutch, and Irish villages were also set up at world's fairs, but were staged by Europeans themselves to celebrate their "authentic" national identity and culture. The white man was seen as the "standard" human, capable of self-representation, while colonized people were presented as exotic animals. One Dutch brochure described Ashanti people on display as more similar "to Apes than to people"—a racialized metaphor that was fueled by scientific theory at the

time. In Germany, with the rise of bloody African resistance to imperialism, the press increasingly framed Black Africans as savage monsters. These racial categories still haunt contemporary ethnographic museums. At the AMNH in New York, non-European societies fall under the rubric of "Natural History" and are displayed in bleak dioramas alongside apes and dinosaurs.[7] (European societies are pointedly absent.)

Zoological representations of Native peoples predate both museums and world's fairs. In the 1800s, Carl Hagenbeck, an exotic animal entrepreneur, was known for bringing back Nubians and African animals to be put on display in special German showcases known as *Volkerschau*, or human zoos. In 1850, the American artist George Catlin proposed a floating "Museum of Mankind," in which a ship would stop at international ports to gather human and nonhuman material for a traveling exhibit. The urge to collect and display humanity also manifested in early ethnographic films, described by media scholar Alison Griffiths as a "flickering museum of mankind" that brought together the educational value of the natural history exhibition with the spectacle of the popular dime museum.

The exhibition of "exotic" people for public entertainment goes back even further. During the classical period, the mentally ill were exhibited as objects of bizarre curiosity.[8] Ancient Romans were also fond of parading captive people

and exotic animals, and Caesar brought Egyptian artifacts back to Cleopatra as evidence of his conquest. In 1550, at Rouen, outside Paris, the French constructed two pseudo-Brazilian villages to celebrate Henry II's entry into the city. In what has been described as "one of the most thorough performances of an alien culture staged by the Renaissance," fifty Tabbagerres and Toupinabouz Indians were displayed there, as well as 250 Frenchmen masquerading as native "extras." Flora and fauna were imported from Brazil alongside parrots, marmots, and apes. As a grand finale, the simulated villages were ceremoniously burned to the ground in mock battles.[9] As cultural theorist Steven Mullaney imagined it: "The New World [was] both recreated in the suburbs of the Old and made over into an alternative version of itself."

Jump to nineteenth-century fairs, and we again see people on display as homages to processes of colonization and modernization, which, it was anticipated, would eventually lead to the destruction of colonized peoples. If, as author Viet Thanh Nguyen writes, "all wars are fought twice, the first time on the battlefield, the second time in memory," the opposite is true as well: battlefields of colonial conquest are rehearsed in the realm of spectacle, exhibition, and simulation before they are carried out on the ground.

The close relationship between exhibition and destruction was perhaps most obvious when it came to the genocide

of Native Americans in the United States. "Buffalo Bill's Wild West," an entertainment variety show that ran from 1883 to 1913, was particularly popular in Eastern American cities where audiences were eager to vicariously experience the drama and romanticism of the closing Western frontier. The show featured historical reenactments, including The Battle of Little Bighorn and other battles from the Plains Wars. It generally concluded with a grand finale, in which Buffalo Bill and his cowboys swiftly defeated a pack of "savage Indians." Blurring the line between reality and simulation, the spectacle featured many actual Native Americans and hundreds of live animals. Yet much like the frontier characters that roam the Westworld theme park in the popular American sci-fi television show by the same name, Buffalo Bill's "Indians" were never real to begin with. The cultural realm had transformed them into a consumable, pacified typology—encompassing romantic savages, valiant but vanquished foes, and above all, infiltrators on their own land. Even as Native people were being annihilated from the real world, they were actively absorbed into art and entertainment, photographs and paintings, world's fairs and museums.[10]

At Chicago's fair, the "Midway Plaisance" was a mile-long avenue that effectively served as an outdoor museum of "primitive" human beings. It included a fake African village, a massive street meant to resemble Cairo (inspired by

Paris' Rue du Caire), and other ethnological shows. Like the Rhodesian Museum, it also served as a de facto advertisement for future imperialist conquest. The Hawaiian exhibit, for example, was organized by white settlers who were advocating for American annexation of the island.

The occasion marked the debut of extensive hula performances in the West. A Polynesian art expression traditionally performed as part of religious ceremonies, hula was received by Euro-American audiences at world's fairs as an eroticized spectacle—a form of colonial culture that blended into the other forms of racialized entertainment on view at the Midway Plaisance.

Yet one woman's experience as a dancer reveals the cracks that were always present in the fair's attempted binary rendering of "barbaric" versus "civilized" cultures. Kini Kapahu Wilson (born Ana Kini Kapahukulaokamämalu Kuululan, known as Jennie Wilson, and later designated as "Hawaii's First Lady") was one of four women hula dancers at Chicago's Fair. Based on oral history interviews conducted towards the end of her life, we know that Kini fought against American sexualized demands for dancers to be fully nude in order to conform to an imagined fantasy of "primitive" women. Instead, she insisted that the dancers be clothed in traditional costumes. Likewise, rather than adhering to her prescribed role as a racialized and gendered object to be consumed by white audiences, Kini also

attended the fair as an audience member, equally intrigued by the sights and sounds of the Midway's "Street of Cairo" as white visitors.[11] Backstage, she befriended other performers, forming long-term relationships with the Egyptian and Samoan dancers in neighboring pavilions.

Elsewhere in the fair were other opportunities to unsettle the fair's civilizing discourse. Haiti's presence is a prime example. Curiously, the Black Republic—born out of an anti-slavery struggle for independence—erected a national pavilion not on the exoticized Midway, but in White City, an area of the fairground known for its displays of high culture and modern civilization.

Arguably, the decision to include Haiti in the Exposition at all was entirely based on political opportunism. At a time of unfettered European colonial expansion, the U.S. was scrambling to secure Pan-American economic cooperation. Haitian leaders, meanwhile, saw the fair as an opportunity to assert their newfound sovereignty as a modern nation and attract international trade through displays of the country's raw material, including coffee and sugar cane products.

In framing Haiti for Western commercial audiences, the pavilion's organizers largely diluted the country's revolutionary founding. They flaunted Christian churches, for example, while burying local practices of Vodou—an African diasporic religion that was largely misinterpreted in the U.S. as

Kini Kapahu and fellow hula dancer at the Midway Plaisance
at the World's Columbian Exhibition, Chicago, 1893.
Photo courtesy Wikimedia Commons.

a form of barbarism. Likewise, the historical exhibit omitted any mention of the radical revolutionary leader Jean-Jacques Dessalines; instead, audiences were presented with leaders associated with Enlightenment values who had compromised with the French.

For these reasons, Haiti's pavilion may not have been considered a significant site of political resistance for most Haitians. Still, it served as a key location for protest and diasporic solidarity for the African American community. Prominent abolitionist Frederick Douglass was a co-commissioner for the pavilion, and gave an impassioned speech at its inauguration, connecting Haiti's revolutionary foundations with the struggle for civil rights in the U.S.

Similarly, civil rights leader Ida B. Wells used the Haitian pavilion as a site to distribute a pamphlet she had co-produced titled "The Reason Why The Colored American is not in the World's Columbian Exposition." The collection of essays by prominent African American thinkers called out the politics of exclusion that defined the fair, spotlighted the achievements of Black people since emancipation, and educated foreign visitors on the inequalities faced by Black people in the U.S., including lynching, racial segregation, and mass incarceration. In response to her tireless crusade, the fair organizers eventually scheduled a "Negro Day," which Wells rejected as a superficial gesture. Too little, too late.

Exterior view of the pavilion for the Republic of Haiti at the World's
Columbian Exposition in Chicago, Illinois, 1893.
Source: The Louveture Project.

Inspired by the potential of the Haitian Pavilion as a
site of resistance, and outraged by the invisibility of Black
life in the Chicago Exposition more broadly, Black lead-
ers looked towards another fair—the 1900 Exposition
Universelle in Paris—as an important opportunity to
finally authentically represent their communities and cul-
ture on an international stage. With the financial back-
ing of Congress, Black sociologist W.E.B Du Bois curated
an exhibition on African American life and culture. The
exhibition brought together hundreds of crowd-sourced
photographs depicting Black life, a bibliography of African
American writing and patented inventions, a small sculp-
ture of Frederick Douglass, and, perhaps most impres-
sive, a collection of handmade data visualizations created
by an interdisciplinary team of Black sociologists across
the American South. In vibrant color and cutting-edge
Modernist style, the infographics illustrated the evolution
of Black life since the end of slavery through indicators
such as population growth, literacy, and economic life. Du
Bois described the material he gathered as forming "an
honest straightforward exhibit of a small nation of people,
picturing their life and development without apology or
gloss, and above all made by themselves."[12]

While the exhibition was a powerful intervention into
a subject—and a people—that had been largely neglected in

previous international events, Du Bois ultimately left Paris disappointed. The American press had barely mentioned the exhibit despite it having won several awards. And then there was the fact that racism at home continued unabated.

The 1899 lynching of Black farmer Sam Hose in Atlanta shook Du Bois to his core. He became disenchanted with the scientific approach he used at the Paris Exposition to convince the world of the injustice experienced by African Americans. As he wrote, "one could not be a calm, cool, and detached scientist while Negroes were lynched, murdered, and starved."

Even as he had successfully constructed a space for Black representation within a Eurocentric world's fair, Du Bois had to continuously grapple with the fact of white supremacy—that "system of reality" that desperately clung to a status quo defined by structural inequality and brutal violence.

Living Encyclopedias and Evolutionary Timelines

Human displays at world's fairs served as more than just exotic entertainment for white masses. They were also research laboratories for scholars. During the run of "Buffalo Bill's" in Paris in the summer of 1889, ethnologists and anthropologists were present to study the participating Cheyenne and Sioux. World's fairs, meanwhile, were presented as "veritable living encyclopedias," in which the world could

An infographic by Du Bois, showing the percentage
of illiterate African Americans from 1860 to 1900.
Image courtesy the Library of Congress.

be scientifically collected and displayed.[13] Colonial villages in particular were considered to be "temporary museums" where scholars could access "samples" of a number of the world's races.[14] Anthropological societies from across Europe flocked to conferences organized around the fairs, eager to experience the illusion of peering into a different continent, and, as they saw it, a different time period. Frequently, those on display were asked to undress so that members of these learned societies could take photographs, anthropometric measurements, and plaster casting of different body parts for research purposes.

In many cases, these studies continued after the death of the exhibited person. In the mid-1830s, P.T. Barnum launched his career with the exhibition of Joice Heth, an elderly enslaved African American woman who was said to be the 161-year-old nurse of the infant George Washington. Upon her death, Barnum set up a public autopsy in front of 1,500 spectators. Perhaps the most well-known case of exhibited individuals is that of Sarah Baartman, sometimes called "Saartjie" (the diminutive form), brought to Europe and paraded around "freak shows" under the racist stage name "Hottentot Venus." Upon her death, her genitalia were carefully dissected and interpreted as a sign of backwardness by well-known French naturalist and zoologist

Georges Cuvier, and later put on display in France's Musée de L'Homme.

The practice of looking at non-European human bodies at world's fairs, dissection tables, and museums served to put a scientific stamp of approval on theories of racial hierarchy that were popular at the time. Fueled by Charles Darwin's theory of evolution by natural selection, exhibits arranged humanity along a progressive timeline. European males occupied the final point of development, whereas other types of humans were relegated to earlier stages of social evolution. It is no coincidence that Baartman's dissected genitalia were displayed in the Musée de l'Homme just above the brain of Paul Broca, the most influential proponent of biological determinism who had donated his brain to the museum for the "light it might throw on the brain structure of an advanced European."[15] The purpose of these anatomical displays was to exhibit and demonstrate the sexual differences rooted in the structure of male and female skeletons, with an additional layer of difference between Europeans and "uncivilized" Others.[16]

This storyline of human cosmic ascent towards industrial, white civilization was essential to imperial propaganda that framed European hegemony as natural, and therefore desirable. Colonized people (and by extension, their human

remains) were illustrative of savagery and barbarity, in contrast to the progress brought by colonialism. Through science and imperial conquest, higher races would inevitably triumph over lower ones.

There was a Christian, reformist message at work as well, in which white populations, in principle, could ascend along a progressive path of self-improvement. The museum was considered an instrument towards such ends—a space of learning and personal growth for the working class that could counteract "the corrupt influences of the saloon and the race-track," as Boas put it. In this way, the museum served a similar function as the prison. Both were holding spaces—of objects and bodies, respectively—as much as they were highly surveilled institutions that promised personal salvation and rehabilitation.

And yet not all people were seen as capable of rehabilitation. Polygenism—the idea that Black and white people developed from separate origins and therefore continue along separate evolutionary paths—was especially popular in the American South, where many white people took comfort in the idea that the evolutionary gap would preclude Black emancipation. Native Americans, by contrast, were seen as capable of assimilation into civilized white society.[17] This was a recurring message at the St. Louis Fair, where Geronimo—a captured Apache leader—was put on display to illustrate an

example of a "civilized" Indian. As David R. Francis, the chairman of the Fair's executive committee, recounted: "the once bloody warrior Geronimo completed his own mental transformation from savage to citizen and for the first time sought to assume both the rights and the responsibilities of the high stage."

Many of these evolutionary concepts jumped from world's fairs to museums. Louis Agassiz, the founder of the Museum of Comparative Anatomy at Harvard, espoused polygenism in the 1850s, arguing that the different races had been created separately.[18] Albert Eide Parr, director of the AMNH from 1942 to 1959, believed that natural history museums should bring visitors along a timeline of linear advancement—from the simplest elements of life all the way to man's place at the end of the sequence. In this sequence, human races were ranked in order of intelligence, with Africans located somewhere between man and lower primates, and Caucasians occupying the highest position. At AMNH, white visitors were enlisted as progressive subjects who could physically move through this itinerary of evolutionary history.

This is precisely the racial hierarchy that W.E.B. Du Bois aimed to challenge in his curation of the "Exhibition of American Negroes" in Paris. His compilation of photographs for the Exposition favored depictions of young,

talented African Americans in various professions—as musicians, pharmacists, dentists, university students, and more. While respectability politics might have influenced his choice to spotlight the social and economic success of African Americans, doing so also served as an urgent rebuke to racist "scientific" concepts like polygenism.[19]

Representations of Black professional success gained an additional layer of meaning when placed beside Du Bois' sociological infographics, which detailed the economic and social inequalities that African Americans faced. Further, by presenting a wide range of skin tones, hair styles, and fashion, the photo collections presented a mosaic of Black life that debunked the myth of the so-called "Negro type."

In Europe too, evolutionary narratives were both reflected and produced in museum structures. In 1888, Augustus Henry Pitt-Rivers, the so-called "father of British archeology" and a well-known anthropologist and eugenicist, proposed an anthropological exhibit that would be set up as concentric circles. Objects from the paleolithic period would occupy a central ring, followed by those from Neolithic and Bronze ages; after that, in expanding developmental order, would come Egyptian, Greek, Assyrian, Roman antiquities; and finally, the outermost rings would exhibit objects from Anglo-Saxon, Frankish, and Merovingian periods. Pitt-Rivers considered these latter societies to be the "cradles

Photograph from the collection titled "African American
Photographs Assembled for 1900 Paris Exposition."
Image courtesy the Library of Congress.

of civilization," with non-Europeans occupying a lower rank.[20] The Pitt Rivers Museum in Oxford continues to be governed by this Eurocentric vision, with objects arranged by type along an evolutionary timeline.

The British Empire operated under the same logic espoused by Pitt-Rivers—that the inner rings of non-European humanity would never catch up with the outer ring of European civilization. Accordingly, England kept its colonies at arm's length. Through indirect rule, colonized people were governed by existing tribal structures with British oversight.

The French method of rule, in contrast, was based on the idea of *association*, in which the colonial project was framed as a collaboration between France and its colonized "partners."[21] This was reflected and enacted through the 1931 Paris Colonial Exhibition, which aimed to valorize human difference and affirm the diversity of races and cultures that made up the French Empire. The Chief Commissioner of the Exhibition, Maréchal Lyautey, aimed to use the colonial pavilions to highlight the "personality" of each colony, and frame colonial policy as gentle, humane, and respectful of difference. This project continues today in the Musée du Quai Branly in Paris. By bringing together "treasures" collected from across the French Empire, the museum promotes a message of humanism—a subtle, yet elaborate, form of colonial propaganda.

Reclaimed Stories

In discussion about human beings on display, it's important to remember that we are talking about real people who experienced real trauma. These individuals were treated as specimens and forced to live in hideous conditions with no control over their lives. Many dealt with homesickness, difficulty adjusting to Western climate and food, and deadly infections. Often, they actively resisted the roles forced onto them, by running away or refusing to play along with their own objectification.

Take legendary Sioux warrior Sitting Bull, who previously led his people during years of resistance to U.S. government policy. In 1885, he joined "Buffalo Bill's Wild West" for a season tour, and a photograph of him and Buffalo Bill became one of the most popular souvenirs of the show. He may have deigned to repeat the struggle of his people as theater, yet Sitting Bull's spirit of resistance shone through. During a public address at a lavish ceremony commemorating the completion of the North Pacific Railroad, he abandoned his scripted text and instead declared in the Sioux language that he hated all white people and that they were thieves and liars. Horrified, his interpreter translated the speech as a "flowery welcome full of faux Indian clichés," while the audience applauded enthusiastically.[22]

O. F. BARRY.

WEST SUPERIOR,
WIS.

SITTING BULL AND BUFFALO BILL.

Copyrighted 1897.

Sitting Bull and Buffalo Bill. Photograph by D. F. Barry.
Photo courtesy the Library of Congress.

We see another instance of vengeful anger in the story of Ota Benga, an African exhibited at the St. Louis Fair. After the fair, he became a permanent feature at an exhibition at the AMNH, where, during a fundraising event, he was asked to seat philanthropist Florence Guggenheim. Benga, angered at being treated like an object of curiosity, pretended not to understand the request and hurled a chair at her instead, narrowly missing her head. Benga was transferred to become part of an exhibit at the Bronx Zoo, and eventually took his own life.

There are few archival sources that document the inner lives of people like Benga and Sitting Bull. What were their fears and grievances? What did it feel like to unleash their rage? How did they conceive of themselves and the Western people they met? With this dearth of firsthand accounts, historians have looked towards paintings or photographs of colonized people to imagine how those put on display used visual media to return the imperial gaze. Alice Procter, for example, writes about Mai, the first Pacific Islander that we know of to visit Britain. Although British portraitist Joshua Reynolds gave Mai the option to don contemporary dress, Mai chose to pose in traditional Tahitian clothes. Procter argues that the portrait is not a pure depiction of European fantasy, but rather contains this moment of refusal—Mai's creative choice to construct himself as Other and reject notions of assimilation.[23] Similarly, Anne Maxwell imagines that Native Hawaiians on

display at Chicago's World Columbian Exposition used promotional photoshoots as an opportunity to assert control over their own representation. By carefully choosing their own clothing and poses, they could regain a sense of dignity.

While the lives and traumas of countless people used for display will forever remain obscured, the stories of some of the best documented figures continue to resonate in the present day. In recent years, the figure of the Hottentot Venus has found her way into works by several Black female artists, including Kara Walker, Deborah Willis, Renée Green, Carrie Mae Weems, Jean Weisinger, Carla Williams, and Renee Cox. The resurgence of Venus not only represents a Black feminist reclamation project; it also serves as a stark reminder of the persistence of imperial and eugenic ideologies surrounding Black female sexuality.

Other artists have played with irony as a means of subverting colonial legacies of display. In his 1995 docudrama "Bontoc Eulogy," director Marlon Fuentes presents a fictionalized account of his grandfather's journey from a village in the Philippines to an Igorot reservation display at the St. Louis World's Fair in 1904. Visitors flocked to see the reservation, alongside an array of Native tribes in their "natural habitat." His fictional grandfather eventually escapes the fair and mysteriously disappears. At the time of the film's release, many viewers felt cheated when they found out the story was

a complete fabrication. For Fuentes, this blurred line between fiction and reality is precisely the point. By using ethnographic elements to craft an elaborate fiction, he conjures the same kind of deception that pervaded the world's fair.

At the end of the film, Fuentes extends his critique to the museum of today, as he wanders through the storage room of what looks like the Smithsonian Museum, in search of his grandfather's skeletal remains. Similar remains have, in fact, been housed at the museum. After the closing of the St. Louis exposition, Aleš Hrdlička, one of the world's premier physical anthropologists, infamously severed the heads of two Filipinos and sent their brains to the Smithsonian for preservation and study.

In their 1992-1994 performance "The Couple in the Cage: Two Undiscovered Amerindians Visit the West," artists Coco Fusco and Guillermo Gómez- Peña took Fuentes' variety of deception one step further. Locking themselves in an oversized cage overseen by two guards, the artists exhibited themselves as representatives from a newly discovered, non-existent island in the Gulf of Mexico. The performance traveled to venues across the U.S. and Europe where non-Europeans had historically been exhibited in ethnographic displays. While the original intent was to set up a critical commentary on Western concepts of discovery, primitivity, and "human zoos," the artists found that most viewers fell for their hoax.

With a lack of context and no dramatic "reveal," people came away from the performance either horrified or amused.

Ethnographic exhibits of human beings may have died out after World War II, but in their place, the museum wielded a classificatory order and scientific rationale that relegated colonial history into oblivion. While humans are no longer being shipped across the world to be gawked at by Western audiences, their objects—artifacts, art, and even human remains—continue to sit in the glass boxes of museum displays, or gather dust in storage rooms and archives. Yet even as museums are beginning to acknowledge—and in some cases, repatriate—looted art and artifacts in their collection, the traumas of colonialism run deep, and the scars are often hard to see.

At a time when most museums still fail to reckon with past mistakes and colonial legacies, the ironic "gotcha" carried out by Fusco and Gómez-Peña is, unfortunately, not enough to unravel the historical amnesia that defines American consciousness. Museums of today need to hold space to tell the real stories of real people who were exhibited in ethnographic displays. A decolonial ethos requires a radical memorialization of the dehumanization at the center of histories of museums and their predecessors. It also demands a more expansive, liberatory form of truth-telling—one that has the potential to transform the museum into a site of healing. This project is the subject of the next chapter.

Chapter 3

REWRITING THE NARRATIVE

On a cold day in December 2019, I rushed down the icy streets of Fifth Avenue into the soaring warmth of the Great Hall of the Metropolitan Museum of Art. It was the opening night of *mistikôsiwak* (Wooden Boat People), an exhibit by Cree artist Kent Monkman, and the excitement was palpable. There, in the Met's Great Hall, were two monumental paintings. One canvas depicted the chaotic arrival of Europeans in North America, with Native inhabitants rescuing drowning newcomers. The other portrayed Indigenous people set adrift at sea, with white nationalists occupying the only land in sight, their guns raised triumphantly.

Both scenes subvert nineteenth-century artistic depictions of North America as a virgin continent ripe for exploitation—a storyline still deeply embedded in American historical consciousness. Several of the painting's Indigenous figures are based directly off protagonists of European and North American art in the Met's collection—specifically works by Eugène Delacroix, Emanuel Leutze, and Henry Inman, among others— that render Native Americans as a noble and disappearing breed.[1]

Monkman's work celebrates Indigenous survival and resilience, without ignoring the devastating and ongoing costs of European colonization. In pushing back against fantastical stories of European-Indigenous relations (think Pocahontas), Monkman mixes the past and present, the real and the mythical, and offers up a long view of Native resistance—from revolts against nineteenth century settler encroachment to the 2016 Dakota Access Pipeline protests at Standing Rock to the ongoing struggle against climate change.

Both paintings in the Great Hall that evening feature Monkman's gender fluid alter ego, Miss Chief Eagle Testickle, a reflection of Indigenous Two Spirit traditions, which challenge Eurocentric binaries between masculine and feminine identities. The exhibit's opening event starred Monkman as Miss Chief, gliding across the stage of the Grace Rainey Rogers Auditorium in a dress resembling a teepee, where, moments before, Indigenous elders performed an opening ceremony.

The entire evening, and the commission itself, were remarkable, especially given recent history at the Met. A year earlier, the museum came under fire for its uncritical display of items of Native American cultural heritage as "art" in its American wing, including a number of sacred items that had ended up in the museum's collection through trafficking and looting.

Kent Monkman, *Resurgence of the People*, acrylic on canvas, 2019.
Reproduced with permission of the artist.

Both Monkman and the Met's leadership know that *mistikôsiwak* cannot on its own solve these kinds of longstanding colonial injustices. Nevertheless, the Met's commission of Monkman's work signals the institution's willingness to engage with its own colonial past and that of the art historical canon it maintains. The anger and humor contained in Monkman's work becomes even more potent when placed against the neoclassical backdrop of the Great Hall, a space whose columns and archways invoke a nostalgia for empire.

The dream of empire is dying and the Met knows it. That's why the museum appears to be making moves that will allow marginalized communities to control their own images and stories. In November 2020, the Met hired Patricia Marroquin Norby, who is descended from Mexico's Indigenous Purépecha people, as its first ever curator of Native American art. In her new role, Norby plans to work collaboratively with Native American communities to craft culturally sensitive exhibitions that reflect Indigenous histories, contemporary issues, and aesthetic expressions.

Norby's appointment represents a reckoning that is taking place across the museum world. In recent years, a slew of artistic and curatorial initiatives have attempted to illuminate the intertwined histories of exhibition and empire as well as ongoing processes of institutional racism in the museum. The word "decolonization" is suddenly on everyone's lips.

But what exactly does this word mean? How can museums like the Met, which owe much of their collections to colonial enterprises, successfully present anticolonial perspectives? And why are museums suddenly interested in doing this work now?

Museum as Contact Zone

Over the course of the past two chapters, we have seen the various ways that museums have historically defined themselves: as authoritative voices, as universal arbiters of culture, as sites of preservation and conservation, and as disciplinary institutions.

Toward the end of the 1980s, a new concept of the museum emerged as part of what some theorists have referred to as the "new museology."[2] Proponents of the ideology called for museums to take on a more active role in the communities they purportedly serve—to educate, promote social activism, and establish greater connections with wider audiences.

The movement gained steam during a broader cultural moment in the 1980s, in which the humanities began to pay more attention to questions of representation and the social construction of knowledge. Scholars from across academic disciplines began asking questions: How do some interpretations come to be regarded as "neutral" or "right"? Who

gets included (or excluded) from what is considered to be "canon"—in literature, art, philosophy, and so on?

Around the year 2000, a second wave of "new museology" pushed this critical framework even further. Rather than a top-down instrument of governmentality and education, the museum was reimagined to be a space for cross-cultural exchange. Mainstream museums, initially those in settler colonial societies of North America, Australia and New Zealand, and later in Europe, sought new inclusionist models of partnerships and collaborations with Indigenous people.

Central to the philosophy behind these initiatives was Mary Louise Pratt's concept of the "contact zone," which, in her 1992 book *Imperial Eyes: Travel and Transculturation,* she defines as:

> . . . social spaces where cultures meet, clash, and grapple with each other, often in contexts of highly asymmetrical relations of power, such as colonialism, slavery, or their aftermaths as they are lived out in many parts of the world today.

Writing specifically about travel writing, Pratt highlights processes of cross-cultural negotiation and translation that take place in the contact zone between the colonizer and colonized. Unlike the term "frontier," which assumes a one-way march of European expansion into empty land, the contact zone invokes "the spatial and temporal *copresence* of subjects," which is defined by an "interactive" and even

"improvisational dimension." In 1997, anthropologist James Clifford applied the concept of the contact zone to museums, as permeable spaces for transcultural encounters.

We see this kind of permeability in Monkman's painted scenes, in which North America is a zone of contact where Native resilience meets colonial genocide, ecocide, and destruction. The work takes on an additional layer of transcultural meaning when hung in the Met—the largest museum in New York City, the center of world capitalism, where diverse people have collided for centuries. The contact zone is more than just a literal shore where native and foreign interact; it is also a *psychological* landscape, where, despite power imbalances, Native agency—to resist or engage in exchange—is recognized and taken seriously.

Since the late 1990s, three major shifts have taken place in museums that subscribe to the new museology. First, the focus of exhibits has shifted from objects to concepts. As Amy Lonetree explains, objects are still central, but they are selected to illustrate certain themes that resonate with Native communities, such as the importance of family, elders, or relationship to land, as well as contemporary issues of survival, sovereignty, education, and language. Some scholars even consider these objects to be microcosmic contact zones in themselves, as they embody both the local knowledge that produced them as well the

global histories of Western expansion which resulted in their transfer to museums. Second, the purpose of the museum has shifted from conservation to active curation, in which the concerns and ambitions of Indigenous 'source' communities are taken into account at all stages of exhibition making.

Finally, the turn towards new museology has highlighted the role of visitors as active agents in the museum's contact zone. You might recall from the previous chapter that 19th century museums and cultural spaces occupied an "exhibitionary order" in which audiences were conceived of as bodies to be disciplined, or else as sponges waiting to soak up imperial forms of knowledge production. Today, galleries are no longer thought of as spaces of passive consumption. Increasingly, visitors are viewed as active interpreters who are capable of constructing meaning based on their own sense of identity, personal experience, and bias.

Responding to these new trends, museum professionals have recognized the need for collaborative projects that fall into two categories: the multivocal exhibit and the community-based exhibit. The former allows for multiple and reflexive perspectives in the exhibition. The latter allows for the community to be the "final arbiter" of exhibition content. Below, I discuss these models alongside other critical approaches to decolonial exhibition-production.

Multivocal Exhibits: Artist Interventions

I will never forget my own confusion when I stumbled upon the bones of a mermaid skeleton at Copenhagen's Danish National Museum in 2012. Its presence was covert. Like the adjacent bones of the Bronze Age Egtved Girl on display, it was carefully lit behind a glass vitrine. Its official-looking tombstone dryly categorized its species as *Hydronymphus pesci* and provided a short description of how the skeleton was found in mainland Denmark by a farmer while ploughing his field. Later, I learned that this cryptozoological prank was instigated by artist Mille Rude as a way to challenge the scientific aesthetic of "neutrality" that surrounds archaeological objects of study. Years later, I still think about that mermaid—a subtle, yet persuasive intervention that made me pause to consider how I take in scientific and evidentiary tropes in natural history exhibits.

The mermaid skeleton might be considered an example of multivocal exhibition, a practice whereby museum staff work to illuminate multiple meanings attributed to objects and ways of knowing. Since the turn to "new museology," ethnographic museums are increasingly trying their hands at experimentations like artist interventions, transforming galleries from spaces of representation into spaces of encounter.

Mille Rude certainly wasn't the first artist invited into a museum to stimulate multivocal conversation and debate. One of the most well-known examples is Fred Wilson's

1992 exhibition, *Mining the Museum*, which was organized by the Maryland Historical Society (MdHS). As an African American artist, Wilson was invited in to sift through the museum's collections and rearrange the space from his own point of view. Using glass cabinets, neat labels, and selective lighting, he mimicked the usual methods of museum display in order to expose its constructed-ness. In one installation, titled "Metalwork 1793-1880," he placed ornate silver jugs alongside a pair of iron slave shackles, explaining:

> . . . I placed them together because normally you have one museum for beautiful things and one museum for horrific things. Actually, they had a lot to do with one another; the production of one was made possible by the subjection enforced by the other.

Mining the Museum wasn't the first time that Wilson used his work to demystify museum operations. In his earlier work *Rooms with a View: The Struggle Between Culture, Content and Context in Art* at the Bronx Council of the Arts in 1987, he set up a series of "mock museum" spaces, including ethnographic and Victorian museums as well as a contemporary "white cube" gallery, to show how the same objects can be vastly reinterpreted based on their display settings. In his 1991 *Colonial Collection* at the Gracie Mansion Gallery, meanwhile, Wilson blindfolded African masks with the flags of their French and British colonizers and labeled them: "Stolen from the Zonga tribe." In all of these projects, Wilson illustrates

how museums whitewash the acquisition of such objects while anesthetizing their own colonial history.

While Wilson rearranged an existing museum, the French-Algerian artist Kader Attia creates his own version of museums—as spaces where healing might begin to take place. In one installation, called *The Repair from Occident to Extra-Occidental Cultures* (2012), Attia constructs a museum storeroom to display a number of objects related to healing and repair, including sculptures of prosthetic legs that allude to phantom-limb syndrome, a sensation that an amputated or missing limb is still attached. By invoking curatorial aesthetics of nineteenth-century ethnographic displays—including plinths, vitrines, and theatrical lighting—the installation serves as a metaphor for the lasting scars of colonialism, with the missing limbs referencing the impact of missing cultural heritage on the collective psyche of the colonized world.

Meanwhile, Christian Thompson, the first Aboriginal student to study at the University of Oxford, offers an important intervention into a museum steeped in colonial modes of knowledge production. In 2012, he presented *We Bury Our Own*, a group of eight large photographic self-portraits made in response to the extensive photography collection of Indigenous Australians found at the Pitt Rivers Museum. Through his self-portraits, in which he dons the university's formal gowns and obscures his face with votive objects,

Thompson captures the perspective of an Indigenous person experiencing the museum's painful histories. He has called his project one of "spiritual repatriation," an attempt to reclaim the visual history of his people.

Thompson's intervention holds emotional power as a form of truth-telling that connects the museum, the archive, and the embodied viewer. But Alice Procter warns us that the concept of "spiritual repatriation" doesn't go far enough in institutions such as Pitt Rivers, which continues to house objects sought by Indigenous communities all over the world. It's easy for a museum to bring in an artist to give the institution a critical coat of paint; it's much harder to take practical steps towards restitution.

That's why an intervention staged by artist Divya Mehra is all the more remarkable. In 2019, Mehra was invited to stage an exhibition at the MacKenzie Art Gallery at the University of Regina in Canada. While she was researching objects in the museum's permanent collection, she discovered the colonial history behind an 18th century statue that had been looted from a temple in India. (Mehra's findings prompted MacKenzie's Interim CEO John Hampton to repatriate the artifact to India.) Mehra alludes to this theft in her exhibition, which included a sculpture of a sack of sand placed on an altar. Titled "There is nothing you can possess which I cannot take away (Not Vishnu: New ways of Darsána)" (2020),

the piece recalls the colonial crime scene in *Raiders of the Lost Ark*, in which Indiana Jones attempts to steal a golden idol by swapping it out with a bag of sand equal in weight.

Beyond a powerful form of truth-telling, Mehra's intervention is a call to action. It has prompted the MacKenzie Art Gallery to begin research into other objects in its collections that may need repatriating. Her bag of sand, which has entered the museum's permanent collection, is a lesson for future acquisition practices. "As we're having conversations about repatriation, it's a good time for institutions to acquire new works to replace items that are leaving their collections," she explained. "And, if you have gaps, why not commission BIPOC artists to fill them?"

Mixed Messages

Multivocal experimentation, like the mermaid skeleton, often takes place through trickery, as if the curator is winking at the visitor. Other times it involves shifting exhibitions from displays of objects to displays *of* displays.

An exhibition at the Museum der Kulturen in Basel, "Expeditions" is a good example of this curatorial process. One installation asked visitors to consider field notes from a colonial expedition as if they were a contemporary art installation. In another display, a set of carved wooden statues were arranged to turn away from visitors, prompting questions as

to how they were originally intended to be seen and exhibited. Such reflexive interventions are meant to strip bare the social construction of ethnographic knowledge, revealing the museum's own colonial history, methods, and instruments.

Yet such experiments can still fall flat. Sometimes, visitors are not equipped with the cultural resources or power necessary to engage in the various interpretations put forth by the museum. In these cases, an exhibition's multivocal message could either be completely ignored or it could be misinterpreted altogether. Considering the fact that visitors bring their own identities and "cultural baggage" to an exhibition, museums run the risk of bolstering preconceived misconceptions rather than offering an intended critical reading. It is possible to simultaneously accept that museums are not neutral *and* that they should be committed to presenting certain points of view as truthful. Not all interpretations are equal, and some, such as those that validate colonial or racist viewpoints, should not be sanctioned by the museum.

Perhaps ironically, self-exposing multivocality may also be "token gestures," serving only to legitimize what is on display. Reflexivity might cloak exhibits in irony, thus granting curators "subcultural capital" while shielding them from difficult questions. In the case of the Museum der Kulturen, the artistic interventions into museum discourse ultimately exempted staff from engaging with difficult political issues,

such as the presence of human remains in the museum collection.[3]

A similar evasion plagued a 1990 exhibition at the Royal Ontario Museum (ROM) called *Into the Heart of Africa*, where a pervasive ambiguity diluted the exhibit's attempt at self-reflection. As curator Enid Schildkrout points out, the exhibit "was meant to criticize colonialism (but not particular colonialists), missionaries (but not particular missions), museums (but not necessarily the ROM)." The exhibition ultimately became the center of heated protests, and plans for it to travel to other museums were canceled.

A successful multivocal approach is more direct in addressing how colonial dynamics continue to manifest through exhibitionary modes. For example, Anthony Shelton, curator of the 1999 exhibit *African Worlds* at London's Horniman Museum, matched ethnographic items to a range of interpretations—from voices of living community members to Western anthropology's understanding of the objects' functions and meanings. One of the installations in the exhibit, The Voices Project, was a collection of photographs and interviews with people of African and Caribbean descent in the London area, who were asked to speak about their impressions of some of the objects represented in the gallery. Many expressed a critical view of the museum. As participant Oloye B.A. Adelakan noted: "Many people brought

many things into this part of the world, without knowing what they are." These layered viewpoints breathed new life into the exhibition, while highlighting how these artifacts continue to hold significance within contemporary communities. Ultimately, *African Worlds* reflected the dual goals of multivocal exhibits—to encourage visitors to reflect on their own position in relation to objects on display, and to illuminate the tension between colonial anthropology and the contemporary community's point of view.

Two years after its disastrous *Into the Heart of Africa* exhibit, ROM used similar tactics in an exhibition that was far more successful. The exhibit, titled *Fluffs and Feathers: An Exhibit on the Symbols of Indianness*, was a collaboration with Canada's Assembly of First Nations and the Canadian Museum Association, and had previously been on view for Woodland, a cultural center in the largest First Nations reserve in Canada.

It began with what looked like a standard ethnographic approach, but soon elements of popular culture—including stereotypical representations of "Indianness" in novels, comic books, and films—became interspersed with the objects on display. The result was a blend of authenticity and reproduction, as well as popular and sacred culture. In one gallery, viewers were invited to "try on" Native costumes and head dresses, and pose against a backdrop while looking into a full-length mirror.[4]

At the time of its opening, museum professionals deemed the exhibition to be a successful example of what ethnographer Babarba Babcock calls "double play," a combination of social criticism and humor. The exhibition certainly went well beyond its traditional role of producing knowledge of an ethnographic group, instead becoming a commentary on how stereotypes are created and upheld in the present. In Chapter 2, we saw how early museums and exhibitions maintained strict distinctions between representation and reality, and between representation and visitor. In multivocal exhibits like *Fluffs and Feathers*, representation itself is mocked, and therefore subverted.

Participant interviews and observations conducted by social anthropologist Eva Mackey at the time revealed that visitors to the exhibition felt encouraged to touch and play with the objects on display as if they were at a yard sale rather than in a formal gallery. Yet the study did not assess what was going through visitors' minds as they tried on an Indigenous headdress. Did standing in front of a mirror dressed in native costume help non-Indigenous visitors reflect on their own subject position or how it felt to embody a stereotype?

If *Fluffs and Feathers* were to be revived today, this activity would certainly seem insensitive. With debates over cultural appropriation now a part of everyday discourse, it wouldn't matter whether or not the curators *intended* for such an activity

to spark critical reflection on the very nature of representation; visitors could still walk away with pre-existing stereotypes about Indigenous people intact.

The gap between curatorial intent and audience reception exploded during the 2017 Whitney Biennial. The flashpoint was Dana Schutz's painting *Open Casket,* which depicted the mutilated corpse of Black teenager Emmett Till, who was lynched in 1955 after being falsely accused of whistling at a white woman. The original photograph on which the painting is based was largely credited with galvanizing the Civil Rights movement. At the time, Till's mother, Mamie Till Mobley, insisted that his body be photographed, stating, "I wanted the world to see what they did to my boy."[5]

Schutz's abstract rendering of Till's body immediately came under fire. Artist Hannah Black went so far as to call for its destruction. Black and many others pointed to the artist's position as a white woman who was appropriating and profiting off Black suffering. Schutz's intent—that her work was an expression of empathy for Mobley's motherhood—was unacceptable to her detractors. Art critic Aruna D'Souza sums up Schutz's insensitivity as twofold: by equating Black motherhood with her own experiences of white motherhood, Schutz centered white pain in her response to Black death. She also failed to engage with the complicity of white womanhood in Till's murder.

The intentions of Whitney Biennial curators Christopher Y. Lew and Mia Locks—to provide a "museum platform" for artists to explore "critical issues" like "the history of race relations in this country"—also mattered little to those who saw the painting as exploitative. Soon after the Biennial opened to the public, artist Parker Bright launched a silent protest. Photos of him standing in front of the painting with the words "Black Death Spectacle" written across his T-shirt went viral on social media.

In line with director Adam Weinberg's characterization of the museum as a "safe space for unsafe ideas," the Whitney agreed to host a public conversation to discuss the controversy—criticized by one artist as a hollow "'kumbaya' moment."[6] It was ultimately the resistance strategies of artists and activists like Bright and Black that added a crucial layer of multivocality to the gallery.

Assessing Audience Experience

Given the complexity of multivocal exhibitions, how can museums gauge *whether* or *how* audiences have received an intended curatorial message? Without a viral controversy like the one that rocked the Whitney, it may be hard to assess audience reactions to a particular exhibition.

Today, museums use a host of tools to collect data on visitors, including questionnaires, interviews, visitor

observation, and focus groups. Visitor feedback helps evaluate the value of a museum experience through a variety of lenses, including satisfaction (did visitors enjoy themselves and will they return?); learning outcomes (did they learn something new, and were they able to decipher the museum's intended lessons?); and meaning-making (did they have a meaningful or valuable experience?).

These evaluation mechanisms also collect information about participants' demographics (age, race, gender, etc.), as well as their knowledge, expectations, preferences, and beliefs. This data is particularly useful in assessing whether visitors are representative of local or wider communities. They can also help museum professionals understand visitors' diverse learning processes and assess the accessibility of their own spaces—ensuring, for example, that people with physical or learning disabilities can fully enjoy and benefit from museum offerings.

In recent years, "smart museums" have adopted a variety of technologies to both improve accessibility (think audio guides to assist visually impaired patrons) as well as to collect data on visitor behavior and interests. Eye-tracking and facial recognition technologies can track how long visitors engage with a particular object on display. These technologies begin to look like something right out of the British dystopian science-fiction television show *Black Mirror* when they are

equipped with the capability of measuring an artwork's emotional impact on visitors (joy, confusion, discomfort, and so on). And then there are artificial intelligence robots like the Smithsonian's "Pepper"—a humanoid who can answer questions, offer translations, pose for selfies, and yes, track visitor behaviors. In the Musée du Quai Branly, a robot named "Berenson" analyzes the facial expressions of museumgoers, labels them as "negative" or "positive," and sends them to a database.

Such technologies may help museums assess the emotional impact of their collections, but the ethical issues often overwhelm their usefulness. Museums have used social media to identify the actual identity of visitors and generate targeted ads based on their emotional preferences. This data may also be used by police. Such was the case for the World Museum in Liverpool, which came under fire for its use of facial recognition systems for purposes of "anti-terrorism." These trends are particularly worrying and merit further scrutiny.

The question is not whether technology can be used to enhance visitor experience (it can), but whether or not it can be used in an ethical way to assess the impact of an exhibition. This is particularly advantageous when it comes to multivocal experimentations, in which a museum's use of irony or self-reflexivity may not be received by a visitor as a straightforward message or a decolonial lesson learned.

Community-based Exhibits: Towards a Revolutionary Museum?

The Whitney wasn't the only museum to come under fire in recent years for presenting art that some considered exploitative. The same year as the Schutz controversy, Minneapolis' Walker Art Center faced criticism for its installation of Sam Durant's "Scaffold." The wood-and-steel scaffold is a composite of gallows used in seven state-sanctioned hangings, including the 1862 execution of thirty-eight Dakota-Sioux men in Mankato, Minneapolis—the largest mass execution in U.S. history.[7] In response to protests led by the local Native American community who viewed the sculpture as insensitive to its traumatic history, the museum handed the installation over to Native groups to be dismantled and ceremonially buried. In response to the events, the Walker established a Native American advisory group that would inform more culturally sensitive curatorial protocols and oversee proposals for a new Indigenous Public Art Commission.

The imperative—that museums need to consult Native Americans—is one that Native communities have been calling attention to for decades. Starting in the 1960s, Native Americans began demanding a more relevant and permanent role in exhibition production. As part of a larger project of decolonization, "they wanted not just to be researched but to be respected," as Chip Colwell put it. The Denver Museum of Nature & Science, a small Smithsonian

affiliate, was among the first museums to include an advisory council of Native Americans while planning its hall of Native American history and culture in 1978. Departing from ethnographic exhibits that relegated Indigenous people to a bygone time, the hall boasted an exhibit that explored the urban experiences of contemporary Native Americans. The exhibition launch even opened with the blessing of a medicine man.

This is an example of what would later become known as "community-based exhibitions." Through this curatorial method, community members become the primary decision-makers, while museum professionals take a backseat as "facilitators." The museum becomes an extension of the community's space, a place where community members can project their own values, knowledge, and concerns.

While these initiatives seem promising, a closer look at the case of the Denver Museum reveals an imperfect picture of inclusion. As time went on, it became clear that Native presence at the museum was deployed as a distraction from unanswered repatriation claims. Furthermore, the Native advisory committee became largely honorary, and Native people were only invited into the museum to sell their arts and crafts. As Colwell points out, even the name of the exhibit hall — "Crane Hall" — reflects the museum's prioritization of their donors over their Native constituents. Despite these failures,

it's nearly impossible to find a museum today that doesn't take community voices into account.

Take the National Museum of the American Indian (NMAI), which opened its doors on the National Mall in Washington, D.C. in 2004. Considering the extent to which museums had traditionally misrepresented Indigenous people—whether through cultural insensitivity or outright erasure—the curators knew the stakes of NMAI were sky-high. From the beginning, therefore, the museum presented itself as advancing a new interpretive strategy, one that would transfer curatorial authority to Indigenous people. Establishing trust was at the core of such methodology. In conversation with spiritual leaders, for example, the museum featured sacred tribal ceremonies that communities had previously been reluctant to publicly display. In this sense, NMAI was revolutionary.

Despite the constant process of negotiation and consultation between museum staff and tribal representatives, challenges persisted. In an interview with Lonetree in 2001, for example, one NMAI staff member questioned the full extent of tribal involvement and reciprocity:

> Sure, [Native people] are involved, but I see them as just an information resource—like a book you pull off a shelf and you open, and there is the information on the Indian community. Okay, let's pull people to the table, talk to them, they are just like the books. We are the experts. We put together the exhibition, and all you guys have to do is tell us what you want.[8]

Here, a tension emerges between curatorial expertise and Native perspectives. Furthermore, the needs of the audience are not taken into account at all.

Lonetree notes that in some NMAI installations, the prioritizing of Indigenous forms of knowledge resulted in postmodern abstractions that failed to resonate with visitors. For example, the "Evidence" gallery consists of a large collection of objects—guns, Bibles, and treaties—that represent European encroachment. The installation is arranged to resemble a storm, as if conquest was a natural disaster. All objects are unlabeled, which is meant to reflect an Indigenous way of imparting information, in which knowledge has to be earned. Yet Lonetree contends that such enigmatic curatorial methods fail to reach visitors, many of whom carry their own stereotypes and harmful myths of American history. Instead of speaking hard truths about the genocide that the U.S. committed against Indigenous people, she argues, these exhibits at NMAI reinforce the "historical amnesia" that defines American understanding of colonialism and its ongoing effects.

There are signs that this kind of missed opportunity is beginning to change. A more recent temporary exhibit at NMAI called *Americans* is reminiscent of the multivocal *Fluffs and Fathers*. Bringing together nearly 300 artifacts of Native American representations in American pop culture, including sports logos, movie posters, toys, weapons, and food

products, the curators ask visitors: "How is it that Indians can be so present and so absent in American life?" Departing from the heady abstraction of NMAI's original, permanent galleries, newer exhibits like this one are more explicit in their effort to push visitors into a reckoning with painful, living truths.

Perhaps the most successful models of community-based approaches are taking place in smaller museums, including the Arizona State Museum and the Museum of Indian Arts and Culture in Sante Fe—both of which have created groundbreaking exhibits based on extensive collaboration with Native peoples. The exhibit *Here, Now, and Always* in Sante Fe, for example, is based on eight years of dialogue and co-curation with Native American elders, artists, scholars, and museum professionals. Alongside each displayed artifact are poems, songs, stories, and scholarly discussions that give visitors a full picture of the Southwest's Indigenous communities across time. The exhibit adheres to decolonial principles outlined by Lulani Arquette, President and CEO of the Native Arts and Culture Foundation, including the use of Indigenous language and cultural protocols and the maintenance of long-term relationships with Indigenous communities.

There is also a rich history of Native American communities creating their own tribal museums, such as the Zuni Tribe's A:shiwi A:wan Museum and Heritage Center in New Mexico

and the Saginaw Chippewa Indian Tribe of Michigan's Ziibiwing Center of Anishinabe Culture & Lifeways. Both museums are entirely community-led. Lonetree has described the latter project as "the finest in twenty-first-century tribal museum practice," as it actively engages with both historical trauma and unresolved grief—topics that must be acknowledged to begin the healing process for Native people.

Despite some progress, the work of decolonization at mainstream institutions like the NMAI has barely begun. Celebrating the NMAI as a "decolonial institution," as some scholars have done,[9] not only obscures the museum's lack of clarity when it comes to naming colonialism; it also reifies the historical narrative put forth by the nation-state—one which refuses any apology to Indigenous people, let alone the political will to begin a reparations process.

A similar critique has been leveled against the National Museum of African American History and Culture (NMAAHC), another Smithsonian Institute, which opened its doors in September 2016. The structure of the building guides visitors through a chronological journey, starting with an exploration of slavery in the museum's basement and spiraling upward, all the way to Oprah and Obama. According to art historian Huey Copeland, the path tricks visitors into thinking that "a certain kind of historical project has been achieved," even as Black people in America continue to be

murdered and imprisoned at disproportionate rates. The museum incorrectly seals violence into the past.

Like the NMAI's avoidance of the words "genocide" or "colonialism," NMAAHC talks about the "uneven" history of Black people—euphemisms that repackage history into something palatable and unthreatening. As critic Frank Wilderson III explains, the museum puts forth an "accommodationist nationalist narrative," in which all racial differences can be seamlessly incorporated into the fabric of the nation, or absorbed into narratives of corporate success. Meanwhile, even as Oprah poured $21 million into the museum, reparations for slavery remains a largely untenable topic of conversation on the national stage.

Black critics are well aware of the limitations of such spaces. In a conversation with Wilderson III, Copeland asks: "What would it mean to create spaces that are *not* beholden to the work of narrative, explanation, cultural justification, or black respectability? Spaces where we can plot the possibilities of the truly revolutionary and the radically decolonial?" Wilderson III laughs as he responds: "That would be a very vibrant space for black people, and a very dangerous space for everyone else."[10]

In a political environment defined by police brutality, extrajudicial killings of Black people, and racial injustice, perhaps nothing less than a "dangerous" liberatory museum

is desperately needed. As the #BlackLivesMatter movement has shifted the conversation around racism in the U.S., is it even possible to celebrate the narrative of progress that the NMAAHC advances? Likewise, is it possible to praise the "museological reconciliation" put forth by the NMAI at a time when Native Americans continue to suffer disproportionately from mass incarceration, poverty, and a lack of access to resources? By staging history as a progressive path towards liberation, museums such as the NMAI and NMAAHC risk lending themselves to what Pauline Wakeham describes as a "cooptation by the state for the purposes of staging postcolonial rapprochement." Indeed without truly reckoning with both past and present injustices, the museum will only end up serving the interests of the nation-state.

The Shadow of Colonial Museology in Africa

At the House of Slaves on Gorée Island, Senegal and the Cape Coast Castle on the shores of Accra, Ghana, visitors come face to face with "Doors of No Return," through which millions of Africans were forced onto slave ships. Far from the hopeful, teleological journey offered up by the NMAAHC in Washington, D.C., these sites are more solemn memorials. They are heavy with trauma, especially for the many African American descendants of slaves who travel to West Africa to

reconnect with their heritage and memorialize the horrors of the Trans-Atlantic slave trade.[11]

In the decades following independence, many West African governments began restoring historical sites associated with the slave trade in an attempt to generate revenue through tourism. These initiatives were boosted by an explosion of "heritage trips" to West Africa in 1976, after the publication of Alex Haley's popular novel *Roots: The Saga of the American Family*, a mythical telling of African American history that was later adapted into a TV miniseries. In more recent years, advances in DNA-testing biotechnology—by companies like AfroRoots DNA and African Ancestry—have made it easier for Black Americans to trace their ancestry and make pilgrimages to their countries of origin.

Today, the African tourist industry is highly invested in these kinds of visits. The Ghanaian government, for instance, declared 2019 the "Year of Return" for the African diaspora. International institutions have also poured money into diaspora-focused tourist initiatives in Africa. UNESCO's Slave Route Project, for example, promotes cultural tourism through the preservation and restoration of West Africa's numerous "slave castles."[12] In the 1990s, the Smithsonian, in conjunction with the United Nations Development Programme and the United States Agency for International Development, invested $10 million in the development of exhibitions in Ghana's historic forts.

Some critics are uneasy about the modern money-making mission of sites that were once used to profit off African bodies.[13] They are also wary of the rise of a heritage tourism industry at a time when the Ghanaian state is increasingly aligning with a global neoliberal agenda. In a framework in which diasporic African visitors are cast as tourists or customers, the legacy of the trans-Atlantic slave trade risks becoming a marketable commodity.

Slave-trade memorializations aren't the only sites on the continent that rely heavily on international investment. Senegal's Museum of Black Civilization, first proposed in 1966 by the country's first president, Léopold Sédar Senghor, could only be inaugurated after a $34 million investment from China. While the museum may be seen as a powerful signpost of African postcolonial cultural production, the institution's financial backing complicates that narrative, underscoring the ways that outside powers continue to shape the continent's cultural development.

Other popular art institutions across the continent are dependent on international corporations or a handful of wealthy individuals. Le Musée Fondation Zinsou in Benin was founded by Marie-Cécile Zinsou, the daughter of prominent French-Beninese investment banker Lionel Zinsou. The Museum of Contemporary African Art Al Maaden (MACAAL) in Morocco was funded by Othman Lazraq and

his father, Alami, a real estate developer and one of Africa's wealthiest men. Meanwhile, Zeitz MOCAA in South Africa is bankrolled by corporate sponsors like BMW and Gucci, with additional support from the South African Friends of the Israel Museum.

Investment in African museums, however, is not evenly distributed. Many archeological and natural history museums across the continent are struggling to stay up-to-date due to lack of funding. You might recall from the last chapter that many of these museums were established during the colonial era. These were institutions founded to be authoritative transmitters of encyclopedic knowledge, where elite white scholars practiced preservation, conservation and scholarship in the service of imperial ideology. So what became of these institutions after African nation-states attained independence? The answer is complicated. Rather than fashioning new nationalized or decolonial exhibitions overnight, many of these museums are still haunted by the enduring legacy of their colonial origins—what has been called "a shadow that refuses to leave."[14]

Kenya is yet another example. When the country became independent in 1963, what had previously been known as the Coryndon Museum—founded in 1930 for the study of nature in British East Africa—was transformed into the National Museum of Kenya (NMK). But it wasn't until 1970

that British paleoanthropologist Richard Leakey formed
the Kenya Museum Society in an attempt to "Kenyanize"
museum management. Up until that point, only two out of
the sixteen members of the board were of Kenyan origin, and
it is worth noting that Leaky himself is a descendent of white
colonial elites.

For the first two decades of its existence, the museum's
exhibitions remained largely unchanged, with old ethno-
graphic displays presenting an encyclopedic reading of Kenya's
diverse ethnic groups. This "mosaic" of separate cultures was
not only a holdover of the kind of colonial museology rooted
in the detailed study of "backward" cultures. It also flew in
the face of the united, national identity that the Kenyan state
was trying to advance post-independence.

Other displays emphasized human origins through col-
lections of bones and Stone Age artifacts—both Western
anthropological priorities that are often seen as disconnected
from the post-colonial concerns of local Africans. In this
regard, NMK is not unique. Faced with the problem of insuf-
ficient funding, many African natural history museums are
capitalizing on these types of displays as a way to drive tour-
ism and European financial support.

In Ethiopia, for example, the Embassy of France sponsored
the main attraction of the National Museum (NME)—a per-
manent exhibition to house the fossilized bones of humanity's

earliest ancestors, hominids known as "Lucy," "Ardi," and "Baby Selam." The skeletons date back three to five million years and represent groundbreaking discoveries in archeological history. But what does it mean for these remains to be the "celebrities" of the National Museum, as *Science Magazine* referred to them? Who benefits when these bones are trotted out on a U.S. tour to boost Ethiopia's image and encourage tourism, as they were in 2008?[15] What does it say that in 2015, the bones were transferred by motorcade to the National Palace for a private show-and-tell with President Barack Obama? Moved by the experience of touching Lucy's bones, Obama remarked, "When you see our ancestor, 3.5 million years old, we are reminded that Ethiopians, Americans, all the people of the world are part of the same human family, the same chain."

This universalist reading is certainly an improvement from colonial fetishizations of human remains, which fueled racist theories of evolution. Nevertheless, questions remain as to the democratizing potential of these kinds of colonial-era displays. While the NME has been quite successful attracting international interest and dollars through high-profile exhibitions like the Lucy skeleton, it seems they've been less successful engaging local audiences. A 2016 study found that the NME consistently fails to provide "proactive activities" for the general public in the form of exhibition engagement and educational programs.[16] The study is quick to point out

that these failures stem partially from the museum's insufficient budget. Still, a gap remains between Lucy & Co. as instruments of foreign and financial relationship-building and a museum environment that is described by local visitors as "unfriendly" and "inaccessible." (It doesn't help that the labels for hominids are written in English).

In some museums, the problem with displays of human remains is not their irrelevance but rather the affront they present to indigenous African belief systems. The Zimbabwe Museum of Human Sciences contains more than one hundred remains—many of which were exhumed by European colonialists in search of gold. Like their Native American counterparts who advocated for NAGPRA in the U.S., the indigenous Shona people of Zimbabwe consider museum collections of human remains to be an abomination according to their spiritual cosmology.

Similar indignities occur in Zimbabwe, a country where the shadow of colonial museology is particularly pronounced. The Railway Museum in the city of Bulawayo, for example, celebrates a European infrastructure that was built by forced African labor and used to exploit the natural resources of the country. In the same vein, the Mutare Museum of Transport and Antiquity displays collections of military vehicles and guns that Rhodesian forces used to crush liberation fighters. Accompanying labels refer to such fighters as "terrorists."

And then there are the Zimbabwean museums that glorify the architects of colonialism, including the Murray MacDougall Museum, which honors Thomas Murray MacDougall, a "villainous" pioneer of the extractive sugar industry, as well as the Rhodes Stable Museum that serves as a monument to apartheidist Cecil Rhodes.

In one potential sign of the institution's contentiousness, in June 2020, the Rhodes museum was burned to the ground in an alleged arson attack. That's certainly a quick way to rid the museum of its colonial ghosts. But when it comes to undoing deeply entrenched colonial museology, transformation often takes a long time—and traverses many routes.

The NMK offers a compelling case study of such a journey. Following the push towards "new museology" in the late 1980s, NMK officials resolved to chart a new direction for the museum. In the 1990s, they launched new exhibitions that spotlighted the cultural identities of some of the country's ethnic minorities. This message of pluralism was balanced out by a nationalist one. Following renovations in 2008, NMK launched a *History of Kenya* exhibition that emphasized both the emergence of the modern nation-state (through stories and artifacts related to anti-colonial resistance struggles) as well as the creation of national identity (through displays on Kenyan language, media, food, and sports). Through regular workshops, surveys, and radio call-in programs, NMK

ensured that the public played a key role in determining exhibition themes and content. The results were positive, with local visitorship doubling between 2005 and 2012.

What lessons are to be learned from this kind of public participation? In the short term, this accountability means removing Eurocentric displays that perpetuate colonial trauma, and, as we've seen in the case of NMK, mounting exhibits that speak to postcolonial realities. But challenges persist. Many museums in Africa are sustained through donor-driven projects funded by Western countries (and more recently, by China), and are run by personnel who are predominantly white expatriates educated in Western universities.

Some have claimed, however, that those who fixate on these characteristics are missing the point. They argue that instead of judging a museum's value based on its *cultural* relevance for civil society, we should instead focus on its *economic* contribution to society. As we've seen in West Africa, for example, the museum sector drives a tourism industry that creates jobs, injects cash into the economy, and promotes infrastructural upgrades. In this way, museums can be locally relevant institutions, no matter their outdated content or lack of local engagement.

Why must institutions choose between economic viability and decolonial models that uphold and reflect the

multifaceted identity of Africa's civil societies? Arguably, that dilemma is rooted in colonialism's economic legacy.

As the Trans-Atlantic slave trade attempted to empty the African continent of human life, and with it, manpower, income, creativity, and innovation, entire generations disappeared through the "Doors of No Return"—a psychological and material scar that continues to plague the continent.

The burden of correcting this plunder should not fall to African countries and their cultural institutions. Instead, the responsibility should rest with the plunderers, and the wrongs righted through that "fourth R" I discussed in Chapter 1: *reparations*. In 1999, the African World Reparations and Repatriation Truth Commission called for the West to pay $77 trillion for harm caused by the slave trade—a call repeated in a resolution issued in 2001 by the UN-sponsored World Conference against Racism, Racial Discrimination, Xenophobia and Related Intolerance held in Durban, South Africa. Others have demanded that institutions like the IMF and the World Bank cancel debts owed by the Global South to the Global North—debts that perpetuate colonial-era power dynamics and keep many African countries in a state of poverty and economic dependency.

Even as many museums make strides towards breaking the continuum of colonial legacies, their operations remain squeezed by a neocolonial structure of global economic governance. Reparations offer a framework of hope—one based

on the assumption that the unequal structures of our world *can* be reshaped and repaired, and with it, our most treasured cultural institutions.

Museological Challenges in an Unrecognized State

Expunging colonial ideology from postcolonial museums becomes even more urgent—and challenging—in settler colonial societies where the repression of Indigenous peoples and cultures is built into ongoing systems of power. Let's take the case of Palestine, where Israeli encroachment on Indigenous land and resources has eradicated the viability of an independent Palestinian state.

If, as some have argued, Palestinian cultural initiatives and heritage projects are anticipatory of a future state, the Palestinian Museum—an institution founded in the West Bank town of Birzeit in 2016—is indeed faced with a Sisyphean task. How can the museum even begin to convey a unified national identity when 5.6 million Palestinian refugees are exiled across the globe, yearning to return to a homeland that has been sequestered by settlements, checkpoint, and walls?

This lack of cohesion is satirized in *Nation Estate*, a short sci-fi film by Palestinian artist Larissa Sarsour that imagines a future Palestinian state as a single skyscraper that houses the entire population. Each floor represents a Palestinian town or village, and instead of navigating through a labyrinth of

concrete walls and checkpoints, inhabitants can travel with the push of an elevator button.

Sarsour's "vertical" nation is packed floor-to-ceiling with the makings of a modern state—landmarks, archives, hospitals, schools, and yes, museums—but, ironically, the actual Palestinian Museum opened as an empty building. The suspension of the inaugural exhibition due to internal "planning and management issues" was quickly read by many media outlets as an unfortunate metaphor for the Palestinian condition—a globally scattered people who have lost control over their land, resources, and, in this case, cultural institutions. The emptiness of the building only seemed to reify the erasure of Palestinian existence on the global stage. It wasn't a good look.

This embarrassing fiasco is only the tip of a much deeper iceberg of colonial structures that impacted the museum's operations. Due to Israeli restrictions, the museum could not be located in Jerusalem—the symbolic capital of Palestine. Much of Palestinian cultural heritage and archival material, moreover, had been looted and transferred to Israeli museums or collections abroad—making them inaccessible to museum curators. (To add salt to these wounds, many of these Israeli institutions are themselves constructed in buildings or on plots of land directly appropriated from Palestinian families.)[17] Further, there was the issue of funding. With the failure of the national liberation project, much of Palestinian

civil society has become dependent on transnational capital from NGOs and private donors. This is true of the Palestinian Museum as well, a $30 million project backed mostly by the Swiss non-profit Welfare Association (Taawon), an organization committed to "providing development and humanitarian assistance to Palestinians." The remainder of the funding is channeled directly from investors based in the Arab Gulf states (and, as I write, many of those nations are normalizing diplomatic ties with Israel to facilitate a different kind of transnational capital exchange—that of weapons sales).

Despite these challenges, the triumphs of the Palestinian Museum should not be underestimated. Some have even argued that the museum's lack of a "larger national strategic plan" (or national funding for that matter) unintentionally creates a flexibility that allows new notions of Palestinain identity to emerge that are untethered from political party ideologies of restrictive nation-state forms.[18] While the link between the museum and its Gulf partners needs to be further scrutinized, it is not too soon to celebrate the innovative curatorial vision that the Museum has advanced, even after its opening snafu.

The building itself honors the topography of the natural landscape, with native plants and trees nurtured throughout the site. Inside its walls, exhibitions have spotlighted a range of topics that explore Palestinian identity and experience, including the militarization of Jerusalem, representations of

landscapes by Palestinian artists, and the rich local history of Palestinian poster art, among others.

Furthermore, as part of its commitment to serve as a transnational institution "without borders," the museum offers digital and satellite exhibitions that are accessible to Palestinian communities all over the globe. The Family Album Project, for example, digitizes thousands of family photographs of the Palestinian diaspora. Meanwhile, the museum's first satellite exhibition in Beirut takes a critical look at the role of embroidery in Palestinian politics and culture. Other outposts are planned in Amman, Santiago de Chile, and Michigan.

Through these initiatives, the museum moves well beyond the failed dream of Palestinian statehood to experiment with forms of self-determination that are not necessarily defined by nationalism. Additionally, while still operating under the weight of Israeli colonial control, the Museum manages to reach beyond the physical boundaries of its site, engaging both local and diasporic communities in conserving a cultural past as much as crafting an emancipatory vision for a decolonized Palestinian future.

Reckonings in Europe

Up until now, I've discussed how trends in "new museology" have prompted museums in settler or post-colonial societies

to reckon with issues such as slavery, genocide, and ongoing racism with varying levels of success. But what about Europe, where colonial museums in major metropolitan centers have historically celebrated the project of empire?

In the 1960s, while many African and Asian nations were celebrating their newfound independence, most European museums were eager to push the imperial age under the rug and move on. Rather than deal with their recent colonial pasts, museums like Britain's Commonwealth Institute and the Netherlands' Tropenmuseum (The Tropical Museum) opted instead to emphasize international cooperation and contemporary issues of "daily life in the Third World."[19] Others, like France's Musée national des Arts d'Afrique et d'Océanie (MAAO), diluted their colonial origins by purchasing art from regions not colonized by France and shifting their focus from colonial ethnography to general art history. Similarly, the Belgium colonial museum, renamed the Africa Museum after Congolese independence, merely broadened its areas of interest to the Americas and Oceania, willfully forgetting its imperial past.

This "universalist" approach gained momentum at a time when Edward Steichen's exhibition *The Family of Man* toured the world. A declaration of global solidarity in the wake of World War II, the exhibition brought together hundreds of photographs that captured the so-called human

experience, including birth, death, and work. Postcolonial European museums adopted the same approach. Why focus on the historical specificity of colonialism, the logic seemed to go, when you could instead celebrate the universality of human experience?

Eventually this evasion of history became untenable. Much like the turn to new museology in the U.S., the 1990s represented a cultural turning point in Europe. Across the continent, the subject of colonialism reared its ugly head, alongside a renewed academic interest in issues such as multiculturalism, migration, and Orientalism. In response, museum officials and politicians opted to close museums, create new institutions, or revamp old ones (or some combination). These initiatives enjoyed varying degrees of success.

In the 1990s, for example, French president Jacques Chirac transferred the colonial-era collections of the MAOO and the Musée de l'Homme to the new Musée du Quai Branly (MQB). For many, including Congolese activist Mwazulu Diyabanza, MQB represents little more than a neocolonial continuation of its predecessors. Its dim lighting and discreet labels are meant to encourage an aesthetic encounter with objects, yet there is no engagement with how items were accumulated, nor the general impact of colonialism in the societies that produced them. The museum also does not acknowledge repatriation claims on lost or stolen

cultural patrimony. Instead, much like the *modus operandi* of the French Empire, the museum valorizes cultural diversity and the universal nature of human culture.[20]

Even the building's architect, Jean Nouvel, described his task as creating an "asylum for censored and cast off works from Australia and the Americas," as if the museum's collections magically appeared on the shores of France. In an attempt to "challenge our current Western creative expressions," as Nouvel put it, he collaborated with botanist Patrick Blanc to install a vertical hydroponic garden on the structure's northwest facade. For Nouvel, the natural symbolism of the so-called "le mur végétal" is meant to invoke the "human condition" of the "ancestral spirits of men." From another view, the overgrown garden hints at colonial imaginaries that traditionally framed colonized space as untamed wildernesses awaiting Western development and creative pioneering.

Since 2000, the French government has established a number of new museums designed to confront colonial legacies head-on. In 2007, the empty building of the old MAOO was partially transformed into a postcolonial museum, the Cité nationale de l'histoire de l'immigration (CNHI). Built to tackle the history of migration into France, the museum directly confronted colonialism in a 2008 exhibition on the 1931 Paris Colonial Exhibition. Another undertaking—an institution in Marseille devoted to the colonial past—never

came to fruition. From the beginning, the institution faced a vexing challenge: How to serve as an enduring reminder of colonialism without inadvertently glorifying that past?

Britain, too, has witnessed a slow reckoning with its own history of empire. In 2017, the Birmingham Museum and Art Gallery (BMAG) invited six women of color, all with varied postcolonial heritages, to co-curate an exhibition that would use the museum's collection to confront its colonial history. The show, titled *The Past is Now*, not only explored Birmingham's relation to imperial violence, but also inter-rogated the museum's claims of neutrality. For example, in a section about Kenya's independence, homemade guns used in the Mau Mau Rebellion (1952-60), which the museum later acquired, are relabeled with the question: "Can objects col-lected under colonial rule be used to tell a fair story?"

Later, Sumaya Kassim, one of the curators of the exhibit, lamented the emotional labor involved with the project, including inadequate pay, tokenization, and censorship. She felt that she and her fellow curators had been brought in to provide "decolonial thoughts"—which were exploited, and then swiftly discarded. Decolonization cannot simply mean hiring more diverse staff or listening to the concerns of visitors from marginalized communities. Such efforts at inclusion are often used to manage or even avoid a more radical overhaul. These incremental changes are prematurely celebrated as a

sign that the museum, and by extension the nation, is dealing with its past. As Kassim writes, decolonization becomes tacked onto a list of great British accomplishments: "the railways, two world wars, one world cup, and decolonization."

Even new institutions devoted to the history of empire—including the British Empire and Commonwealth Museum in Bristol (which shut its doors in 2013), the International Slavery Museum in Liverpool, and the Museum of London Docklands—are not without controversy. The latter institution, whose permanent gallery, *London, Sugar and Slavery*, tells the story of the city's role in the transatlantic slave trade, has come under fire for its display of contested Benin bronzes. Recently, in the wake of Black Lives Matter demonstrations, the museum removed a statue of slave profiteer Robert Milligan, which had stood outside its building since 1997.

The summer of racial reckoning that followed Floyd's execution has forced other drastic changes in British institutions. After nearly four months of closure due to the coronavirus pandemic, the British Museum scrambled to make adjustments in time for its reopening. The first major change was moving a bust of slave owner Hans Sloane from a prominent plinth into a display case designed to offer more historical context on Britain's involvement in the slave trade. The second move was the creation of a guided route around the museum called "Collecting the Empire," which, according to

the museum's website, encourages visitors to "find out more about the complex, varied—and sometimes controversial—ways in which objects have become part of the collection." The plaques still largely emphasize that most of the items were not stolen, but rather gifted or purchased. (As we've seen, however, the context of colonial relations and power imbalances defined even the most "fair" acquisition practices).

In the midst of these announced changes, the museum posted a statement of support for the Black Lives Matter demonstrators. Writer Stephanie Yeboah mocked the museum's response, tweeting: "LMAO [laughing my ass off]. Did our lives matter when you STOLE ALL OUR THINGS? If we matter that much to you, give it back." She raises a valid point. Despite the museum's best efforts to recontextualize their fraught histories, is it ever possible to move towards decolonization without repatriation—or even reparations—front and center?

Revamping Colonialism

Elsewhere in Europe, the old colonial institutions remain open, with new exhibitions and artist interventions attempting to reckon with uncomfortable legacies. One of these institutions is Amsterdam's Tropenmuseum, which was founded in order to show off Dutch colonial possessions and convince visitors of the benefits of colonial trade. After the

decolonization of Indonesia, the museum tentatively backed away from its colonial associations, yet it wasn't until the 1990s that the museum began a process of revamping its exhibits.

Most notably, in 2003 the museum mounted a permanent exhibition on colonialism called *Ooswart!* (*Eastward!*) It contained life-size wax statues depicting racist colonial scenes, such as Dutch officials using a craniometer to measure the heads of Indonesians. While one of the first museum displays of colonialism in the Netherlands, many, including scholar Iris van Huis, have argued that *Ooswart!* doesn't sufficiently problematize such scenes, noting that they lack context on the exploitation and violence of Dutch colonialism as well as the resistance of colonized people.

In 2015, the museum once again reevaluated Eurocentric representations in its galleries by inviting a diverse group of experts—people of color with ties to Dutch colonial history—for a curatorial intervention. Three of the women in the group, Simone Zeefuik, Hodan Warsame, and Tirza Balk, started the Twitter hashtag #DecolonizeTheMuseum, where they expanded the conversation to allow the public to weigh in on what they described as "the everyday effects of colonial thinking" that are reproduced in the museum. As a result of this intervention, museum curators added new texts to existing exhibits, and developed new exhibitions that offered a more critical perspective on Dutch colonial heritage. Today, a

new gallery called *Afterlives of Slavery* greets visitors with large screens showing contemporary Black artists reciting poems on the topics of slavery and resistance.

The exhibit, which successfully connects the colonial past with contemporary manifestations of inequality, is all the more remarkable in the Netherlands, where the topic of racism often elicits aggressive defensiveness. The reductive memory of the Netherlands as a bastion of resistance during the Holocaust overshadows earlier memories of colonial violence, and has fostered a culture in which white Dutch people generally view themselves as tolerant and inclusive.[21]

In Belgium, the Africa Museum (formerly the Royal Museum for Central Africa or RMCA) in Tervuren, just outside of Brussels, has been less successful in addressing the state's colonial crimes. Journalist Adam Hochschild recounts his disbelief, when, during a visit to the museum in 1995, he discovered that a display of Congo flora included a cross-section of a rubber vine with no mention of the millions of Congolese who died as a result of Belgium's brutal rubber trade. He observes "It was as if a museum of Jewish life in Berlin made no reference to the Holocaust."

In 2013, the museum announced that it was closing for a five-year, $73 million decolonial revamp. But there was one major problem: its main building had colonial statues and symbols built into its walls. These racist statues—with names

including "Belgium Brings Civilization to Congo" and "Belgium Brings Security to Congo"—couldn't be touched because they are protected by heritage laws. The museum's solution was to commission a number of artworks to accompany the offensive elements. In one room, which contains the names of Belgians who died in the Congo, Congolese artist Freddy Tsimbas created a shadow projection of the names of Congolese who were brought to the Brussels International Exposition and died there. Another room features a painting by Congolese artist Chéri Samba, titled *Reorganization*, which interrogates the museum's renovation process by depicting one of the museum's most racist statues teetering in the middle of a tug-of-war between museum officials and the Congolese community.

This tug-of-war continues to materialize inside and outside of the museum. From the right, a group of colonial-era veterans has accused the museum of being "*politiquement correct*" and taking part in "Belgium bashing."[22] Many on the left, however, have argued that the museum's renovation didn't go far enough. On the eve of the reopening of the museum in 2018, several young organizers of the anti-racist collective *Kumbuka* published a zine to document their disappointment. One writer, Françoise Vergès, argued in it that the museum's revamp amounts to "apologetic erasure," whereby elements of colonialism are acknowledged, but only as a way to "mask the

foundation of colonialism." Jeanne Coppens, another member, contended that the revamp represented a "false decolonization." By setting up the exhibition as a journey, in which colonialism is a minor blip, the "uninformed white Belgian will exit Leopold II's palace as they would leave the park after a Sunday promenade; no confrontations, uninterrupted."

According to Coppens, a true decolonial museum would be one that oversees the complete repatriation of its holdings. Over 120,000 items in the Africa Museum come from Congo, collected through colonial military-era or missionary campaigns. With these objects returned, the decolonial Africa Museum of the future could instead hold statues of Leopold II and other colonial figures, transforming it into an institution that memorializes colonialism, instead of repackaging it as something more palatable for public consumption.

Those who would like to see this come to fruition face a tough struggle ahead. Over the past decade, Europe has seen the rise of right-wing populism. Even as far-right parties across the continent declare a "Natives First" (aka Whites First) policy that fuels anti-immigrant and anti-Islam rhetoric, these groups attempt to banish the colonization of Native peoples from their memory.

Today, European museums find themselves pushed and pulled between two ideological discourses: a dominant ethnonationalism that presumes a natural division between

"native" Europeans and the "other," versus a postcolonial discourse, in which history is read critically in the context of imperialism and its inherent power dynamics. As museums across Europe scramble to recontextualize their colonial foundations, it remains to be seen which ideology will win out.

Conclusion: "Bloody at Its Very Foundation"

Since the turn towards "new museology" in the 1990s, curators, educators, and audiences alike are rethinking the very idea of the museum. Once seen as a static warehouse of colonial-era collections, the museum is now a democratizing space where community members are invited into decision-making processes. It's a participatory space, where visitors are free to create, share, and connect with each other and with the content on display. And it's an accountable space, responsive to the input and involvement of diverse audiences.

The role of the museum now goes well beyond its traditional role of collecting, exhibiting, and educating. On the African continent, for example, museums increasingly partner with environmental sustainability projects, offer educational programs or vocational training, feed communities through programs that promote local cuisine, and provide opportunities for local craftspeople to sell their work and teach their trade. In some cases, the architectural structure

of the museum is done away with altogether. From a singular building, generally located in an urban capital, museums have been reconceptualized as "living" institutions defined by open-air displays, traveling exhibits, and even the curation of artifacts in people's homes.

Rural museums, such as the BaTonga and Nambya community museums in Zimbabwe, for example, are spaces that both safekeep Indigenous knowledge and promote community development. The key to decolonizing Africa's museums—and perhaps all museums—is reflected best in the words of Joshua Chikozho, the Curator and Site Manager of the BaTonga Community Museum, who argues, "the community *is* the museum."

Perhaps more local institutions are better suited to realize this philosophy. We see this in Britain, for example, where smaller museums have invested in the country's immigrant communities for years. The Walsall Museum and Art Gallery, for example, inaugurated an exhibition in collaboration with the local Sikh community in 1992, which included a wide range of educational and cultural programs that served the direct needs of the population. Similarly, the Museum of the Home (previously the Geffrye Museum), located in the culturally diverse London borough of Hackney, has actively collaborated with Chinese refugees as well as Greek and Turkish Cypriot, Southeast Asian, and Black and African Caribbean

communities.[23] These partnerships have not only resulted in installations that honor the culture and experiences of each population, but also in activities such as cooking, gardening, performance, and educational classes that draw in people who are typically under-represented in museum-going publics.

Such participatory projects are key to democratizing the very notion of museums. On the other hand, we've seen how larger museums have been slow to deconstruct the colonial museology on which they have been based. The British Museum has been accused of holding onto looted objects, promoting colonial stereotypes, and centering "the experiences of white Britishness over the experiences of others," as one critic put it.[24]

Institutions don't tend to change overnight, which is why activists don't wait around for museums to adopt decolonial programs. Since 2017, art historian Alice Procter, for one, has led Uncomfortable Art Tours at six major cultural institutions in London. In these guerrilla-style tours, Procter asks participants to consider how colonialism has ideologically and financially constructed major national collections. Museum staff rarely interrupt her, thanks to her presentation as a "typical young white girl who's an art history student," as she describes herself.

Other decolonial interventions are not so clandestine. Since 2015, the community group Black Youth Project

100 (BYP100) has led a performative "counter-tour" at the AMNH, through which they highlight the legacies of white supremacy in the museum's display and aesthetics. In the Hall of African peoples, for example, they describe the museum's role in the exploitation of Ota Benga, the African who was displayed at the St. Louis Fair. Inspired by this unauthorized action, Decolonize This Place (DTP) began organizing an annual Anti-Columbus Day Tour at the AMNH in 2016 alongside BYP100 and other local activist groups.[25]

During the tour, activist groups speak about the colonial perspectives embedded in the museum's halls, including the continued dehumanization and exotification of non-European cultures. Together, through chants, banners, drumming, and leaflets, the activists send a clear message against the white supremacy and colonial mythology of Columbus Day that continues to manifest in the museum. In one TV report, Marz Saffore, a member of DTP, points out:

> When I'm in this museum, I think of the Black and Brown and Indigenous school children [on field trips]…and they get here and they too find themselves in the shadows of these oppressive monuments. They find themselves staring at their ancestors through glass, whereas the colonizers' ancestors get statues.

One statue that Saffore might have had in mind was that of Theodore Roosevelt, which guards the entrance of the museum. For years, DTP has demanded its removal. The

controversial statue depicts Roosevelt on horseback, flanked by subservient Native American and African figures on foot—a clear display of racial hierarchy. While Roosevelt was a conservationist and patron of the museum, he was also an outspoken advocate for American colonial expansion as well as eugenics.

DTP wasn't the first group to demand that the museum remove the statue. In 1971, Indigenous activists were arrested for covering Roosevelt in red paint. Then in 2017, a group called the Monument Removal Brigade splattered the statue once again. In a statement online, the Brigade declared its philosophy:

> *Now the statue is bleeding. We did not make it bleed. It is bloody at its very foundation.*

> *This is not an act of vandalism. It is a work of public art and an act of applied art criticism.*

> *We have no intent to damage a mere statue.*

> *The true damage lies with patriarchy, white supremacy, and settler-colonialism embodied by the statue.*

> *It is these forms of oppression that must be damaged again and again… until they are damaged out of existence.*

Activists with the Brigade chose not to wait for the museum to remove the statue. Instead, they rendered what they call a "counter-monumental gesture" to symbolically damage

the values the statue represents: genocide, dispossession, and state terror.

The AMNH has not completely ignored protesters' demands. In 2019, the museum mounted an exhibit called "Addressing the Statue," which explored the history of the Roosevelt statue's design and installation. It featured perspectives of various scholars, artists, and visitors to the museum in order to "[promote] dialogue about important issues of race and cultural representation." For many activists, however, it wasn't enough. In June 2020, as Black Lives Matter protests swept the nation, an anonymous individual covered the statue in paint yet again. Finally, the museum was forced to take more drastic action. "In the current moment, it is abundantly clear that this approach [of dialogue] is not sufficient," declared a public staff memo. The Roosevelt statue was finally coming down.

In a public letter, members of DTP welcomed the AMNH's decision, while reminding the city and the museum of their still unfulfilled demands: the renaming of Columbus Day to Indigenous People's Day; repatriating the museum's collection of human remains and sacred objects; convening a public commission to address harmful representations in the museum; and creating a committee to "oversee a decolonization process at all city museums that enjoy subsidies through taxpayer support."

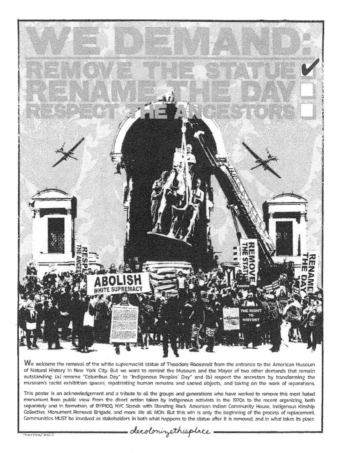

A poster by Decolonize This Place that includes their statement on the removal of the Theodore Roosevelt statue at the AMNH.
Source: Decolonize This Place.

In the past, members of DTP had been invited to closed-door meetings with AMNH curators and officials to discuss these concerns. Partially as a result of these talks, in 2019, the museum added captions on the glass to its diorama depicting the imagined 17th century meeting between Dutch settlers and the Lenape people that I remember seeing as a child. While the original display depicted a neutral "contact zone," the new text asks visitors to "reconsider this scene" and explains how the display "ignores how complex and violent colonization was for Native people." The new wall texts are part of a multi-year, $14.5 million reconstruction of the Northwest Coast Hall.

Is recontextualizing the contact zone sufficient? DTP doesn't think so. In its letter, the group notes that while museum officials may agree that a decolonization process is necessary, activists "feel the oppressive weight of institutional inertia in the room, and the responses are too measured and painfully slow in coming." At the current rate of change, DTP argues, it will take another 50 years to amend all the museum's cultural halls. As Nitasha Dhillon, a core member of DTP explains: "We're talking about changing the entire structure of the institution . . . the entire way the institution functions."

These debates raise larger questions: Is it possible to achieve such structural change through incremental edits to

exhibitions, or must the entire institution be rebuilt within a decolonial framework? Can the museum, as a contact zone, transcend colonial-era dynamics? Or will it continue to superficially adapt itself to function in a neocolonial world?

While it's possible to recognize how initiatives like Kent Monkman's *mistikôsiwak* challenge historic Eurocentrism, we must not move too quickly to celebratory narratives. As we've seen throughout this chapter, doing so risks obscuring persistent asymmetries, appropriations, and biases. When it comes to decolonizing initiatives, we must continue to hold museums accountable. We must continue to ask: Who directs the budget? Whose voices are featured in these exhibits, programs, and collections? To whom do the museum's benefits flow?[26]

These kinds of probing questions must also follow problematic objects once they've been removed from places of prominence. Is it enough to simply move the Roosevelt statue, for instance, in the same way the British Museum has moved Hans Sloane from a heroic plinth into a display case? Will Roosevelt be banished from public view altogether? Or will he, as The Monument Brigade imagines it, molder away as "a ruin in the trash-heap of history" alongside other racist figures like Robert E. Lee and Christopher Columbus? No matter his fate, his empty plinth can serve as a blank slate where new visions of "reparation, freedom, and justice" can be realized.[27]

The work of manifesting these dreams is never over. Activist movements continue to hold museums' feet to the fire and to expand the possibilities for a decolonized world. In the next chapter, we'll see how these same movements have pushed museums to end financial investments in structural injustice.

Chapter 4

FOLLOWING THE MONEY

In 2017, six members of the Huni Kuin, a native people of the Amazon rainforest, gathered inside a multicolored, hand-knotted crocheted tent. One man chanted a traditional song. Another told a story in the Kashinawa language. Outside, well-heeled elites read fragments of poems written on the walls and browsed photo-books of the Huin Kuin in their native land. Those who wandered inside the tent could participate in a simulacrum of a sacred Ayahuasca ceremony and immerse themselves in a "place of sensations, a place of exchange and continuity between people."[1]

This, of course, wasn't a kupixawa, or a traditional meeting place for Indigenous rituals. In fact, it was an installation titled *Um Sagrado Lugar (A Sacred Place)* constructed by Brazilian artist Ernesto Neto for the fifty-seventh Venice Biennale.

While Neto shared authorship of the work with the Huni Kuin people, who willingly traveled to Venice to participate in it, many critics pointed out that the work still framed the Global South as a space of exotic "primitivism" and all too closely resembled the kind of "Native villages" constructed at world's fairs in the nineteenth century.

Zoom out to the Biennale as a whole, and the ghosts of world's fairs come into even sharper focus. While nineteenth century international fairs explicitly "sold" the concept of empire to European and American audiences, the contemporary biennial uses a variety of artistic and experimental spectacles to "sell" concepts of cosmopolitanism and internationalism. This "selling" is quite literal. Neto's installation, for example, was available for purchase: 40 percent of the sale would go to the gallery, 40 percent to the artist, and 20 percent to the Huni Kuin.

This uneven breakdown is reflective of the broader inequalities that plague the Biennale itself. In 2019, Great Britain, once the world's preeminent colonial power, opened its pavilion on top of a hill overlooking the fair's main thoroughfare. Meanwhile, the Venezuela pavilion remained padlocked shut because the government, rocked with political crises, was unable to fund it. In 2017, Kenyan curator Jimmy Ogonga faced a similar situation when he was unable to complete work on his pavilion, even after he had solicited some funding, mostly from private European donors.

At first glance, these variations in scale, budget, and even location perfectly mirror colonial-era power dynamics. But with the rise of non-European economic powers, including China, India, the UAE, and Saudi Arabia, colonial projects are recast through contemporary dynamics of transnational

capital. These days, the powerhouses of the Global South can afford the high rents of the coveted Arsenale section of the Biennale. Some are even flexing their might by literally buying out other countries' pavilions.

In the 2013 and 2015 Venice Biennales, almost all of the artists featured in the Kenyan pavilion were Chinese—"a frightening manifestation of neocolonialism vulgarly presented as multiculturalism," as one critic put it.[2] It wasn't, after all, the first Chinese encroachment into Kenyan affairs. Many Kenyan artists have renounced China's expansive presence in Africa, claiming it has brought about a wave of racism and discrimination against African citizens, not to mention the plundering of the continent's natural resources. Several Kenyan artists have even incorporated this critique into their work. Michael Soi's series "Shame in Venice," for example, is a sharp critique of China's deepening reach into Kenyan affairs, which he sees as stifling to the local art scene.

While colonialism may be a thing of the past, a capitalist system of global circulation—of goods, products, and people—continues to reproduce inequality. In order to decolonize the museum as it exists today, we must recognize the role that cultural institutions play in perpetuating and deepening these unequal dynamics. In this chapter, I'll examine how the rise of neoliberalism has prompted an increased "market

orientation" within the cultural sphere. Museums have looked to survive austerity in this era by rendering themselves as global brands, while national and city governments, simultaneously, have used museums themselves as branding tools to revitalize their image. These trends have prompted a wave of institutional critique—from artists, scholars, and activists alike—that continues to challenge systems of power, influence, and exploitation within the cultural realm.

Competition and Corporate Power

Competition. Branding. Investment. These are words that are generally associated with our market-driven world, where democratic choice is framed through purchasing power and individual competitiveness is prized over the collective good. These are also words that increasingly define the museum world. As public funding to the arts is slashed, museums and other arts organizations have begun to act more and more like private businesses, attempting to attract "customers" through market orientation and branding strategies.

As enterprises, museums are forced to draw upon a diverse range of income streams, incorporating high-end restaurants, cafes, and gift shops into their spaces, and mounting blockbuster exhibits designed to attract wide audiences. Sociologist Nick Prior describes the modus operandi of contemporary museums as one driven by the "soft" values of "consumption,

distraction, and spectacle." Thomas Krens, the director of the Guggenheim Foundation between 1988 and 2008, pioneered the concept of the museum as a commercial entity by launching exhibits such as *The Art of the Motorcycle* in 1998 (sponsored by BMW) and a Giorgio Armani exhibition in 2000. The former included a BMW motorcycle on display in the museum lobby; the latter turned the Guggenheim into a department store. Corporate art sponsorship is now a staple that links cultural institutions with multinational enterprises—a relationship that reflects the corporatization of society more broadly.

It doesn't matter whether a museum is publicly funded, privately funded, or some combination of both. In all three cases, a well-connected financier can contribute their private art collection to receive significant tax deductibles, or can donate their way onto a seat on the board. Often, these corporate sponsors or trustees do not reflect the ethical values that museums claim to uphold.

In December 2018, news broke that Warren Kanders, the vice-chairman of the Whitney Museum board, owns a company that makes tear gas, which has been used along the U.S.-Mexico border against migrants and in Gaza against protesters. In response, more than 100 members of the Whitney's staff demanded that Kanders be removed from his position, and a number of artists and activists staged

visible interventions to illuminate the connections between politically marginalized communities and violent corporate practices.

Decolonize This Place (DTP), for example, plastered protest art throughout New York City's subway platforms that imitated the pop art of Andy Warhol (Kanders was a significant contributor to the museum's 2018-2019 Warhol exhibit). One poster featured rows of tear gas canisters mimicking Warhol's pop art Campbell's soup cans; others layered images of violent conflict and catastrophe at Standing Rock and the Tijuana border on top of promotional posters for the Warhol exhibit. In early December, protesters from DTP began gathering in the lobby of the museum in a series of performative demonstrations, where sage was burned to mimic tear gas. In a letter posted to Facebook, the group made its demand clear: Kanders needed to be removed from the board of the museum. Soon after, artists began withdrawing their work from the Whitney Biennial. In response to mounting pressure, Kanders finally stepped down on June 25, 2019.

Much like the announcement that the Roosevelt statue would be finally removed from AMNH, DTP welcomed Kander's resignation while acknowledging that much work remains to be done. In a statement, the group declared that Kanders is only the tip of the iceberg of "capitalism,

patriarchy and white supremacy" that continues to prop up cultural institutions.

That iceberg runs deep—but so does the resistance to it. In 2019, thirty-seven participating artists in MoMA PS1's exhibition *Theater of Operations: The Gulf Wars 1991-2011*, signed an open letter calling for the museum to separate itself from trustees with ties to both private prisons as well as the defense contractor Constellis (formerly Blackwater). One of the signatories, artist Michael Rakowitz, requested that his video work—on display in the exhibit—be literally paused in protest of what he called "toxic philanthropy." Another artist, Ali Yass, planned a guerrilla action in which he asked protesters to tear down his own work from the museum's walls.

Some artists build their protest against the museum-military entanglement directly into their work. In her 2013 piece "Is the Museum a Battlefield?" German artist Hito Steyerl delivers a performative lecture about her investigation into the 1998 death of her friend Andrea Wolf, a Kurdish Workers Party (PKK) fighter. She traces the machine-gun bullet that killed her friend in southern Turkey to its producer, Lockheed Martin—a major sponsor of the Istanbul Biennial where she delivered her lecture. In the lecture, she describes a "sort of weird feedback loop" whereby the bullet flies in a circle from battlefield to museum and then back again, "killing a lot of people in its way."

Bullets aren't the only noxious product circling through this deadly feedback loop. Consider the Met, where one of the biggest attractions, the Temple of Dendur, sits in the Sackler Wing. The Sackler family has faced backlash over the role of their company, Purdue Pharma, in perpetuating and profiting from the opioid crisis that has killed thousands of people. One of those victims was Mariah Lotti, who developed an opioid addiction and died from an overdose at the age of nineteen. Today, users of the augmented reality "Mariah App" can use their smartphone cameras to transform the Met's Sackler Wing into a memorial site for the teenager and others who have lost their lives to the epidemic.

In New York City alone, in addition to the Met, the Sacklers have given substantial gifts to the Guggenheim, the AMNH, and the New York Academy of Sciences. Activist groups, most notably P.A.I.N. (Prescription Addiction Intervention Now) founded by photographer Nan Goldin, have led a number of highly visible actions, using the unique interior structure of the Guggenheim as a performative canvas to stage demonstrations. The group has orchestrated die-ins in the lobby, while dropping banners and leaflets from the iconic spiral atrium. In 2019, the Guggenheim and the Met finally announced that they would stop accepting gifts from members of the Sackler family.

The story of ethical dilemmas around corporate sponsorship in the art world would not be complete without mentioning the role of oil companies. Members of Liberate Tate have staged dozens of actions to urge the museum to drop its British Petroleum (BP) sponsorship. These guerrilla performances have included a miniature oil spill at the Tate's summer gala ("License to Spill," 2010); the instillation of a fifty-four-foot-long wind turbine blade in the museum's Turbine Hall ("The Gift," 2010); and a recreation of Malevich's iconic Black Square as a symbol of the black stain of oil sponsorship on cultural institutions ("Hidden Figures," 2014). In 2016, BP finally ended its twenty-six-year relationship with the Tate.

The struggle to remove fossil fuel funding from museums continues. Even as museums have made public efforts to reduce their carbon footprints through "greening" initiatives, many continue to depend on some of the most environmentally destructive corporations in the world for financial support. On its website, the British Museum thanks BP for supporting numerous exhibits and the museum's lecture theatre. An activist group calling itself BP or Not BP? has organized dozens of actions inside and outside of BP-supported cultural institutions in Britain—what they call "disobedient theatre." The purpose, in their own words, is to make these museums "profoundly uncomfortable with the noxious,

treach'rous [sic], belching oily rogue they have chosen as a partner."

Sometimes these corporate sponsors are not so explicitly "oily." On October 21, 2020, BP or Not BP crashed the British Museum's press preview for the exhibit *Arctic: Culture and Climate* by holding a socially distanced protest in the lobby. While the exhibition is indeed cutting edge in its centering of Indigenous people's perspectives on climate change, it is sponsored by Citibank—the world's third-largest funder of fossil fuels.

Direct actions against oil interests in the art world go back decades. In 1988, more than a dozen representatives from First Nations across Canada gathered to voice opposition to the opening of the exhibit *The Spirit Sings* in Calgary, which coincided with the occasion of the winter Olympics. In addition to the lack of Indigenous curatorial input and the display of disputed sacred objects, the exhibit came under fire for its corporate sponsor: Shell Canada. Since the 1970s, drilling in northern Alberta by Shell has destroyed the culture and livelihoods of the Lubicon Lake Cree people. Three days before *The Spirit Sings* opened to the public, Indigenous artist Rebecca Belmore carried out a performance titled *Artifact #671B*, in which she sat inside a museum case in below freezing weather, her body tagged like an artifact with Shell's corporate logo.

Performances like Belmore's expose the duplicity of companies that use the arts as a smoke screen from political scrutiny. A public relations executive at Mobil has referred to the company's support of the arts "a good will umbrella," while his colleague at Exxon has referred to it as a "social lubricant."[3] David H. Koch, dubbed "the ultimate climate change denier" by the *New York Times*, single-handedly donated $65 million to the Met to redesign and renovate a plaza in his name.

Museums have long explicitly offered their services to corporations or philanthropists in need of a branding make-over. In a 1984 pamphlet titled "The Business Behind Art Knows the Art of Good Business," the Met assures prospective sponsors that arts sponsorship can provide a "creative and cost-effective answer to a specific marketing objective, particularly where international, governmental or consumer relations may be a fundamental concern."

Visual artist Hans Haacke plays with the title of that leaflet in his 2014 piece "The Business Behind Art Knows the Art of the Koch Brothers," which directly confronts the role of ethically dubious corporate sponsorship in the arts. In it, giant $100 bills cascade from a framed photograph of the Met's Koch Plaza. It wasn't the first time that Haacke interrogated the links between art, money, and power. His 1985 work, *MetroMobiltan*, criticized the

relationship between the Met and its corporate sponsor Mobil Corporation (now ExxonMobil), as well as Mobil's ties to the South African apartheid regime. It consists of three banners hanging from what looks like the institution's façade. Two banners include statements from the Mobil Corporation about its involvement in South Africa. A third announces a recent exhibit of Nigerian artifacts at the Met sponsored by Mobil. Behind the banners is a photomural depicting a funeral for Black victims of South African apartheid. The juxtaposition implies that the company's sponsorship of art from one African country intends to cancel out its unethical doings in another. (As we've seen, exhibits of African artifacts in museums like the Met come with their own host of ethical anxieties).

In 2019, the New Museum presented a major retrospective of Haacke's work, and found itself caught in the kind of ethical double bind that Haacke loves to expose. On the eve of the retrospective opening, as the museum patted itself on the back for being one of the only American institutions that would welcome such controversial work, the museum remained locked in a bitter contract fight with its newly unionized workers who demanded better pay and healthcare. If Haacke's life work challenges corporations that use the arts to rebrand their image, the opening of his show at the New Museum during the peak of a labor

dispute exposes how even the most critical artwork can be used by museums as a progressive cover-up for their own predatory practices.

In his 1974 piece "All the 'Art' That's Fit to Show," Haacke argued that strategies used to expose the "economic and political underpinnings" of cultural institutions are "liable to be considered 'works of art' in their own right." Under this logic, much of the political work being done by artists, art workers, and museum-going publics today—including at the New Museum—falls under the banner of "art." Consider the anonymous salary-sharing spreadsheet created by art workers in New York to increase transparency around pay, or the calculator tool created by Working Artists and the Great Economy (W.A.G.E.) used to help artists determine equitable compensation for their labor. These tools have been instrumental in sparking discussion around worker compensation and management power.

Instead of only highlighting connections between "money, state and culture" at the top, as Haacke does so well, we must also look towards grassroots practices like these, which build relationships between those on the bottom. We must pay attention to the struggles of museum workers who are underpaid and exhausted, even as their employers capitalize on the progressive visions of artists they exhibit. Decolonizing the museum goes beyond interrogating colonial

histories and collections; it also forces a radical redistribution of social, cultural, and financial capital in the art world.

To decolonize is to unsettle. Remember the words of Fanon in regard to capitalist powers: "*They must pay.*"

Urban Regeneration

Part of reckoning with inequality in the art economy is recognizing the role that museums play in gentrification. Another irony haunted Haacke's retrospective at the New Museum. Haacke's most renowned work, "Shapolsky et al. Manhattan Real Estate Holdings as of May 1971" (1971), shines a light on exploitative real estate holdings. Meanwhile, the New Museum sits in a $50 million building in SoHo, a neighborhood which it helped gentrify. By now, this is a familiar phenomenon. David Berliner, former CEO of a real estate company responsible for displacing hundreds of local residents in Brooklyn, serves on the board of the Brooklyn Museum. The MoMA is also knee-deep in real estate projects, having erected a luxury apartment complex over its own building and demolished neighboring buildings to expand its hold on Midtown Manhattan.

Museums don't transform neighborhoods alone. Often, cities pour resources into cultural institutions as a means to positively alter their own public image while "regenerating" urban areas. A 2018 guide for local governments,

communities, and museums written by ICOM and the inter-governmental OECD (Organization for Economic Co-operation and Development) advocates for the renovation and construction of museums as a way to "bring new life into areas losing their social dynamism and traditional economic base." This "new life"—which often manifests itself as "creative districts" that cater to the so-called "creative class"—kickstarts the gentrification of a neighborhood. More and more, urban renewal results in urban removal.

Affected communities are well aware of this dynamic. That's why, in 2017, New York City-based collective Chinatown Art Brigade (CAB) protested an exhibit at the James Cohan gallery in which artist Omer Fast constructed a caricature of a derelict Chinatown storefront. While Fast intended for his work to be read as a commentary on the demographic shifts in the neighborhood, CAB saw the work as racist "poverty porn." Beyond harmful stereotypes, the group's grievances encompassed larger issues of gentrification in marginalized communities, specifically the role that galleries like James Cohan have played in displacing small businesses and tenants in the neighborhood. ("Gentrifiers go away, Chinatown is here to stay!" was one popular protest chant).

Residents of the Latinx neighborhood of Boyle Heights in Los Angeles make up another community fighting

"artwashing" as a tool of mass displacement. For years, community activist groups like Defend Boyle Heights and BHAAD (Boyle Heights Alliance Against Artwashing and Displacement) have assembled to oppose the influx of gallery spaces, which they see as the first step in a wave of development that would inevitably hike up rents and privatize public housing.

Indeed, developers, local elected officials, and city administrations have weaponized the arts to advance gentrification, all in the name of invigorating "vibrant creative and cultural quarters," as the ICOM/OECD guide puts it. These actors also invest in the arts as a way to add brand value to a specific location. Just look at the Guggenheim in Bilbao. Located in the north of Spain in the Basque country, Bilbao was perceived as a "decaying backwater" when its economy fell into sharp decline after the death of Franco in 1975. To shift the city's image, the Basque government paid the Guggenheim Foundation to erect a museum in the city's port area. Guggenheim Bilboa, with its iconic Frank Gehry design, has become exemplary of how a global cultural franchise can kickstart a host city's economy. It has also led to the rapid gentrification of the surrounding neighborhoods. The local government of Bilbao has taken an active role in attracting new residents and private investors to the area, which in turn has driven

up housing prices and accentuated existing social and spatial inequalities.

For this reason, communities often resist the arrival of a big hot global art brand on their shores. Plans for a Guggenheim in Rio de Janeiro were squashed in 2003 due to local outrage over the allocation of public funds to a foreign brand at the expense of more pressing needs like hospitals, schools, and infrastructure. Groups in the Brazilian cultural sector also demanded a greater investment in local institutions and artists. They saw the Guggenheim as a neo-colonial invasion of Brazil's art world—an unwanted megabrand along the lines of Starbucks and McDonald's.

Nation Branding

In an increasingly globalized world, many countries are facing an identity crisis. One consequence has been the rise of reactionary populism, which seeks a return to supposed national glory. Another reaction is nation branding, which renders national identity as a marketable product. Culture has become an important currency within this marketplace of national identities.

Those who sign on to the cultural boycott of Israel understand this. The Boycott, Divestment, and Sanction (BDS) campaign was founded in 2005 in direct response to a "Brand Israel" PR initiative launched by the Israeli Ministry

of Foreign Affairs to shift the image of the country. As Arye Mekel, the deputy director general for cultural affairs in the Israeli foreign ministry explained it: "We will send well-known novelists and writers overseas, theater companies, exhibits. This way you show Israel's prettier face, so we are not thought of purely in the context of war." Increasingly, artists are actively rejecting this project, choosing to withdraw their creative energies from any international programs funded by or aligned with Israeli state agencies.

In recent years, the cultural boycott has forced a number of artists and art institutions to awkwardly cling to "liberal tenets" like free speech and intercultural dialogue in order to avoid participating in more radical—and uncomfortable— forms of justice.[4] For example, in 2014, more than 100 signatories in academia and culture wrote a public letter calling on artists in New York-based public art nonprofit Creative Time's traveling exhibition *Living as Form* to withdraw their work. Unbeknownst to the participating artists, the show had been touring in Israel for six months—including an appearance at an Israeli university with extensive ties to the country's military industry. In response, Creative Time apologized to the artists and came out against the cultural boycott, citing the "need for a nuanced response to complex issues."

But for many, the military occupation of Palestinian land is not a complicated matter. And, as art critic Kareem Estefan

argues, rather than shutting down dialogue, boycotts have the potential to "generate challenging and productive discussions." Artists who leverage the power of boycott can reveal the tension between the progressive rhetoric of art institutions like Creative Time and the politics of nation branding, which serves to gloss over human rights abuses through a progressive facade.

Israel isn't the only country to trade in this kind of deception. Perhaps one of the most prominent examples of nation branding is the Louvre in Abu Dhabi, which opened its doors in 2017 on Saadiyat Island ("Happiness Island" in Arabic)—a twenty-seven-billion-dollar cultural district that includes luxury hotels, a boutique shopping quarter, an NYU portal campus, and eight museums, including the Louvre and the Guggenheim. The museum's building, designed by French "starchitect" Jean Nouvel, cost an estimated $108 million to build; Abu Dhabi reportedly paid $525 million to France to use the "Louvre" name.

The initiative was largely symbiotic. For its part, the French government took the opportunity to extend its own cultural "brand" while generating economic and diplomatic clout in the Gulf. In return, Abu Dhabi has used the Louvre as a symbol of its own status as a cultural powerhouse, with Mohammed bin Zayed al Nahyan, the crown prince, positioning himself as a "patron of a modern Arab Renaissance."

By partnering with the Louvre, Abu Dhabi is attempting to achieve an international reputation as a cultural hub rivaling Paris, London and New York.

Despite being heralded as a "secular cosmopolitan space" comparable with Western "universal" museums, [5] the "Louvre in the desert" has been widely criticized. Some say that the institution veers into the realm of cultural imperialism, with French tastes dictating the artworks on display, with no attention given to a more localized art scene.[6] Others have voiced concern that the museum will censor potentially sensitive or explicit artwork. The loudest critique by far, however, concerns the inhumane treatment of migrant workers from south and south-east Asia on the building site. The same critique extends to the construction of NYU's portal campus as well as Guggenheim Abu Dhabi. Human Rights Watch has pointed to a range of violations by employers, including unsafe working conditions (that have resulted in deaths), passport confiscation, squalid living conditions, and underpayment or wage theft. The problem is structural: The Gulf's kafala (sponsorship) labor system gives employers substantial control over migrant workers and facilitates exploitation and slave labor.

In 2011, a group of artists founded the Gulf Labor Coalition (GLC) to pressure the Guggenheim to redress these dire conditions. The group's tactics include direct negotiations with the museum, research trips to Gulf construction

sites, and yes, boycotts, in which artists have pledged to withhold their artwork from acquisition until labor conditions are improved. Such an action amounts to what Kuba Szreder calls a "productive withdrawal," a tactic used across industries whereby workers withhold their labor and ideas to ensure that business as usual cannot continue. It's the opposite approach to that taken by architect Zaha Hadid, who, when questioned about the death of 500 Indian and 382 Nepalese migrant workers who constructed her al-Wakrah stadium in Qatar, said: "It's not my duty as an architect to look at it ... I cannot do anything about it because I have no power to do anything about it."

While Hadid's remarks erase the existence of those who have erected her iconic global architecture, other groups, like Who Builds Your Architecture? (WBYA?) have assembled architects from all over the world to dive head-first into the ethics of migrant labor. In their 2016 exhibition at the Istanbul Design Biennale, WBYA? installed a "workroom" that mapped the vast network of migrant workers needed to construct a fictional building project. A wall text for the piece asked visitors: "How can we expand the definition of sustainable architecture to include sustaining human life?"

In 2014, a new faction of the GLC called Global Ultra-Luxury Faction (G.U.L.F.), began initiating more direct confrontations with the museum, including dropping

"1%" bills into the rotunda, staging sit-ins, and project-
ing phrases like "Art Is Not A Luxury" onto the building's
facade. The group, made up of artists, academics, and activ-
ists, believe that putting pressure on global art institutions
like the Guggenheim and the Louvre should be understood
as part of a larger struggle against "global ultra luxury econ-
omy, underpinned by empire and white supremacy." During
the 2015 Venice Biennale, G.U.L.F joined forces with Gulf
Labor to occupy the dock landing of the Peggy Guggenheim
Collection. The event was a continuation of previous
actions—all intended to amplify labor issues in the Persian
Gulf and South Asia.

In contrast with Hadid's hands-off approach, G.U.L.F.
views labor struggles through a transnational lens, declaring
in An Address to Cultural Workers: "We do not imagine the
workers as victims to be saved, but rather as fellow human
beings whose freedom is bound up with our own. We have
connected with their struggle because our own dignity depends
on it. Our liberation is either collective or it is nonexistent."

Conclusion: "We are here because you were there"

Even as ICOM's new definition reimagines museums as
"democratizing, inclusive, and polyphonic spaces" which
contribute to human dignity and social justice, a more
sinister reality continues to lurk in the shadows. The social

dynamics on Abu Dhabi's "Happiness Island" is an unfortunate Exhibit A. One only need travel a few miles from the fancy lace dome atop Jean Nouvel's Louvre to find the squalid quarters where more than a dozen migrant workers who helped build the museum share living space of barely 200 square feet. In a digital collage, artist Janet Koenig brings together these interconnected realities, imagining what it would look like for the museum's inaugural exhibit to feature these often invisible workers.

Insisting on these interconnections is not just a hypothetical experiment, as G.U.L.F. has made clear. It is, instead, an integral part of decolonial solidarity. As museum goers and consumers of culture, we must hold onto this sense of interconnectedness that has always existed between the institutions that we hold dear and the colonial legacies that have shaped the way we perceive the world. "Put simply, to decolonize is to remember," argues Sumaya Kassim. "It is to say: we have met before. That, we are *here* because you were *there*, and it is to recalibrate how we interact with each other with that earlier meeting in mind."[7] If a colonial mindset is about forgetting the past, decolonization must involve a forceful remembrance.

This remembrance begins as a historical reckoning—a recognition that enslavement and colonial exploitation have shaped our modern world. As spaces where our memories live and our consciousness is shaped—and, indeed, where many

Janet Koenig, "2015: Grand Opening of the Louvre Abu Dhabi," digital collage (2014). Source: Gulf Labor Artist Coalition.

stolen artifacts still reside— museums are crucial to this project. My hope is that museums will eagerly accept this responsibility, and that, as a result, the next generation of American school children won't grow up seeing Native Americans as extinct people behind glass as I once did, but rather as contemporary peoples with thriving, dynamic cultures. If they are slow to take up this task, I expect that activists and artists—either through the paintbrush or the strategically splashed paint bucket—will remind them to pick up the pace.

But rewriting narratives is only a first step. It must be swiftly accompanied by repatriation and reparations. By helping to reunite cultural objects or human remains with Indigenous community members, museums can play a role in the preservation and healing of living heritage and contemporary cultural practices. If, as Adam Hochschild writes, "a good museum should make you start looking at the world beyond its walls with new eyes," a decolonized museum should offer an expansive notion of justice that transcends the walls of their physical spaces. Institutions committed to decolonization should advocate for the return of Indigenous land and life and the revitalization of Indigenous knowledge systems. They should call for doing away with racist anti-immigrant policies that deprive people of human rights. And they should radically rethink the neoliberal structures that keep the Global South in a state of poverty.

These actions may seem to some beyond the scope or mission of a modern museum. But as long as imperialist interests—including the security-industrial complex and extractive industries—continue to shape the cultural institutions we hold dear, they cannot simply be ignored. To decolonize is to recognize how the world shapes our museums, and how museums shape our world—and to address the unjust core that unites them.

By now, we have moved well beyond the question at the center of ICOM's contentious debate surrounding the definition of museums: Should they have an ideological perspective, or present a facade of neutrality? Today, that facade is beginning to crumble. Its complete destruction is our ongoing project. Our reward for getting it right is nothing less than liberation for us all.

EPILOGUE

Since I finished writing this book in April 2021, a *lot* has happened in the museum world.

In November 2021, after years of foot-dragging, the French legislature passed a landmark bill that would allow for the restitution of twenty-six looted artifacts to Benin and Senegal. The items are on track to be displayed at a new museum at the palace in Abomey, which is currently being restored with French funding.

Other museums across Europe have made similar moves. The Dutch minister of culture drew up an official plan to return objects in the national collection that were stolen from former Dutch colonies. Germany set out a plan to return over 1,000 Benin Bronzes. Belgium's Africa Museum announced that it was embarking on a multi-year process of returning stolen art to the Democratic Republic of Congo.

In the U.S., public protest has forced museums to confront their colonial histories and their contemporary connections to destructive industries. The Smithsonian Institution's National Museum of African Art removed a number of

Benin Bronzes from display, and sixteen are now being considered for repatriation to Nigeria. In June, the Met began facilitating the return of two brass plaques from the Court of Benin, which will likely be displayed in the Edo Museum of West African Art in Benin City slated to open in 2025. Six months later, the Met announced that it would drop the infamous Sackler name from its exhibit halls and no longer receive gifts from the family most closely associated with the opioid crisis.

The barrage of headlines may give the impression that we have reached a tipping point, and that museums have collectively begun the process of decolonization. But the fight for justice is far from over. While many museums have been forced to wake up from their slumber, and many have attempted to make amends for their past crimes, some definitely cling to stolen objects and regressive practices. Hundreds of looted works remain in Western museums. Monuments to slavery and colonial violence still stand in public places. The protests continue.

It is my expectation—and my hope—that this book will grow increasingly outdated. The alarm bells of public scrutiny ring louder each day, inspiring new developments in the history of museum decolonization. Long may it continue.

<div style="text-align: right">

Shimrit Lee

February 2022

</div>

ACKNOWLEDGEMENTS

This book is about those who for decades have imagined, demanded, and created more liberatory cultural spaces. I am indebted to activist and artist groups—including Strike MoMa, Decolonize This Place, and MTL Collective, among others—who have worked tirelessly to dismantle the art world's relationship to capitalism, imperialism, and white supremacy, specifically in New York City, the occupied Leni Lenape territory where I wrote this book. Their work— and that of generations of artists, critics, and curators who have come before them to activate the museum as a site of struggle—provide powerful models of decolonization in practice.

Special thanks must be offered to Bhakti Shringarpure for trusting me with this ambitious project, putting up with all sorts of delays, and offering endlessly inspiring insights throughout the process. This project would not be possible without her visionary thinking. Thanks also goes to John Oakes of OR Books and curator Carin Kuoni who both looked over the manuscript with a keen eye. I would also

like to thank Eve Mackey and Poul Otto Nielsen for their consultation.

Writing a book can be a frustrating and lonely endeavor, especially when compounded by a global pandemic. I am grateful to innumerable friends and colleagues for conversations, virtual gatherings, and learning opportunities that pushed me to think in more critical and expansive ways. Many thanks to my students at the Brooklyn Institute for Social Research in courses I taught on "Museums and Empire" and "War and Visual Culture;" my former academic advisors at New York University, Ella Shohat, Helga Tawil-Souri, and Aslı Iğsız; and my curatorial co-conspirators Nataša Prljević and Josh Nierodzinski of the HEKLER art collective.

Finally, I am grateful for the support and care of my family and friends: Charlotte and Arthur Stril, Jennifer Hilguard, Amanda Knudsen, Karl Sluis, Noor Chadha, John Liu, Ashna Ali, Egina Manachova, Ben Goldstein, Tal Lee, Sam Kopansky, Caleb Teicher, Aria Roach, Jenna Spitz, Arielle Milkman, Hannah Scott Deuchar, Eva Schreiner, Caroline Parker, Anna Simone Reumert, Camila Schaulsohn, Kelley O'Dell, Maggie Sager, Kristina Giddens, Shima Houshyar, Ora Batashvili, Jamie Berger, Taylor Ford, Shelly Ronen, David Backer, Ginger Moore, Haley Weiss, Sepehr Makaremi, Dena A Al-Adeeb, Hồng-An Trương, Farideh Sakhaeifar, Isabella Katrina Litke, Rashmi Viswanathan, and

Maysam Taher, among many others. Thanks to my parents Caroline and Edward Lee and my in-laws Marni LaRose and Kenny Karen for their unconditional love. Finally, I wish to thank my life partner and best friend Jordan Teicher for his endless care work, belief in my intellectual and professional ambitions, and constant willingness to read and edit what I produce.

Decolonize Museums is the product of an extended and ongoing global conversation. The book synthesizes and builds upon a half-century of radical scholarship from academics and journalists in the fields of art history, visual culture, anthropology, postcolonial studies, critical race theory, and many, many more. I urge my readers to browse through the bibliography at the end of the book to continue exploring the wealth of literature that has greatly informed my own writing and thinking.

BIBLIOGRAPHY

29th Congress, Sess 1. "Amendment to the Bill (H.R. 5) to Establish the Smithsonian Institute for the Increase and Diffusion of Knowledge." Smithsonian Institution Archives, April 21, 1846. https://siarchives.si.edu/collections/siris_sic_5094.

BP or not BP? "About," March 18, 2012. https://bp-or-not-bp.org/about/.

Abay, Nigussu Mekonnen. "Stakeholder Engagement at the 'National Museum of Ethiopia.'" Addis Ababa University, 2016.

Abu-Lughod, Lila. "Imagining Palestine's Alter-Natives: Settler Colonialism and Museum Politics." *Critical Inquiry* 47, no. 1 (September 1, 2020): 1–27.

Forbes. "Africa's 40 Wealthiest People," November 14, 2011. https://www.forbes.com/pictures/54f4e71dda47a54de8245b37/alami-lazraq/.

Akinwotu, Emmanuel. "Nigerian Scholar Calls for Halt to Auction of Sacred Igbo Artworks." *The Guardian*, June 21, 2020, sec. World news. https://www.theguardian.com/world/2020/jun/21/nigeria-igbo-sacred-artworks-sculpture-christies-paris.

Aldrich, Robert. "Colonial Museums in a Postcolonial Europe." African and Black Diaspora: An International Journal 2, no. 2 (July 1, 2009): 137–56.

National Museum of the American Indian. "Americans (2018)," 2018. https://americanindian.si.edu/americans/#.

Anderson, Martha G., and Lisa Aronson, eds. African Photographer J. A. Green: Reimagining the Indigenous and the Colonial. Illustrated Edition. Bloomington, Indiana: Indiana University Press, 2017.

Angeleti, Gabriella. "Native American Group Denounces Met's Exhibition of Indigenous Objects." The Art Newspaper, November 6, 2018. http://www.theartnewspaper.com/news/native-american-group-denounces-met-s-exhibition-of-indigenous-objects.

Anjos, Moacir dos, Philip Ursprung, Ernesto Neto, and Ralph Rugoff. Ernesto Neto: The Edges of the World. Edited by Cliff Lauson. London: New York: Hayward Gallery Publishing, 2010.

Appiah, Kwame Anthony. Cosmopolitanism: Ethics in a World of Strangers. W.W. Norton & Co, 2007.

Asher-Greve, Julia M. "Gertrude L. Bell (1868–1926)." In *Breaking Ground: Pioneering Women Archaeologists*, edited by Getzel M. Cohen and Martha Sharp Joukowsky, Illustrated edition., 142–97. Ann Arbor: University of Michigan Press, 2006.

Asquith, Wendy. "The Art of Postcolonial Politics in the Age of Empire: Haiti's Object Lesson at the World's Columbian Exposition." *Historical Research* 91, no. 253 (2018): 528–53.

Atkinson, Henry. "The Meanings and Values of Repatriation." In The Long Way Home, edited by Paul Turnbull and Michael Pickering, 1st ed., 15–19. The Meaning and Values of Repatriation. Berghahn Books, 2010.

Azimi, Negar. "The Gulf Art War." The New Yorker, December 12, 2016. https://www.newyorker.com/magazine/2016/12/19/the-gulf-art-war.

Azoulay, Ariella. Potential History: Unlearning Imperialism. Verso Books, 2019.

Ba, Oumar. "Should Africans Care for Emmanuel Macron's 'Africa Speech' in Ouagadougou?" Africa is a Country, November 29, 2017. https://africasacountry.com/2017/11/should-africans-care-for-emmanuel-macrons-africa-speech-in-ouagadougou.

Baden-Powell, Robert Stephenson Smyth. The Downfall of Prempeh. Adamant Media Corporation, 1896.

Bakare, Lanre. "University of Aberdeen to Return Pillaged Benin Bronze to Nigeria." the Guardian, March 25, 2021. http://www.theguardian.com/world/2021/mar/25/university-of-aberdeen-to-return-pillaged-benin-bronze-to-nigeria.

Barghouti, Omar. "The Cultural Boycott: Israel vs. South Africa." In *The Case for Sanctions Against Israel*, edited by Audrea Lim, 25–38. Verso Books, 2012.

Barringer, Tim. "The South Kensington Museum and the Colonial Project." In Colonialism and the Object: Empire, Material Culture and the Museum, edited by Tom Flynn and Tim Barringer, 1 edition. London; New York: Routledge, 1998.

Batty, David, and Glenn Carrick. "In Abu Dhabi, They Call It Happiness Island. But for the Migrant Workers, It Is a Place of Misery." The Guardian, December 22, 2013, sec. World news. https://www.theguardian.com/world/2013/dec/22/abu-dhabi-happiness-island-misery.

Bayryamali, Bayryam Mustafa. "Addressing the British Museum's Colonial History and Hollow Solidarity With Black Lives." Hyperallergic, June 16, 2020. https://hyperallergic.com/570591/letter-to-british-museum-hartwig-fischer/.

Bell, Gertrude. "Letters," March 6, 1924. Gertrude Bell Archive, Newcastle University. http://www.gerty.ncl.ac.uk/letter_details.php?letter_id=690.

Bellagamba, Alice. "Back to the Land of Roots. African American Tourism and the Cultural Heritage of the River Gambia." *Cahiers d'études Africaines* 49, no. 193–194 (June 20, 2009): 453–76.

Bennett, Tony. The Birth of the Museum: History, Theory, Politics. Routledge, 2013.

Bernhardsson, Magnus T. *Gertrude Bell and the Antiquities Law of Iraq. Gertrude Bell and Iraq*. British Academy, n.d.

Bishara, Hakim. "An Augmented Reality App Connects the Life of an Opioid Victim to the Met Museum's Sackler Wing." Hyperallergic, October 27, 2020. https://hyperallergic.com/592739/mariah-app-metropolitan-museum/.

————. "In Letter to MoMA, 37 Artists in Gulf Wars Exhibition Target Trustees." Hyperallergic, January 14, 2020. https://hyperallergic.com/537333/in-letter-to-moma-37-artists-in-gulf-wars-exhibition-target-trustees/.

————. "PAIN Sackler Storms Guggenheim and Metropolitan Museums
for Financial Ties to Opioid Manufacturers." Hyperallergic,
February 10, 2019. https://hyperallergic.com/484109/pain-sackler-
storms-guggenheim-and-metropolitan-museums-for-financial-ties-
to-opioid-manufacturers/.

————. "Protesters Occupy MoMA PS1, Calling Museum 'Complicit
in Global Violence.'" Hyperallergic, March 2, 2020. https://
hyperallergic.com/545525/protesters-occupy-moma-ps1-calling-
museum-complicit-in-global-violence/.

Boas, Franz. "Some Principles of Museum Administration." Science 25,
no. 650 (1907): 921–33.

Boast, Robin. "Neocolonial Collaboration: Museum as Contact Zone
Revisited." Museum Anthropology 34, no. 1 (2011): 56–70.

Bogdanos, Matthew. "The Casualties of War: The Truth about the Iraq
Museum." American Journal of Archaeology 109, no. 3 (2005): 477–526.

Boucher, Brian. "Artist Michael Rakowitz Calls for MoMA PS1 to
Literally Pause His Video in Protest of a Board Member's Ties to
Arms and Prisons." artnet News, December 2, 2019. https://news.
artnet.com/art-world/michael-rakowitz-moma-ps1-protest-1720221.

Boucher, Brian. "While Installing Her Show at a Canadian Museum,
an Artist Discovered a Looted Statue in the Collection. Now, It's
Headed Back to India." Artnet News, November 24, 2020.
https://news.artnet.com/art-world/mackenzie-gallery-looted-
statue-india-1926292.

Brower, Montgomery, and Conan Putnam. "Walter Echo-Hawk Fights
for His People's Right to Rest in Peace—Not in Museums." People,
September 4, 1989. https://people.com/archive/walter-echo-hawk-
fights-for-his-peoples-right-to-rest-in-peace-not-in-museums-vol-
32-no-10/.

Brown, Kate. "Police Are Searching for a Man Who Attacked a British
Museum's Benin Bronzes After He Failed to Appear in Court."
artnet News, September 23, 2020. https://news.artnet.com/art-
world/benin-bronzes-london-court-prosecution-1910000.

Brown, Kate. "Artists and Scholars From Europe and Africa Are
Collaborating to Help Kenya Reclaim Its Art From Foreign

Museums." Artnet News, March 18, 2021. https://news.artnet.com/exhibitions/kenya-missing-art-1952223.

Butler, Judith. *Frames of War: When Is Life Grievable?* London: Verso, 2009.

Cascone, Sarah. "Patricia Marroquin Norby Is the Met's First Curator of Native American Art. Here's How She Navigates the Field's Thorniest Issues." Artnet News, November 4, 2020. https://news.artnet.com/art-world/patricia-marroquin-norby-met-native-american-art-curator-1912338.

"Celebrities." *Science* 317, no. 5843 (September 7, 2007): 1303.

Chang, Yu-Chien, Victoria Rodner, and Chloe Preece. "Country Branding through the Arts." In Museum Marketization: Cultural Institutions in the Neoliberal Era, edited by Karin M. Ekström, 1st Edition., 170–87. Routledge, 2019.

Chapman, Fred. "The Bighorn Medicine Wheel 1988–1999." Cultural Resource Management 3 (1999): 5–10.

Charr, Manuel. "What Implications Are There With Facial Recognition Technology For Museums?" MuseumNext, September 25, 2019. https://www.museumnext.com/article/what-implications-are-there-with-facial-recognition-technology-for-museums/.

Chikozho, Joshua. "Community Museums in Zimbabwe as a Means of Engagement and Empowerment: Challenges and Prospects." In *African Museums in the Making. Reflections on the Politics of Material and Public Culture in Zimbabwe*, edited by Munyaradzi Mawere, Henry Chiwaura, and Thomas Panganayi Thondhlana, 47–78. Mankon, Cameroon: African Books Collective, 2015.

Chong, Derrick. "Art, Finance, Politics, and the Art Museum as a Public Institution." In Museum Marketization: Cultural Institutions in the Neoliberal Era, edited by Karin M. Ekström, 1st Edition., 98–114. Routledge, 2019.

Codrea-Rado, Anna. "Emmanuel Macron Says Return of African Artifacts Is a Top Priority (Published 2017)." The New York Times, November 29, 2017, sec. Arts. https://www.nytimes.com/2017/11/29/arts/emmanuel-macron-africa.html.

The British Museum Blog. "Collecting and Empire," August 21, 2020. https://blog.britishmuseum.org/collecting-and-empire/.

Colwell, Chip. "Can Repatriation Heal the Wounds of History?" The
 Public Historian 41, no. 1 (February 1, 2019): 90–110.
———. Museums Have a Dark Past, but We Can Fix That.
 TEDxMileHigh, 2017. https://www.youtube.com/
 watch?v=DJYS9C06_qY.
———. "Repatriation and the Work of Decolonization." National
 Council on Public History (blog), June 18, 2019. https://ncph.org/
 history-at-work/repatriation-and-decolonization/.
———. Why Museums Are Returning Cultural Treasures.
 TEDxMileHigh, 2017. https://www.ted.com/talks/
 chip_colwell_why_museums_are_returning_cultural_treasures.
Conn, Steven. Do Museums Still Need Objects? Philadelphia: University
 of Pennsylvania Press, 2010.
Copeland, Huey, and Frank Wilderson III. "Red, Black, and Blue: The
 National Museum of African American History and Culture and the
 National Museum of the American Indian." Artforum, September
 2017. https://www.artforum.com/print/201707/red-black-and-blue-
 the-national-museum-of-african-american-history-and-culture-
 and-the-national-museum-of-the-american-indian-70457.
Coppens, Jeanne, and Kumbuka Collective. "Repackaging Colonialism:
 The False Decolonisation of Belgium's AfricaMuseum." Arts of the
 Working Class, Fall 2019.
Corbey, Raymond. "Ethnographic Showcases, 1870-1930." Cultural
 Anthropology 8, no. 3 (1993): 338–69.
Cornum, Lou. "What Are We Really Getting Out Of 'Westworld'?"
 BuzzFeed News, June 21, 2018. https://www.buzzfeednews.com/
 article/loucornum/westworld-season-two-native-american-
 fantasy.
Corrin, Lisa G. "Mining the Museum: An Installation Confronting
 History." Curator: The Museum Journal 36, no. 4 (1993): 302–13.
Cotter, Holland. "A Cree Artist Redraws History." The New York
 Times, December 19, 2019, sec. Arts. https://www.nytimes.
 com/2019/12/19/arts/design/kent-monkman-metropolitan-
 museum.html.

Cox, Alison, and Amarjit Singh. "Walsall Museum and Art Gallery and the Sikh Community: A Case Study." In *Cultural Diversity: Developing Museum Audiences in Britain*, edited by Eilean Hooper-Greenhill, 159–67. Leicester University Press, 2001.

Creative Time. "Commitment to Universal Human Rights and Free Expression - The Creative Time Summit," March 2014. https://creativetime.org/summit/about-the-summit/ commitment-to-universal-human-rights-and-free-expression/.

Crenn, Gaëlle. "Reformulation of the Museum's Discourse in Reflexive Ethnographic Exhibitions. Limits and Ambivalences at the Museum Der Kulturen (Basel) and the Neuchâtel Ethnography Museum." ICOFOM Study Series, no. 45 (September 17, 2017): 37–46.

Croft, Kyle. "How the Museum Is Like a Prison." Hyperallergic, November 26, 2018. https://hyperallergic.com/471031/ how-the-museum-is-like-a-prison/.

Cubillo, Franchesca. "Repatriating Our Ancestors:: Who Will Speak for the Dead?" In The Long Way Home, edited by Paul Turnbull and Michael Pickering, 1st ed., 20–26. The Meaning and Values of Repatriation. Berghahn Books, 2010.

Dafoe, Taylor. "After Years of Foot-Dragging, France's National Assembly Just Approved the Restitution of Looted Artifacts to Benin and Senegal." artnet News, October 7, 2020. https://news.artnet.com/ art-world/french-lawmakers-passed-first-step-approving-law- return-looted-artifacts-benin-senegal-1913806.

Dagen, Philippe. "Benin Blazes a Trail for African Modern Art with Opening of Museum in Ouidah." The Guardian, January 6, 2014. http://www.theguardian.com/artanddesign/2014/jan/06/ contemporary-art-benin-ouidah-zinsou.

Dahir, Abdi Latif. "A Kenyan Painter Casts a Critical Eye on China's Role in Africa." *The New York Times*, February 21, 2020, sec. World. https://www.nytimes.com/2020/02/21/world/africa/michael-soi- kenya-china.html

Dakar, Ruth Maclean. "Bronzes to Benin, Gold to Ghana ... Museums under Fire on Looted Art." *The Observer*, December 2, 2018,

sec. Culture. https://www.theguardian.com/culture/2018/dec/02/
british-museums-pressure-give-back--looted-african-art-treasures.

Artforum. "Dakota Nation Demands Removal of Sculpture at Walker
Art Center," May 29, 2017. https://www.artforum.com/news/
dakota-nation-demands-removal-of-sculpture-at-walker-art-
center-68759.

Diawara, Manthia. "A Letter to President Macron: Reparations Before
Restitution." Hyperallergic, January 16, 2020. https://hyperallergic.
com/537422/a-letter-to-president-macron-reparations-before-
restitution/.

DiSanto, Jill. "News Release: Museum Announces the Repatriation
of the Morton Cranial Collection." Penn Museum, April 12,
2021. https://www.penn.museum/documents/pressroom/
MortonCollectionRepatriation-Press%20release.pdf.

"Document: Declaration on the Importance and Value of Universal
Museums: 'Museums Serve Every Nation,'" November 16, 2006.
https://read.dukeupress.edu/books/book/2107/chapter/244831/
DocumentDeclaration-on-the-Importance-and-Value-of.

Donadio, Rachel. "Zuni Ask Europe to Return Sacred Art." The
New York Times, April 8, 2014, sec. Arts. https://www.nytimes.
com/2014/04/09/arts/design/zuni-petition-european-museums-to-
return-sacred-objects.html.

Doughton, Sandi. "Lucy on Display with Controversy." The Seattle
Times, October 2, 2008. https://www.seattletimes.com/
seattle-news/lucy-on-display-with-controversy/.

Douglass, Frederick. "1893 Frederick Douglass Lecture on Haiti at
the World's Fair in Chicago." Lecture, Quinn Chapel, Chicago,
January 2, 1893. https://thelouvertureproject.org/index.
php?title=Frederick_Douglass_lecture_on_Haiti_(1893).

D'Souza, Aruna. *Whitewalling: Art, Race & Protest in 3 Acts.* Illustrated
edition. New York: Badlands Unlimited, 2018.

Du Bois, W.E.B. "The American Negro at Paris." *The American Monthly
Review of Reviews* XXII, no. 5 (November 1900): 575–77.

Durón, Maximilíano. "Art Historian Calls Out Christie's for Selling
Objects Taken from Nigeria: 'Public Sales of These Objects Should

Stop.'" ARTnews (blog), June 10, 2020. https://www.artnews.com/
art-news/news/
christies-igbo-sculptures-chika-okeke-agulu-1202690696/.

Eilperin, Juliet. "In Ethiopia, Both Obama and Ancient Fossils Get a
Motorcade." *Washington Post*. Accessed February 23, 2021. https://
www.washingtonpost.com/news/post-politics/wp/2015/07/27/
in-ethiopia-both-obama-and-ancient-fossils-get-a-motorcade/.

Elbaor, Caroline. "The Nazis Purged German Museums of
Thousands of 'Degenerate' Works. Now an Expressionist
Painting Sold by Hildebrand Gurlitt Has Gone Home." artnet
News, December 6, 2019. https://news.artnet.com/art-world/
christian-rohlfs-gurlitt-1723479.

elysee.fr. "Emmanuel Macron's speech at the University of
Ouagadougou," November 28, 2017. https://www.elysee.fr/
emmanuel-macron/2017/11/28/emmanuel-macrons-speech-at-the-
university-of-ouagadougou.en.

Eräranta, Kirsi, Johanna Moisander, and Visa Penttilä. "Reflections on the
Marketization of Art in Contemporary Neoliberal Capitalism." In
Museum Marketization: Cultural Institutions in the Neoliberal Era,
edited by Karin M. Ekström, 1st Edition., 19–33. Routledge, 2019.

Estefan, Kareem. "Introduction." In *Assuming Boycott: Resistance, Agency
and Cultural Production*, edited by Kareem Estefan, Carin Kuoni, and
Laura Raicovich, 11–17. New York: OR Books, 2017.

Estes, Nick. "A Vision for the Future." In Revision and Resistance:
Kent Monkman and Mistikôsiwak (Wooden Boat People) at The
Metropolitan Museum of Art, edited by Suda Sasha, Shirley Madill,
and Kent Monkman, 1 edition. Art Canada Institute, 2020.
https://aci-iac.ca/the-essay/a-vision-for-the-future-by-nick-estes.

Estoile, Benoît de l'. "From the Colonial Exhibition to the Museum of
Man. An Alternative Genealogy of French Anthropology." Social
Anthropology 11, no. 3 (October 2003): 341–61.

Eyo, Ekpo. "Return and Restitution of Cultural Property." Museum
XXL, no. 1 (1979): 18–21.

Eyo, Ekpo. "Conventional Museums and the Quest for Relevance in
Africa." *History in Africa* 21 (ed 1994): 325–37.

Fabian, Johannes, and Matti Bunzl. Time and the Other: How Anthropology Makes Its Object. Unknown edition. New York: Columbia University Press, 2002.

Fanon, Frantz. The Wretched of the Earth. Translated by Richard Philcox. Reprint edition. New York: Grove Press, 2005.

Farrell, Betty, and Maria Medvedeva. "Demographic Transformation and the Future of Museums." American Association of Museums, 2010.

The British Museum. "Figure: Copper Bull." Accessed April 14, 2021. https://www.britishmuseum.org/collection/object/W_1924-0920-1.

Firestone, David. "Rescue in Manhattan:A Zuni War God Goes Home." New York Newsday, May 27, 1998, sec. II.

Fisch, Jörg. "Africa as Terra Nullius: The Berlin Conference and International Law'." In Bismarck, Europe, and Africa: The Berlin Africa Conference 1884-1885 and the Onset of Partition, edited by Stig Forster, Wolfgang J. Mommsen, and Ronald Robinson, 347–75. Oxford; New York: Oxford University Press, 1989.

Ford, Caroline. "Museums after Empire in Metropolitan and Overseas France." The Journal of Modern History 82, no. 3 (September 1, 2010): 625–61.

Forrest, Jason. "Exploring the Craft and Design of W.E.B. Du Bois' Data Visualizations (Part 3)." Medium, January 1, 2019. https://medium.com/nightingale/exploring-the-craft-and-design-of-w-e-b-du-bois-data-visualizations-part-3-b110d034fd36.

———. "The Legacy of W.E.B. Du Bois 'The Exhibit of American Negroes' (Part 5)." Medium, January 1, 2019. https://medium.com/nightingale/the-legacy-of-w-e-b-du-bois-the-exhibit-of-american-negroes-part-5-6b735a426c68.

Foster, Harriet. "Evaluation Toolkit for Museum Practitioners." Norwich: The East of England Museum Hub, February 2008. http://visitors.org.uk/wp-content/uploads/2014/08/ShareSE_Evaltoolkit.pdf.

Foucault, Michel. The Birth of Biopolitics: Lectures at the Collège de France, 1978-1979. First edition. New York: Picador, 2010.

Frammolino, Ralph. "The Goddess Goes Home." Smithsonian Magazine, November 2011. https://www.smithsonianmag.com/history/the-goddess-goes-home-107810041/.

Francis, David Rowland, and Louisiana Purchase Exposition. The Universal Exposition of 1904. St. Louis: Louisiana Purchase Exposition Company, 1913.

Gareth, Harris. "Palestinian Museum Opens—with No Exhibition or Collection." The Art Newspaper, May 17, 2016. http://www. theartnewspaper.com/news/palestinian-museum-opens-with-no-exhibition-or-collection.

Gathara, Patrick. "Berlin 1884: Remembering the Conference That Divided Africa." Al Jazeera, November 15, 2019. https://www.aljazeera.com/opinions/2019/11/15/berlin-1884-remembering-the-conference-that-divided-africa/.

Gaylor, Sabrina. "Richard Leakey." Freedom From Religion Foundation. Accessed February 23, 2021. https://ffrf.org/news/day/dayitems/item/14913-richard-leakey.

Geus, Daan de. "Here's What a Smart Museum Could Look Like." *IoT For All* (blog), September 12, 2018. https://www.iotforall.com/smart-museums.

Returning Heritage. "Ghost Dance Shirt Returned by Glasgow to Lakota Sioux Indian Community," November 1998. http://www.returningheritage.com/ghost-dance-shirt-returned-by-glasgow-city-council-to-the-lakota-sioux-indian-community-y.

Gikandi, Simon. "Picasso, Africa, and the Schemata of Difference." Modernism/Modernity 10, no. 3 (September 5, 2003): 455–80.

Global Interactions. #DecolonizetheMuseum - Hodan Warsarme and Simone Zeefuik. GI Annual Event: On the Poetics and Politics of Redress. Leiden, The Netherlands, 2015. https://vimeo.com/164082870.

Global Ultra Luxury Faction (G.U.L.F.). "On Direct Action: An Address to Cultural Workers." E-Flux Journal 56th Venice Biennale, June 25, 2015. http://supercommunity.e-flux.com/texts/on-direct-action-an-address-to-cultural-workers/.

Goldstein, Caroline. "The Whitney 'Cannot Right All the Ills of an Unjust World': Adam Weinberg Responds to Staff Protests Over a Board Member." Artnet News, December 3, 2018. https://news.artnet.com/art-world/whitney-protest-adam-weinberg-response-1409164.

Goode, G. Brown. "The Principles of Museum Administration." In *A Memorial of George Brown Goode, Together with a Selection of His Papers on Museums and on the History of Science in America*. Washington, DC: Government Printing Office, 1901.

Gould, Stephen Jay. "The Hottentot Venus." Natural History 91, no. 10 (1982): 20–27.

Green, Jonathan A. Portrait of the King of Benin. 1897. Photograph. Af,A47.70. British Museum. https://www.britishmuseum.org/collection/object/EA_Af-A47-70.

Greenberger, Alex. "'I Am Not the Problem': Whitney Vice Chair Responds to Open Letter Calling for Action Against Him [Updated]." ARTnews (blog), December 3, 2018. http://www.artnews.com/2018/12/03/not-problem-whitney-vice-chair-responds-open-letter-calling-action/.

Greenberger, Alex. "'The Painting Must Go': Hannah Black Pens Open Letter to the Whitney About Controversial Biennial Work." *ARTnews* (blog), March 21, 2017. https://www.artnews.com/artnews/news/the-painting-must-go-hannah-black-pens-open-letter-to-the-whitney-about-controversial-biennial-work-7992/.

Greenhalgh, Peter. "Education, Entertainment and Politics: Lessons from the Great International Exhibitions." In New Museology, edited by Peter Vergo, 74–98. Reaktion Books, 1989.

Griffiths, Alison. Wondrous Difference: Cinema, Anthropology & Turn-of-the-Century Visual Culture. Columbia University Press, 2002.

Gronlund, Melissa. "The Hidden Cost of Being at the Venice Biennale." The National. Accessed September 10, 2020. https://www.thenational.ae/arts-culture/art/the-hidden-cost-of-being-at-the-venice-biennale-1.862971.

Gross, Daniel A. "The Troubling Origins of the Skeletons in a New York Museum." The New Yorker, January 28, 2014. https://www.newyorker.com/culture/culture-desk/the-troubling-origins-of-the-skeletons-in-a-new-york-museum.

Gulf Labor Artist Coalition. "Week 47: Janet Koenig, '2015: Grand Opening of the Louvre Abu Dhabi,'" September 3, 2014.

https://gulflabor.org/2014/week-47-janet-koenig-2015-grand-opening-of-the-louvre-abu-dhabi/.

Haacke, Hans. "All the Art That's Fit to Show (1974)." In Institutional Critique and After, edited by John C. Welchman and Southern California Consortium of Art Schools, 53–56. Southern California Consortium of Art Schools Symposia. Zurich: JRP Ringier, 2006.

———. "Museums: Managers of Consciousness." In Hans Haacke: For Real: Works 1959-2006, edited by Matthias Flügge and Robert Fleck, 273–281. Düsseldorf: Richter, 1983.

Hafford, Brad. "Reconstructing Excavation Processes." Penn Museum: Ur Digitization Project, September 4, 2013. https://www.penn.museum/blog/museum/ur-digitization-project-august-2013/.

Halperin, Julia. "How the Dana Schutz Controversy—and a Year of Reckoning—Have Changed Museums Forever." Artnet News, March 6, 2018. https://news.artnet.com/art-world/dana-schutz-controversy-recent-protests-changed-museums-forever-1236020.

Harding, Luke. "Mosul Descends into Chaos," The Guardian, April 12, 2003, sec. World news, http://www.theguardian.com/world/2003/apr/12/iraq.arts.

Harding, Sarah. "Justifying Repatriation of Native American Cultural Property." Indiana Law Journal 72, no. 3 (July 1, 1997): 723–74.

Harris, Gareth. "Jack Persekian Steps down as Director of New Palestinian Museum." The Art Newspaper, December 11, 2015. http://www.theartnewspaper.com/news/jack-persekian-steps-down-as-director-of-new-palestinian-museum.

Hatzipanagos, Rachel. "The 'Decolonization' of the American Museum." Washington Post, October 11, 2018. https://www.washingtonpost.com/nation/2018/10/12/decolonization-american-museum/.

Heddaya, Mostafa. "Over 100 Artists and Intellectuals Call for Withdrawal from Creative Time Exhibition." Hyperallergic, June 10, 2014. https://hyperallergic.com/131497/over-100-artists-and-intellectuals-call-for-withdrawal-from-creative-time-exhibition/.

Hemming, Steve. "Audience Participation: Working with Local People at the Geffrye Museum, London." In Cultural Diversity: Developing

Museum Audiences in Britain, edited by Eilean Hooper-Greenhill, 168–82. Leicester University Press, 2001.

Hickley, Catherine. "Culture Ministers from 16 German States Agree to Repatriate Artefacts Looted in Colonial Era." The Art Newspaper, March 14, 2019. http://www.theartnewspaper.com/news/culture-ministers-from-16-german-states-agree-to-repatriate-artefacts-looted-in-colonial-era.

———. "Dutch Museums Take Initiative to Repatriate Colonial-Era Artefacts." The Art Newspaper, March 14, 2019. http://www.theartnewspaper.com/news/dutch-museums-take-initiative-to-repatriate-colonial-era-artefacts.

Hicks, Dan. The Brutish Museums: The Benin Bronzes, Colonial Violence and Cultural Restitution. Pluto Press, 2020.

Higginbotham, Evelyn Brooks. *Righteous Discontent: The Women's Movement in the Black Baptist Church, 1880–1920.* Revised edition. Cambridge, Mass.: Harvard University Press, 1994.

Hochschild, Adam. "The Fight to Decolonize the Museum." The Atlantic. Accessed September 1, 2020. https://www.theatlantic.com/magazine/archive/2020/01/when-museums-have-ugly-pasts/603133/.

Hoffenberg, Peter H. An Empire on Display: English, Indian, and Australian Exhibitions from the Crystal Palace to the Great War. University of California Press, 2001.

Holmes, Helen. "Germany Is In Accelerated Talks to Definitively Return Its Benin Bronzes to Nigeria." *Observer* (blog), March 23, 2021. https://observer.com/2021/03/benin-bronzes-berlin-nigeria/.

Hooper-Greenhill, Eilean. "Changing Values in the Art Museum: Rethinking Communication and Learning." *International Journal of Heritage Studies* 6, no. 1 (January 1, 2000): 9–31.

"How Did the Elgin Marbles Get Here?" BBC News, December 5, 2014, sec. Entertainment & Arts. https://www.bbc.com/news/entertainment-arts-30342462.

Hsu, Hua. "What W. E. B. Du Bois Conveyed in His Captivating Infographics." The New Yorker. Accessed April 13, 2021.

https://www.newyorker.com/books/page-turner/what-web-du-bois-conveyed-in-his-captivating-infographics.

Huis, Iris van. "Contesting Cultural Heritage: Decolonizing the Tropenmuseum as an Intervention in the Dutch/European Memory Complex." In Dissonant Heritages and Memories in Contemporary Europe, edited by Tuuli Lähdesmäki, Luisa Passerini, Sigrid Kaasik-Krogerus, and Iris van Huis, 215–48. Palgrave Studies in Cultural Heritage and Conflict. Cham: Springer International Publishing, 2019.

Hunt, Tristram. "Should Museums Return Their Colonial Artefacts?" The Guardian, June 29, 2019, sec. Culture. https://www.theguardian.com/culture/2019/jun/29/should-museums-return-their-colonial-artefacts.

Iandoli, Louis J. "The Palace of the Tuileries and Its Demolition: 1871-1883." The French Review 79, no. 5 (2006): 986–1008.

Imada, Adria L. "Transnational Hula as Colonial Culture." The Journal of Pacific History 46, no. 2 (September 1, 2011): 149–76.

Ta Nea. "Interview with Hartwig Fischer," January 26, 2019. https://www.tanea.gr/print/2019/01/26/greece/h-ellada-lfden-einai-o-nomimos-lfidioktitis-lfton-glypton-lftou-parthenona/.

"J20 Art Strike." MIT Press Journal, no. 159 (Winter 2017): 143–47. https://doi.org/10.1162/OCTO_a_00286.

Jackson, John P., and Nadine M. Weidman. Race, Racism, and Science: Social Impact and Interaction. Rutgers University Press, 2006.

James Baldwin and William Buckley: "The American Dream at The Expense of the American Negro?" Cambridge University, 1965. https://www.youtube.com/watch?v=FxLUbKebYvc.

Jansari, Sushma, and Hartwig Fischer. "The Museum Podcast Special: Sir Hans Sloane." Accessed November 25, 2020. https://www.britishmuseum.org/the-british-museum-podcast.

Jegroo, Ashoka. "Photos: Hundreds Of Protesters Condemn Colonialism, Patriarchy, And White Supremacy At AMNH." Gothamist, October 10, 2018. https://gothamist.com/news/photos-hundreds-of-protesters-condemn-colonialism-patriarchy-and-white-supremacy-at-amnh.

Kaminer, Ariel, and Sean O'Driscoll. "Workers at N.Y.U.'s Abu Dhabi Site Faced Harsh Conditions." The New York Times, May 19, 2014, sec. New York. https://www.nytimes.com/2014/05/19/nyregion/workers-at-nyus-abu-dhabi-site-face-harsh-conditions.html.

Kealiinohomoku, Joann Wheeler. "A Court Dancer Disagrees with Emerson's Classic Book on the Hula." Ethnomusicology 8, no. 2 (1964): 161–64.

Karp, Ivan. Exhibiting Cultures: The Poetics and Politics of Museum Display. Edited by Steven D. Lavine. Smithsonian Books, 2012.

Kassim, Sumaya. "The Museum Will Not Be Decolonised." Media Diversified (blog), November 15, 2017. https://mediadiversified.org/2017/11/15/the-museum-will-not-be-decolonised/.

Katz, Brigit. "Sprawling Museum of Black Civilizations Opens in Senegal." Smithsonian Magazine, December 10, 2018. https://www.smithsonianmag.com/smart-news/sprawling-museum-black-civilizations-opens-senegal-180970976/.

Keller, Mitch. "The Scandal at the Zoo." The New York Times, August 6, 2006, sec. New York. https://www.nytimes.com/2006/08/06/nyregion/thecity/06zoo.html.

Kipling, Rudyard. Souvenirs of France. London: Macmillan, 1938.

Kirshenblatt-Gimblett, Barbara. "Performing the State: The Jewish Palestine Pavilion at the New York World's Fair, 1939/40." In The Art of Being Jewish in Modern Times. University of Pennsylvania Press, 2008.

Facebook. "Kumbuka Zine Décolonial: Repenser Le Musée," November 23, 2018. https://www.facebook.com/events/1995283530510534/.

Lagat, Kiprop. "Representations of Nationhood in the Displays of the National Museums of Kenya (NMK): The Nairobi National Museum." Critical Interventions 11, no. 1 (January 2, 2017): 24–39.

Legêne, Susan. "Identité nationale et 'cultures autres': Le musée colonial comme monde àpart aux Pays-Bas." In Du musée colonial au musée des cultures du monde, edited by Dominique Taffin, 87–102. Paris: Maisonneuve et Larose, 2000.

Leonard, Christopher. "David Koch Was the Ultimate Climate Change Denier." The New York Times, August 23, 2019, sec. Opinion.

https://www.nytimes.com/2019/08/23/opinion/sunday/david-koch-climate-change.html.

Levius, Travis. "For Black Americans, a Heritage Trip to West Africa Can Be Life-Changing." Travel + Leisure, January 22, 2021. https://www.travelandleisure.com/trip-ideas/west-africa-heritage-trip.

Lewis, Geoffrey. "The 'Universal Museum': A Case of Special Pleading?" Art and Cultural Heritage: Law, Policy and Practice, February 10, 2005.

"Liberate Tate's Six-Year Campaign to End BP's Art Gallery Sponsorship – in Pictures." The Guardian, March 19, 2016, sec. Environment. https://www.theguardian.com/environment/gallery/2016/mar/19/liberate-tates-six-year-campaign-to-end-bps-art-gallery-sponsorship-in-pictures.

Lippard, Lucy R. "Biting the Hand: Artists and Museums in New York since 1969." In Alternative Art, New York, 1965-1985: A Cultural Politics Book for the Social Text Collective, edited by Julie Ault, 79–120. U of Minnesota Press, 2002.

Liscia, Valentina Di. "Climate Activists Crash Arctic Exhibition at British Museum to Protest Oil Funding." Hyperallergic, October 21, 2020. https://hyperallergic.com/596057/climate-activists-crash-arctic-exhibition-at-british-museum-to-protest-oil-funding/.

Lonetree, Amy. Decolonizing Museums: Representing Native America in National and Tribal Museums. Univ of North Carolina Press, 2012.

Lothar von Schweinitz, Hans. "Deutschland Und Seine Kolonien Im Jahre 1896. Amtlicher Bericht Über Die Erste Deutsche Kolonial-Ausstellung (Germany and Its Colonies in 1896. Official Report on the First German Colonial Exhibition)." Berlin, 1896.

Lubar, Steven. "'To Polish and Adorn the Mind': The United States Naval Lyceum at the Brooklyn Navy Yard, 1833–89." Museum History Journal 7, no. 1 (January 1, 2014): 84–102.

Lukka, Priya. "Repairing Harm Caused: What Could a Reparations Approach Mean for the IMF and World Bank?" Bretton Woods Project, October 6, 2020. https://www.brettonwoodsproject.org/2020/10/repairing-harm-caused-what-could-a-reparations-approach-mean-for-the-imf-and-world-bank/.

Lutten, Éric. "Les Enfants Noirs Ont Aussi Des Poupées Mai." Le Monde
 Colonial Illustré, mai 1934, 129 edition.

Macdonald, Sharon, and Paul Basu, eds. Exhibition Experiments. John
 Wiley & Sons, 2008.

MacGregor, Neil. "The British Museum: A Museum for the World." Google
 Europe Blog (blog), November 13, 2015. https://europe.googleblog.
 com/2015/11/the-british-museum-museum-for-world.html.

Mackey, Eva. The House of Difference: Cultural Politics and National Identity in
 Canada. Toronto: University of Toronto Press, 2002.

Maddra, Sam. "The Wounded Knee Ghost Dance Shirt." Journal of
 Museum Ethnography 8 (May 1996): 41–58.

Mansky, Jackie. "W.E.B. Du Bois' Visionary Infographics Come Together
 for the First Time in Full Color." Smithsonian Magazine. Accessed
 April 13, 2021. https://www.smithsonianmag.com/history/first-
 time-together-and-color-book-displays-web-du-bois-visionary-
 infographics-180970826/.

Marshall, Alex. "Belgium's Africa Museum Had a Racist Image. Can It
 Change That?" The New York Times, December 8, 2018, sec. Arts.
 https://www.nytimes.com/2018/12/08/arts/design/africa-museum-
 belgium.html.

———. "The British Museum Reopens to a World That Has Changed."
 The New York Times, August 27, 2020, sec. Arts. https://www.
 nytimes.com/2020/08/27/arts/design/british-museum-reopening.html.

Matheka, Grace. "Invisible Inventories Launched to Reclaim Lost Kenyan
 Art in Foreign Museums." HapaKenya (blog), March 15, 2021.
 https://hapakenya.com/2021/03/15/invisible-inventories-launched-
 to-reclaim-lost-kenyan-art-in-foreign-museums/.

Matthes, Erich Hatala. "The Ethics of Cultural Heritage." In The Stanford
 Encyclopedia of Philosophy, edited by Edward N. Zalta, Fall 2018.
 Metaphysics Research Lab, Stanford University, 2018. https://plato.
 stanford.edu/archives/fall2018/entries/ethics-cultural-heritage/.

Mawere, Munyaradzi, and Tapuwa Mubaya. "'A Shadow That Refuses
 to Leave': The Enduring Legacy of Colonialism in Zimbabwean
 Museum Governance." In African Museums in the Making. Reflections
 on the Politics of Material and Public Culture in Zimbabwe, edited by

Munyaradzi Mawere, Henry Chiwaura, and Thomas Panganayi Thondhlana, 137–62. Mankon, Cameroon: African Books Collective, 2015.

Maxwell, Anne. Colonial Photography and Exhibitions: Representations of the Native and the Making of European Identities. Leicester University Press, 2000.

McAlister, Melani. Epic Encounters: Culture, Media, and U.S. Interests in the Middle East Since 1945. University of California Press, 2005.

McCarthy, Rory. "Row over Plan to Build Jewish Museum of Tolerance on Site of Muslim Cemetery." The Guardian, February 10, 2010. http://www.theguardian.com/world/2010/feb/10/jewish-museum-tolerance-muslim-cemetery.

McDouggal, Liam. "Iraq: A Nation Robbed of Its History." The Sunday Herald. April 20, 2003.

Mead, Wendy. "Gertrude Bell: 7 Facts About Her Fascinating Life." Biography, July 13, 2016. https://www.biography.com/news/gertrude-bell-biography-facts.

Merenstein, Adele. "The Zuni Quest for Repatriation of the War Gods: An Alternative Basis for Claim." American Indian Law Review 17, no. 2 (1992): 589–637.

Merritt, Elizabeth. "'Decolonizing Is Literally Unsettling': Repatriation of Nonprofit Land and Assets." American Alliance of Museums (blog), October 6, 2020. https://www.aam-us.org/2020/10/06/decolonizing-is-literally-unsettling-repatriation-of-nonprofit-land-and-assets/.

Minamore, Bridget. "Slaver! Invader! The Tour Guide Who Tells the Ugly Truth about Museum Portraits." The Guardian, April 24, 2018, sec. Art and design. https://www.theguardian.com/artanddesign/2018/apr/24/slaver-invader-tour-guide-ugly-truth-empire-uncomfortable-art-tours-alice-procter.

Mingren, Wu. "A Bull-Headed Lyre: Reconstructing the Sound and Style of Ancient Mesopotamia." Ancient Origins. Ancient Origins, June 30, 2018. https://www.ancient-origins.net/artifacts-other-artifacts/lyre-reconstructing-sound-ancient-mesopotamia-021959.

Mitchell, Jerry. "See the Photo Emmett Till's Mother Wanted You to See — the One That Inspired a Generation to Join the Civil

Rights Movement." Mississippi Center for Investigative Reporting, August 28, 2020. https://www.mississippicir.org/news/see-the-photo-emmett-tills-mother-wanted-you-to-see-the-one-that-inspired-a-generation-to-join-the-civil-rights-movement.

Mitchell, Timothy. "The World as Exhibition." Comparative Studies in Society and History 31, no. 2 (April 1989): 217–36.

Mitchell, W. J. T. What Do Pictures Want?: The Lives and Loves of Images. University of Chicago Press, 2005.

Molesworth, Charles. "How a Capitalist and a Critic Shaped Metropolitan Museum of Art." New York Post (blog), March 6, 2016. https://nypost.com/2016/03/06/how-a-capitalist-and-a-critic-shaped-metropolitan-museum-of-art/.

Montsho, Goabaone. "Making Museums Accessible to Those With Disabilities." MuseumNext, January 22, 2020. https://www.museumnext.com/article/making-museums-accessible-to-those-with-disabilities/.

Monument Removal Brigade. "Prelude to the Removal of a Monument," October 26, 2017. https://monumentremovalbrigade.tumblr.com/?og=1.

Morley, David. "Populism, Revisionism and the 'New' Audience Research." Poetics 21, no. 4 (August 1, 1992): 339–44.

Morphy, Howard. "Scientific Knowledge and Rights in Skeletal Remains – Dilemmas in the Curation of 'Other' People's Bones." In The Long Way Home, edited by Paul Turnbull and Michael Pickering, 1st ed., 147–62. The Meaning and Values of Repatriation. Berghahn Books, 2010.

MTL Collective. "From Institutional Critique to Institutional Liberation? A Decolonial Perspective on the Crises of Contemporary Art." MIT Press Journal 165 (Summer 2018): 192–227.

Mubaya, Tapuwa, and Munyaradzi Mawere. "Orphans in a Strange Land: Controversies and Challenges in the Repatriation of African Cultural Property from European Museums." In African Museums in the Making, edited by Munyaradzi Mawere, Henry Chiwaura, and Thomas Panganayi Thondhlana, 79–114. Langaa Research & Publishing CIG, 2015.

Mubaya, Tapuwa. "Africanising Museums on the African Soil: A Critique of the Western Concept of Keeping Human Remains in Zimbabwean Museums." In *African Museums in the Making. Reflections on the Politics of Material and Public Culture in Zimbabwe*, edited by Munyaradzi Mawere, Henry Chiwaura, and Thomas Panganayi Thondhlana, 201–21. Mankon, Cameroon: African Books Collective, 2015.

Muhammad, Abdul-Aliy. "Penn Museum Owes Reparations for Previously Holding Remains of a MOVE Bombing Victim." The Philadelphia Inquirer, April 21, 2021. https://www.inquirer.com/opinion/commentary/penn-museum-reparations-repatriation-move-bombing-20210421.html.

Mullaney, Steven. "Strange Things, Gross Terms, Curious Customs: The Rehearsal of Cultures in the Late Renaissance." Representations, no. 3 (1983): 40–67.

Munjeri, Dawson. "Refocusing or Reorientation? The Exhibit or the Populace: Zimbabwe on the Threshold." In *Exhibiting Cultures: The Poetics and Politics of Museum Display*, edited by Steven D. Lavine and Ivan Karp, Illustrated edition., 444–56. Washington: Smithsonian Books, 1991.

Muñoz-Alonso, Lorena. "'Shame in Venice': Italian-Chinese Line-up for Kenya's Biennale Pavilion Sparks Outrage." artnet News, March 25, 2015. https://news.artnet.com/exhibitions/outrage-kenyan-pavilion-venice-biennale-281137.

Muñoz-Alonso, Lorena. "Dana Schutz's Painting of Emmett Till at Whitney Biennial Sparks Protest." Artnet News, March 21, 2017. https://news.artnet.com/art-world/dana-schutz-painting-emmett-till-whitney-biennial-protest-897929.

Munro, Cait. "Meet Berenson, The Robot Art Critic." Artnet News, February 29, 2016. https://news.artnet.com/art-world/robot-art-critic-berenson-436739.

Murphy, John. "Powerful Symbol, Weak in Facts." Daily Press, June 30, 2004. https://www.dailypress.com/dailypress/bal-slavery0630-story.html.

Tripadvisor. "National Museum of Ethiopia." Accessed February 23, 2021. http://www.tripadvisor.com/ShowUserReviews-g293791-d480664-r687366724-National_Museum_of_Ethiopia-Addis_Ababa.html.

Artforum. "National Museum of Ireland Makes Plans to Return Benin Bronzes," April 13, 2021. https://www.artforum.com/news/national-museum-of-ireland-makes-plans-to-return-benin-bronzes-85454.

Nayeri, Farah. "To Protest Colonialism, He Takes Artifacts From Museums." The New York Times, September 30, 2020, sec. Arts. https://www.nytimes.com/2020/09/21/arts/design/france-museum-quai-branly.html.

Nguyen, Viet Thanh. Nothing Ever Dies: Vietnam and the Memory of War. Harvard University Press, 2016.

Nicholls, David G. "African Americana in Dakar's Liminal Spaces." In *Monuments of the Black Atlantic: Slavery and Memory*, edited by Frances L. and Edwin L. Cummings Professor of American Studies and English Joanne M. Braxton and Joanne M. Braxton, 141–51. LIT, 2004.

Noce, Vincent. "What Exactly Is a Museum? Icom Comes to Blows over New Definition." August 19, 2019. The Art Newspaper. Accessed April 22, 2021. http://www.theartnewspaper.com/news/what-exactly-is-a-museum-icom-comes-to-blows-over-new-definition.

Norris, Mary. "Should the Parthenon Marbles Be Returned to Greece?" The New Yorker, November 22, 2019. https://www.newyorker.com/culture/cultural-comment/should-the-parthenon-marbles-be-returned-to-greece.

Nouvel, Jean "Presence-Absence or Selective Dematerialization," *Ateliers Jean Nouvel* (blog). Accessed January 28, 2021, http://www.jeannouvel.com/en/projects/musee-du-quai-branly/.

Nti, Kwaku. "Slave Heritage Is Big Business, Tainting the Diaspora's Bonds with Africa." The Conversation, January 9, 2017. http://theconversation.com/slave-heritage-is-big-business-tainting-the-diasporas-bonds-with-africa-70062.

OECD/ICOM. "Culture and Local Development: Maximising the Impact," 2018. https://icom.museum/wp-content/uploads/2019/08/ICOM-OECD-GUIDE_EN_FINAL.pdf.

Okeke-Agulu, Chika. "A Pair of Igbo Sculptures on Auction at Christie's." *Instagram* (blog), June 6, 2020. https://www.instagram.com/p/CBFMuvbFE7k/.

"On Matters of Time and Space: Interview with Sam Kling." On the Media. Accessed August 11, 2020. https://www.wnycstudios.org/podcasts/otm/episodes/on-the-media-matters-time-space.

Opoku, Kwame. "Benin to Berlin Ethnologisches Museum: Are Benin Bronzes Made in Berlin?" Modern Ghana (blog), February 13, 2008. https://lootedart.com/news.php?r=MVMR05596191.

———. "Did Germans Never Hear Directly Or Indirectly Nigeria's Demand For Return Of Looted Artefacts?" Blog. Africavenir, September 6, 2013. http://www.africavenir.org/fr/newsdetails/archive/2013/september/article/kwame-opoku-did-germans-never-hear-directly-or-indirectly-nigerias-demand-for-return-of-looted-art.html?tx_ttnews%5Bday%5D=03&cHash=10fb344ac8e9b89c262bddd4a7df03cf.

———. "Macron Promises to Return African Artefacts in French Museums: A New Era in African-European Relationships or a Mirage?" Blog. AACHRONYM (blog), December 11, 2017. http://aachronym.blogspot.com/2017/12/macron-promises-to-return-african.html.

Organization of African Unity. "Pan-African Cultural Manifesto." Africa Today 17, no. 1 (1970): 25–28.

Marabou at the Museum. "Organizing for Indigenous Peoples' Day 2018," October 3, 2018. https://marabouatthemuseum.com/2018/10/03/organizing-for-indigenous-peoples-day-2018/.

Packard, Cassie. "Artist Discovers a Looted Statue in a Canadian Museum's Collection, Leading to Its Repatriation." Hyperallergic, December 7, 2020. https://hyperallergic.com/604586/artists-research-leads-mackenzie-art-gallery-to-restitute-an-18th-century-statue-acquire-her-work/.

———. "Dan Hicks on the Benin Bronzes and Ultraviolence of World Culture Museums." Hyperallergic, January 29, 2021. https://hyperallergic.com/613840/dan-hicks-the-brutish-museums/.

The Palestinian Museum. "The Family Album." Accessed March 25, 2021. https://www.palmuseum.org/projects/the-family-album#ad-image-thumb-1651.

The Palestinian Museum. "The Museum." Accessed March 25, 2021. https://www.palmuseum.org/about/the-building-2#ad-image-thumb-1914.

The Palestinian Museum. "Previous Exhibitions." Accessed March 25, 2021. https://www.palmuseum.org/ehxibitions/previous-exhibitions-2#ad-image-thumb-1875.

The Palestinian Museum. "Satellite Exhibitions." Accessed March 25, 2021. https://www.palmuseum.org/ehxibitions/previous-exhibitions-1.

Parr, A. E. Mostly About Museums. Washington: American Museum of Natural History, 1959.

Pasternak, Anne. "Creative Time Responds to BDS Arts Coalition Petition," June 13, 2014. https://creativetime.org/blog/2014/06/13/creative-time-responds-to-bds-arts-coalition-petition/.

Peers, Laura. "Decolonizing Museums in Practice with the Museum Ethnographers Group" Part 2: Stories and Objects. Anthropological Airwaves, 2018. https://soundcloud.com/anthro-airwaves/decolonizing-museums-in-practice-with-the-museum-ethnographers-group-part-2-stories-and-objects.

Pelletier, Mary. "'They Tell Lies': Israel's 'museum of Coexistence' Erases Palestinian History." Middle East Eye, June 6, 2017. http://www.middleeasteye.net/features/they-tell-lies-israels-museum-coexistence-erases-palestinian-history.

Change.org. "Petition: Stop Christie's from Selling STOLEN Igbo Sculptures," June 2020. https://www.change.org/p/united-nations-blackartsmatter-stop-christie-s-from-selling-stolen-igbo-sculptures-3343b8a9-91e8-47d5-b070-9c4d3e872eea.

Phillips, Ruth B. "Introduction: Community Collaboration in Exhibitions: Towards a Dialogic Paradigm." In Museums and Source Communities, edited by Alison K. Brown and Laura Peers, 1 edition., 155–70. London; New York: Routledge, 2003.

Pitman, Bonnie. "Muses, Museums, and Memories." *Daedalus* 128, no. 3 (1999): 1–31.

Pitt-Rivers, Augustus Henry Lane-Fox. "Address as President of the Anthropological Section of the British Association." Report of the British Association for the Advancement of Science. Bath, September 6, 1888. https://web.prm.ox.ac.uk/rpr/index.php/primary-documents-index/14-general/728-baas-september-1888-1888.html.

———. The Evolution of Culture: And Other Essays. Clarendon Press, 1906.

Pratt, Mary Louise. Imperial Eyes: Travel Writing and Transculturation. 2 edition. London: New York: Routledge, 2007.

Prentice, Alessandra, and Siphiwe Sibeko. "Ghana Cashes in on Slave Heritage Tourism." *Reuters*, August 20, 2019. https://www.reuters.com/article/us-africa-slavery-tourism-idUSKCN1VA11N.

Press Association. "Ruling Tightens Grip on Parthenon Marbles." The Guardian, May 27, 2005, sec. UK news. https://www.theguardian.com/uk/2005/may/27/arts.parthenon.

Preston, Douglas J. "Skeletons in Our Museums' Closets." Harper's Magazine, February 1, 1989. https://harpers.org/archive/1989/02/skeletons-in-our-museums-closets/.

Price, Sally, and Dan Hicks. "Has the Sarr-Savoy Report Had Any Effect since It Was First Published?" Apollo Magazine, January 6, 2020. https://www.apollo-magazine.com/sarr-savoy-report-sally-price-dan-hicks/.

Prior, Nick. "Postmodern Restructuring." In A Companion to Museum Studies, edited by Sharon Macdonald, 509–24. John Wiley & Sons, 2011.

Procter, Alice. The Whole Picture: The Colonial Story of the Art in Our Museums & Why We Need to Talk about It. Cassell, 2020.

Pronczuk, Monika, and Megan Specia. "Belgium's King Sends Letter of Regret Over Colonial Past in Congo." The New York Times, June 30, 2020, sec. World. https://www.nytimes.com/2020/06/30/world/europe/belgium-king-congo.html.

Puleo, Risa, ed. Walls Turned Sideways: Artists Confront the Justice
 System. Miami, FL: Contemporary Arts Museum Houston, 2019.

Ragbir, Lise. "What Black Panther Gets Right About the Politics of
 Museums." Hyperallergic, March 21, 2018. https://hyperallergic.
 com/433650/black-panther-museum-politics/.

Raicovich, Laura. "Twitter Post." Twitter (blog), September 5, 2017.
 https://twitter.com/LauraRaicovich/status/905151971350499332.

Rea, Naomi. "France Released a Groundbreaking Report on the
 Restitution of African Art One Year Ago. Has Anything Actually
 Changed?" artnet News, December 11, 2019. https://news.artnet.
 com/art-world/french-restitution-report-global-1728216.

———. "France Returns to Senegal a 19th-Century Saber That It Looted
 During the Colonial Period." artnet News, November 18, 2019.
 https://news.artnet.com/art-world/france-restitutes-senegal-saber-
 1707042.

———. "The British Museum Is Helping to Return Hundreds of Looted
 Ancient Artifacts to Museums in Iraq and Afghanistan." artnet
 News, July 9, 2019. https://news.artnet.com/art-world/british-
 museum-afghanistan-iraq-artifacts-1595683.

Regas, Rima. "Transcript: James Baldwin Debates William F. Buckley
 (1965)." *Blog #42* (blog), June 7, 2015. https://www.rimaregas.
 com/2015/06/07/transcript-james-baldwin-debates-william-f-
 buckley-1965-blog42/.

Reiss, Benjamin. The Showman and the Slave: Race, Death, and Memory
 in Barnum's America. 1 edition. Cambridge, Mass.: Harvard
 University Press, 2010.

Riach, James. "Zaha Hadid Defends Qatar World Cup Role Following
 Migrant Worker Deaths." The Guardian, February 25, 2014, sec.
 World news. https://www.theguardian.com/world/2014/feb/25/
 zaha-hadid-qatar-world-cup-migrant-worker-deaths.

Rice, Ryan. "Trouble Me Venice: An Indigenous Curator's View of the
 Biennale." Canadian Art, May 30, 2017. https://canadianart.ca/
 reviews/ryan-rice-venice-biennale/.

Riding In, James. "Decolonizing NAGPRA." In For Indigenous Eyes
 Only: A Decolonization Handbook, edited by Michael Yellow

Bird and Waziyatawin Angela Wilson, 53–66. Santa Fe: School for Advanced Research Press, 2005.

Riegel, Henrietta. "Into the Heart of Irony: Ethnographic Exhibitions and the Politics of Difference." The Sociological Review 43 (May 1, 1995): 83–104.

Robertson, Kirsty. Tear Gas Epiphanies: Protest, Culture, Museums. Montreal; Kingston; London; Chicago: McGill-Queen's University Press, 2019.

American Museum of Natural History. "Roosevelt Equestrian Statue Removal: Press Release," June 21, 2020. https://www.amnh.org/about/press-center/amnh-requests-statue-removal.

Rose, Edwin D. "Specimens, Slips and Systems: Daniel Solander and the Classification of Nature at the World's First Public Museum, 1753–1768." The British Journal for the History of Science 51, no. 2 (June 2018): 205–37.

Roth, Henry Ling. Great Benin: Its Customs, Art and Horrors. Routledge & K. Paul, 1903.

Rude, Mille. "The Haraldskaer Mermaid." In Shaped by Time. Contemporary Art Embedded in Prehistory 12,500 BC - 2012, edited by Milena Hoegsberg. Berlin: Revolver Publishing, 2012.

Rukoro v. Federal Republic of Germany, No. 19-609 (United States Court of Appeals for the Second Circuit September 24, 2020).

Rydell, Robert. "World Fairs and Museums." In A Companion to Museum Studies, edited by Sharon Macdonald, 312–46. John Wiley & Sons, 2011.

Rydell, Robert W. All the World's a Fair: Visions of Empire at American International Expositions, 1876-1916. Reprint edition. Chicago: The University of Chicago Press, 1987.

Christie's. "Sale 1278: An Important Benin Bronze Plaque, 16th Century," April 3, 2003. https://www.christies.com/lotfinder/lot_details.aspx?intObjectID=4070061.

Samudzi, Zoé. "Reparative Futurities: Thinking from the Ovaherero and Nama Colonial Genocide." The Funambulist Magazine, August 2020.

Samuel, Sigal. "It's Disturbingly Easy to Buy Iraq's Archeological Treasures." The Atlantic, March 19, 2018. https://www.theatlantic.com/international/archive/2018/03/iraq-war-archeology-invasion/555200/.

Sarr, Felwine, and Bénédicte Savoy. "The Restitution of African Cultural Heritage: Toward a New Relational Ethics." Translated by Drew S. Burk, November 2018.

Savoy, Bénédicte. "The Restitution Revolution Begins." The Art Newspaper, February 16, 2018. http://www.theartnewspaper.com/comment/the-restitution-revolution-begins.

Sayej, Nadja. "New York's Chinatown Hits Back at Omer Fast's 'poverty Porn' Art Exhibition." The Guardian, October 20, 2017, sec. Art and design. https://www.theguardian.com/artanddesign/2017/oct/20/chinatown-omer-fast-art-poverty-porn.

Schildkrout, Enid. "Ambiguous Messages and Ironic Twists: Into the Heart of Africa and The Other Museum." Museum Anthropology 15, no. 2 (1991): 16–23.

Schneider, Gerhard. "Das Deutsche Kolonialmuseum in Berlin Und Seine Bedeutung Im Rahmen Der Preussischen Schulreform Um Die Jahrhunder." In Jahrhundertwende. In Die Zukunft Beginnt in Der Vergangenheit. Schriften Des Historischen Museums XVI. Frankfurt: Historisches Museum, 1982.

Schuessler, Jennifer. "What Should Museums Do With the Bones of the Enslaved?" The New York Times, April 20, 2021, sec. Arts. https://www.nytimes.com/2021/04/20/arts/design/museums-bones-smithsonian.html.

Scott, Monique. "Museums Matter in the Current Climate of Anti-Black Racism." Anthropology News 60, no. 2 (March 2019). https://onlinelibrary.wiley.com/doi/abs/10.1111/AN.1119.

Seeley, John Robert. The Expansion of England. London: Macmillan, 1884.

Sharp, Sarah Rose. "Mississippi Returns Stolen Remains of Chickasaw People in States Largest Repatriation." Hyperallergic, April 12, 2021. https://hyperallergic.com/636891/mississippi-returns-stolen-remains-of-chickasaw-people-repatriation/.

Shaw, Thurstan. "Whose Heritage?" Museum International 38, no. 1 (1986): 46–48.

Shelton, Anthony. "Curating African Worlds." Journal of Museum Ethnography, no. 12 (2000): 5–20.

———. "Curating African Worlds." In Museums and Source Communities, edited by Alison K. Brown and Laura Peers, 1 edition., 181–93. London; New York: Routledge, 2003.

Shohat, Ella, and Robert Stam. Unthinking Eurocentrism: Multiculturalism and the Media. Routledge, 1994.

Shyllon, Folarin. "Benin Dialogue Group: Benin Royal Museum--Three Steps Forward, Six Steps Back." Art Antiquity & Law 23, no. 4 (December 1, 2018): 341–47.

Skrydstrup, Martin. "What Might an Anthropology of Cultural Property Look Like?" In The Long Way Home, edited by Paul Turnbull and Michael Pickering, 1st ed., 59–81. The Meaning and Values of Repatriation. Berghahn Books, 2010.

Slyomovics, Susan. "Discourses on the Pre-1948 Palestinian Village: The Case of Ein Hod/Ein Houd." Traditional Dwellings and Settlements Review 4, no. 2 (1993): 27–37.

Small, Zachary. "A New Definition of 'Museum' Sparks International Debate." Hyperallergic, August 19, 2019. https://hyperallergic.com/513858/icom-museum-definition/.

Smith, Andrea. "Indigeneity, Settler Colonialism, White Supremacy." In Racial Formation in the Twenty-First Century, edited by Daniel Martinez HoSang, Oneka LaBennett, and Laura Pulido, First edition., 66–90. Berkeley: University of California Press, 2012.

Smith, Claire. "Decolonizing the Museum: The National Museum of the American Indian in Washington, D.C." Antiquity 79, no. 304 (2005): 424–39.

Smith, Shawn Michelle. "African American Photographs Assembled for 1900 Paris Exposition." Library of Congress, 1999. //www.loc.gov/pictures/collection/anedub/dubois.html.

Smithsonian Institution, Office of International Relations. "Country Files, circa 1992-1998," 1998 1992. https://sova.si.edu/record/SIA.FA99-111?q=*&n=10&s=0.

Smithsonian Institution. "Smithsonian Launches Pilot Program of 'Pepper' Robots," April 24, 2018. https://www.si.edu/newsdesk/releases/smithsonian-launches-pilot-program-pepper-robots.

Solnit, Rebecca. River of Shadows: Eadweard Muybridge and the Technological Wild West. Viking, 2003.

Sönmez, Sevil, Ercan Sirakaya-Turk, and Victor Teye. "Heritage Tourism in Africa: Residents' Perceptions of African-American and White Tourists." *Tourism Analysis*, June 2011.

Starzmann, Maresi. "Germany Needs to Own Up to the Horrors of Its Colonial Past in Africa." Jacobin (blog), July 3, 2020. https://jacobinmag.com/2020/07/german-colonialism-herero-nama-genocide-court-case.

Steyerl, Hito. "A Tank on a Pedestal: Museums in an Age of Planetary Civil War." *E-Flux*, February 2016. https://www.e-flux.com/journal/70/60543/a-tank-on-a-pedestal-museums-in-an-age-of-planetary-civil-war/.

Steyerl, Hito. "Is the Museum a Battlefield?" Vimeo, 2013. https://vimeo.com/76011774.

Strike MoMA. "Strike MoMA: Framework and Terms for Struggle," March 23, 2021. https://www.strikemoma.org.

Stromberg, Matt. "Boyle Heights Art Space Closes, Blaming Anti-Gentrification Activists." Hyperallergic, February 22, 2017. https://hyperallergic.com/360174/boyle-heights-art-space-closes-blaming-anti-gentrification-activists/.

Stutz, Liv Nilsson. "Archaeology, Identity and the Right to Culture. Anthropological Perspectives on Repatriation. Current Swedish Archaeology 15." Current Swedish Archaeology 15 (2007): 1–16.

Stylianou-Lambert, Theopisti. "Re-Conceptualizing Museum Audiences: Power, Activity, Responsibility." *Visitor Studies* 13, no. 2 (October 11, 2010): 130–44.

Styx, Lauren. "How Are Museums Using Artificial Intelligence, and Is AI the Future of Museums?" MuseumNext, September 18, 2020. https://www.museumnext.com/article/artificial-intelligence-and-the-future-of-museums/.

Suro, Roberto. "Zunis' Effort to Regain Idols May Alter Views of Indian
 Art." The New York Times, August 13, 1990, sec. U.S.
 https://www.nytimes.com/1990/08/13/us/zunis-effort-to-regain-
 idols-may-alter-views-of-indian-art.html.

Sutton, Benjamin. "Occupy Museums Challenges Us to Face Fascism
 with the #J20 Art Strike." Hyperallergic, January 19, 2017.
 https://hyperallergic.com/352991/occupy-museums-j20-art-
 strike/.

Sutton, Benjamin. "New Museum of Black Civilizations Opens in
 Senegal, with Chinese Backing." Artsy, December 7, 2018. https://
 www.artsy.net/news/artsy-editorial-large-chinese-funded-
 art-museum-opened-senegal.

Szreder, Kuba. "Productive Withdrawals: Art Strikes, Art Worlds, and Art
 as a Practice of Freedom." E-Flux (blog), December 2017. https://
 www.e-flux.com/journal/87/168899/productive-withdrawals-art-
 strikes-art-worlds-and-art-as-a-practice-of-freedom/.

Tamir, Chen. "A Report on the Cultural Boycott of Israel." Hyperallergic,
 February 4, 2015. https://hyperallergic.com/179655/a-report-on-
 the-cultural-boycott-of-israel/.

Teo, Wenny. "Neocolonialism as Multiculturalism at the Kenya Pavilion."
 The Art Newspaper, n.d. Link no longer active.

Tharoor, Kanishk. "The Louvre Comes to Abu Dhabi." The Guardian,
 December 2, 2015, sec. News. https://www.theguardian.com/
 news/2015/dec/02/louvre-abu-dhabi-guggenheim-art.

Tharoor, Kanishk, and Maryam Maruf. "Museum of Lost Objects: Looted
 Sumerian Seal." BBC News, March 11, 2016, sec. Magazine.
 https://www.bbc.com/news/magazine-35774900.

ENC NEWS. "The British Museum: A Museum of the World for the
 World," April 24, 2018. https://eng.enc-news.com/articles/1204/.

The Laura Flanders Show. Decolonize Is A Verb: Anti Columbus Day
 Tour 2018, 2018. https://www.youtube.com/watch?v=
 UTcLJg7GimM&feature=youtu.be&ab_channel=TEDxTalks.

The Museum Will Not Be Decolonised, 2018. https://vimeo.
 com/302162709.

The New York Times. "How Statues Are Falling Around the World."
The New York Times, September 12, 2020, sec. U.S.
https://www.nytimes.com/2020/06/24/us/confederate-statues-
photos.html.

Thompson, Erin L. "A Benin Bronze With Fishy Provenance Goes to
Auction." Hyperallergic, June 26, 2020. https://hyperallergic.
com/573457/fishy-provenance-benin-bronze-christies/.

Thondhlana, Thomas Panganayi. "'Old Wine in New Bottles': A Critical
Historiographical Survey of Zimbabwean Museum Institutions." In
*African Museums in the Making. Reflections on the Politics of Material and
Public Culture in Zimbabwe*, edited by Munyaradzi Mawere, Henry
Chiwaura, and Thomas Panganayi Thondhlana, 15–46. Mankon,
Cameroon: African Books Collective, 2015.

Toukan, Hanan. "The Palestinian Museum." *Radical Philosophy* 2, no. 03
(December 2018). https://www.radicalphilosophy.com/article/
the-palestinian-museum.

Trope, Jack F., and Walter R. Echo-Hawk. "The Native American Graves
Protection and Repatriation Act: Background and Legislative
History." Arizona State Law Journal 24 (1992): 35.

Tuck, Eve, and K. Wayne Yang. "Decolonization Is Not a Metaphor."
Decolonization: Indigeneity, Education & Society 1, no. 1
(September 8, 2012).

Tweedie, Ann M. Drawing Back Culture: The Makah Struggle for
Repatriation. University of Washington Press, 2015.

UNRWA. "Who We Are." Accessed March 4, 2021. https://www.unrwa.
org/who-we-are.

Valley, Greer. "Decolonization Can't Just Be a Metaphor." Africa Is
a Country (blog), November 12, 2019. https://africasacountry.
com/2019/11/decolonization-cant-just-be-a-metaphor.

Vartanian, Hrag. "Artist Omer Fast Compares Protesters to Alt-Right,
Chinatown Art Brigade Responds." Hyperallergic, October 20,
2017. https://hyperallergic.com/406545/artist-omer-fast-protesters-
nazis-chinatown-art-brigade/.

———. "Decolonize This Place Announces January 26 Town Hall
Regarding Whitney Museum's Tear Gas Problem." Hyperallergic,

December 26, 2018. https://hyperallergic.com/477510/decolonize-this-place-announces-january-26-town-hall-regarding-whitney-museums-tear-gas-problem/.

———. "Gulf Labor and Other Arts Groups Occupy Venice's Guggenheim #GuggOccupied." Hyperallergic, May 8, 2015. https://hyperallergic.com/205465/breaking-gulf-labor-and-other-arts-groups-occupy-venices-guggenheim-guggoccupied/.

Vega, Paula Clemente. "The 2017 Venice Biennale and the Colonial Other." Third Text (blog), November 1, 2018. http://thirdtext.org/vega-2017-venice-biennale#Txtn6.

Vergo, Peter. "Introduction." In New Museology, edited by Peter Vergo, 1–5. Reaktion Books, 1989.

Vicario, Lorenzo, and P. Manuel Martinez Monje. "Another 'Guggenheim Effect'? The Generation of a Potentially Gentrifiable Neighbourhood in Bilbao." Urban Studies 40, no. 12 (November 2003): 2383–2400.

Gov.uk. "Visits to Museums and Galleries: Ethnicity Facts and Figures," December 17, 2019. https://www.ethnicity-facts-figures.service.gov.uk/culture-and-community/culture-and-heritage/adults-visiting-museums-and-galleries/latest.

Viso, Olga. "Decolonizing the Art Museum: The Next Wave." The New York Times, May 1, 2018, sec. Opinion. https://www.nytimes.com/2018/05/01/opinion/decolonizing-art-museums.html.

Vogel, Susan. "Fang: An Epic Journey." Icarus Films, 2001.

Volait, Mercedes. "The Rue Du Caire at the Exposition Universelle in Paris (1889)." The Bibliothèque nationale de France. Accessed August 11, 2020. https://heritage.bnf.fr/bibliothequesorient/en/street-of-cairo-art.

Wakeham, Pauline. "Performing Reconciliation at the National Museum of the American Indian." In The National Museum of the American Indian: Critical Conversations, edited by Amy Lonetree and Amanda J. Cobb, 354–83. U of Nebraska Press, 2008.

Wallis, Jonathan. "The Past Is Now: Birmingham and the British Empire, Birmingham Museum & Art Gallery." Museums Association,

January 2018. https://www.museumsassociation.org/museums-journal/reviews/2018/01/01022018-the-past-is-now-birmingham-and-the-british-empire-birmingham-museum-and-art-gallery/.

————. "The Past Is Now: Birmingham and the British Empire, Birmingham Museum & Art Gallery." Museums Association, January 2018. https://www.museumsassociation.org/museums-journal/reviews/2018/01/01022018-the-past-is-now-birmingham-and-the-british-empire-birmingham-museum-and-art-gallery/.

Walker Art Center. "The Walker Art Center Launches Call to Artists for Indigenous Public Art Commission," January 16, 2019. https://walkerart.org/press-releases/2019/walker-art-center-launches-call-to-artists-for-indigenous-public-art-commission.

Webber, Jasmine. "A Whitney Museum Vice Chairman Owns a Manufacturer Supplying Tear Gas at the Border." Hyperallergic, November 27, 2018. https://hyperallergic.com/472964/a-whitney-museum-vice-chairman-owns-a-manufacturer-supplying-tear-gas-at-the-border/.

————. "Decolonize This Place Plans Action at the Whitney Opposing Tear Gas Manufacturer on Museum Board," December 7, 2018. https://hyperallergic.com/475016/decolonize-this-place-plans-action-at-the-whitney-opposing-tear-gas-manufacturer-on-museum-board/.

Wells, Ida B., Frederick Douglass, Irvine Garland Penn, and Ferdinand Lee Barnett. *The Reason Why the Colored American Is Not in the World's Columbian Exposition.* Edited by Ida B. Wells. Chicago, IL, 1893. https://digital.library.upenn.edu/women/wells/exposition/exposition.html.

Weiner, Melissa F. "The Ideologically Colonized Metropole: Dutch Racism and Racist Denial." Sociology Compass 8, no. 6 (2014): 731–44.

Whitby-Last, Kathryn. "Legal Impediments to the Repatriation of Cultural Objects to Indigenous Peoples." In The Long Way Home, edited by Paul Turnbull and Michael Pickering, 1st ed., 35–47. The Meaning and Values of Repatriation. Berghahn Books, 2010.

Who Builds Your Architecture? "WBYA? Installation at the 2nd Istanbul Design Biennial," November 1, 2014. http://whobuilds.org/wbya-installation-at-the-2nd-istanbul-design-biennial/.

Wildman, Sarah. "The Revelations of a Nazi Art Catalogue." *The New Yorker*, February 12, 2016. https://www.newyorker.com/books/page-turner/the-revelations-of-a-nazi-art-catalogue.

Wilkening, Susie. "Beginning to Measure Meaning in Museum Experiences." *Association of Science and Technology Centers* (blog), May 26, 2015. https://www.astc.org/astc-dimensions/beginning-to-measure-meaning-in-museum-experiences/.

Willis, Deborah, ed. Black Venus 2010: They Called Her "Hottentot." Illustrated edition. Philadelphia, Pa: Temple University Press, 2010.

Wolfe, Patrick. "Settler Colonialism and the Elimination of the Native." *Journal of Genocide Research* 8, no. 4 (December 1, 2006): 387–409.

World Tourism Organization, and UNESCO. "Accra Declaration on the WTO-UNESCO Cultural Tourism Programme 'The Slave Route.'" Madrid, 1995.

Yeboah, Stephanie. "Tweet from @StephanieYeboah." Twitter (blog), June 6, 2020. https://twitter.com/StephanieYeboah/status/1269384193823444993.

Young, Damon. "The Definition, Danger and Disease of Respectability Politics, Explained." The Root, March 21, 2016. https://www.theroot.com/the-definition-danger-and-disease-of-respectability-po-1790854699.

Younge, Gary. "Ambalavaner Sivanandan Obituary." the Guardian, February 7, 2018. http://www.theguardian.com/world/2018/feb/07/ambalavaner-sivanandan.

Zeefuik, Simone. "Breaking Towards Repair." Switch (blog), May 9, 2018. https://www.swich-project.eu/nocache/blog/detail/article/breaking-towards-repair/index.html.

Zeitz MOCAA. "Supporters." Accessed March 25, 2021. https://zeitzmocaa.museum/supporters-2/.

ENDNOTES

Introduction

1 Ella Shohat and Robert Stam compare the film's portrayal of the obliviousness of the Egyptian people towards their own historical treasures to the more contemporary view of Arabs who are ignorant of the oil resources that they happen to "sit" on. See Ella Shohat and Robert Stam, *Unthinking Eurocentrism: Multiculturalism and the Media* (Routledge, 1994), 151–52.

2 Vincent Noce, "What Exactly Is a Museum? Icom Comes to Blows over New Definition," August 19, 2019, The Art Newspaper, accessed April 22, 2021, http://www.theartnewspaper.com/news/what-exactly-is-a-museum-icom-comes-to-blows-over-new-definition.

Chapter 1: Returning the Collection

1 Betty Farrell and Maria Medvedeva, "Demographic Transformation and the Future of Museums" (American Association of Museums, 2010).

2 Taco Dibbits, the director of the Rijksmuseum in Amsterdam, called the guidelines issued by the National Museum of World Cultures in the Netherlands "a good first step," adding that the country should have taken the initiative much sooner. See Hickley, "Dutch Museums Take Initiative to Repatriate Colonial-Era Artefacts."

3 Fanon is referring specifically to African intellectuals that collaborated with the French colonial regime. However, I would argue that this framework can be applied to Africans in the Niger Coast Protectorate Force, who participated in a number of British-led punitive expeditions,

including the capture of Benin city in 1897. See Frantz Fanon, *The Wretched of the Earth*, trans. Richard Philcox, Reprint edition (New York: Grove Press, 2005), 213.

4 Jonathan A. Green, *Portrait of the King of Benin*, 1897, Photograph, 1897, Af,A47.70, British Museum, https://www.britishmuseum.org/collection/object/EA_Af-A47-70.

5 Henry Ling Roth, *Great Benin: Its Customs, Art and Horrors* (Routledge & K. Paul, 1903), xix.

6 Article 22 of the Antiquities Law of 1924 stipulated the following: "*At the close of excavations, the Director shall choose such objects from among those found as are in his opinion needed for the scientific completeness of the 'Iraq Museum. After separating these objects, the Director will assign to the person who has been given the permit for excavation such objects as will reward him adequately, aiming as far as possible at giving such person a representative share of the whole result of excavations made by him.*" Curiously, Bell wrote the law using male pronouns to refer to the Director—which was none other than herself. For more excerpts of the Law, see Brad Hafford, "Reconstructing Excavation Processes," Penn Museum: Ur Digitization Project, September 4, 2013, https://www.penn.museum/blog/museum/ur-digitization-project-august-2013/.

7 Gertrude Bell, "Letters," March 6, 1924, Gertrude Bell Archive, Newcastle University, http://www.gerty.ncl.ac.uk/letter_details.php?letter_id=690.

8 See Kanishk Tharoor and Maryam Maruf, "Museum of Lost Objects: Looted Sumerian Seal," *BBC News*, March 11, 2016, sec. Magazine, https://www.bbc.com/news/magazine-35774900.

9 To illustrate the tension in France between the "universalistic emphasis on the unity of mankind" and "the particularistic recognition of the diversity of cultures," Benoît de l'Estoile cites the linguist Antoine Meillet who praised the Colonial Exhibition in Paris for teaching both lessons: "It shows us first of all, the immense diversity of humanity, which is a precious asset; it also reveals, under dissimilar appearances, the strength of human unity." *XVe Congrès internationale* 1933: 83. Cited in l'Estoile, "From the Colonial Exhibition to the Museum of Man. An Alternative Genealogy of French Anthropology," 355.

10 Ariella Azoulay, *Potential History: Unlearning Imperialism* (Verso Books, 2019), 64.

11 This is the argument made by Simon Gikandi. See Gikandi, "Picasso, Africa, and the Schemata of Difference," *Modernism/Modernity* 10, no. 3 (September 5, 2003): 474.

12 For example, the UNESCO Convention does not recognize the principal defined in the 1993 Mataatua Declaration on Cultural and Intellectual Property Rights of Indigenous Peoples, which states that "Indigenous peoples should 'define for themselves their own … cultural property." Cited in Kathryn Whitby-Last, "Legal Impediments to the Repatriation of Cultural Objects to Indigenous Peoples," in *The Long Way Home*, ed. Paul Turnbull and Michael Pickering, 1st ed., The Meaning and Values of Repatriation (Berghahn Books, 2010), 36.

13 Okeke-Agulu, who termed Christie's auctioned Benin objects "blood art," argued that the convention needs to be revised: "When enough voices call a law unjust—or, in this case, convention—the powers that be might decide 'It's indefensible. We need to change this,'" he said, adding, "we'll see what happens, but this matter is not going away." See Maximilíano Durón, "Art Historian Calls Out Christie's for Selling Objects Taken from Nigeria: 'Public Sales of These Objects Should Stop,'" *ARTnews* (blog), June 10, 2020, https://www.artnews.com/art-news/news/christies-igbo-sculptures-chika-okeke-agulu-1202690696/.

14 As French journalist Éric Lutten writes, the transactions resembled "a kind of raid led by a troop of Europeans who, with a pencil and ruler in hand, haphazardly searched for items everywhere." Éric Lutten, "Les Enfants Noirs Ont Aussi Des Poupées Mai," *Le Monde Colonial Illustré*, mai 1934, 129 edition, 79; Cited in Sarr and Savoy, "The Restitution of African Cultural Heritage: Toward a New Relational Ethics," 56.

15 L.a Saint-Raymond, Le Pari des enchères : le lancement de nouveaux marchés artistiques à Paris entre les années 1830 et 1939, doctoral thesis, universit. Paris-Nanterre, 2018. Cited in Sarr and Savoy, 56

16 Robert Stephenson Smyth Baden-Powell, *The Downfall of Prempeh* (Adamant Media Corporation, 1896), 129; Cited in Kwame Anthony Appiah, *Cosmopolitanism: Ethics in a World of Strangers* (W.W. Norton & Co, 2007), 115–16.

17 Cited in Sarr and Savoy, "The Restitution of African Cultural Heritage: Toward a New Relational Ethics," 16.

18 "Visits to Museums and Galleries: Ethnicity Facts and Figures," Gov.uk, December 17, 2019, https://www.ethnicity-facts-figures.service.gov.uk/culture-and-community/culture-and-heritage/adults-visiting-museums-and-galleries/latest.

19 This is a metaphor used by Hicks, who argues that "the museum [was] a weapon reloaded after 9/11" with the world-view set out in Tony Blair's speech on "Western values" delivered to the US Congress on July 17, 2003. See Hicks, The Brutish Museums, 206.

20 This incident is cited in Oumar Ba, "Should Africans Care for Emmanuel Macron's 'Africa Speech' in Ouagadougou?," Africa is a Country, November 29, 2017, https://africasacountry.com/2017/11/should-africans-care-for-emmanuel-macrons-africa-speech-in-ouagadougou.

21 Diawara, "A Letter to President Macron."

22 The plaintiffs have since filed an appeal with the Second Circuit US Court of Appeals. For an analysis and a full update on the situation see Maresi Starzmann, "Germany Needs to Own Up to the Horrors of Its Colonial Past in Africa," Jacobin (blog), July 3, 2020, https://jacobinmag.com/2020/07/german-colonialism-herero-nama-genocide-court-case.

23 Gross, "The Troubling Origins of the Skeletons in a New York Museum."

24 This is a contrast made by Chip Colwell in his 2017 TED Talk. See Chip Colwell, Museums Have a Dark Past, but We Can Fix That, TEDxMileHigh, 2017, https://www.youtube.com/watch?v=DJYS9C06_qY.

25 NAGPRA was preceded by the National Museum of the American Indian Act (NMAIA) in 1989, which applies to the Smithsonian Institution. See Jack F. Trope and Walter R. Echo-Hawk, "The Native American Graves Protection and Repatriation Act: Background and Legislative History," Arizona State Law Journal 24 (1992): 141; Cited in Amy Lonetree, Decolonizing Museums: Representing Native America in National and Tribal Museums (Univ of North Carolina Press, 2012), 18.

26 Conn argues that the language used by Cherokee-American anthropologist Russell Thornton to praise NAGPRA for its ability to heal "the wounds of traumatic events" is exactly the language of Oprah Winfrey. Conn, Do Museums Still Need Objects?, 69.

27 In order to bring back the War Gods under the UNESCO Convention, some have suggested that the Zuni should declare full sovereignty. After

all, they meet many of the conditions for statehood, including a defined territory, a permanent population, and a government. As a sovereign state, the Zunis could take advantage of international law and contend with other states, as well as the world community, for the return of their tribal cultural heritage. See Merenstein, "The Zuni Quest for Repatriation of the War Gods."

28 In April 2021, the Penn Museum and the University of Pennsylvania issued an apology to the family of the victims. Princeton University also apologized for its part in the case, including allowing the victim's remains to be used as teaching tools in an online forensic anthropology course. See Abdul-Aliy Muhammad, "Penn Museum Owes Reparations for Previously Holding Remains of a MOVE Bombing Victim," The Philadelphia Inquirer, April 21, 2021, https://www.inquirer. com/opinion/commentary/penn-museum-reparations-repatriation-move-bombing-20210421.html; Colleen Flaherty, "Penn, Princeton Apologize for Treatment of MOVE Bombing Victim's Remains," Inside Higher Ed, April 29, 2021, https://www.insidehighered.com/ quicktakes/2021/04/29/penn-princeton-apologize-treatment-move-bombing-victims-remains.

Chapter 2: Subverting the Gaze

1 These types of lessons in the natural sciences flourished through the Lyceum movement, an early form of adult education through local museums and libraries. The movement gained popular appeal in the northeast and midwest U.S. from the 1820s up until the Civil War. As historian Steven Lubar explains: "For the Lyceum, as for other museums of its day, every human artefact told a story, revealed an 'object lesson': often a moral, sometimes a story of progress, but not always." For more on the "object lessons" of the Lyceums see Steven Lubar, "'To Polish and Adorn the Mind': The United States Naval Lyceum at the Brooklyn Navy Yard, 1833–89," Museum History Journal 7, no. 1 (January 1, 2014): 95.

2 Henry Mayhew, 'The Shilling People', quoted from Humphrey Jennings, ed., 'Pandemonium' (London: Andre Deutsch, 1985). Cited in Peter

Greenhalgh, "Education, Entertainment and Politics: Lessons from the Great International Exhibitions," in *New Museology*, ed. Peter Vergo (Reaktion Books, 1989), 75.

3 In a similar way, mid-19th century American urban designers Calvert Vaux and Frederick Law Olmsted designed green spaces such as Central Park to refine the behavior of New York's impoverished immigrants. Through large open promenades, Vaux and Olmsted believed that the working class masses could observe the behavior of moneyed people, and, as if by osmosis, they too could become upright, well-behaved citizens. For a social history of Central Park see "On Matters of Time and Space: Interview with Sam Kling," On the Media, accessed August 11, 2020, https://www.wnycstudios.org/podcasts/otm/episodes/on-the-media-matters-time-space.

4 Sir Arthur Blyth to H.E. Bright, September 26, 1884, Mortlock Library, State Library of South Australia, V 991. Cited in Peter H. Hoffenberg, *An Empire on Display: English, Indian, and Australian Exhibitions from the Crystal Palace to the Great War* (University of California Press, 2001), xix.

5 See Timothy Mitchell, "The World as Exhibition," *Comparative Studies in Society and History* 31, no. 2 (April 1989): 217–36.

6 According to Said, Orientalism strictly maintains a binary in which the Oriental is "feminized," constructed as mysterious and sexual, while the European, by contrast, is masculinized, restrained, and rational. For a comprehensive explanation of these gendered distinctions see Melani McAlister, *Epic Encounters: Culture, Media, and U.S. Interests in the Middle East Since 1945* (University of California Press, 2005), 9.

7 Monique Scott , former head of cultural education at the museum, describes the AMNH's Hall of African Peoples as "bleak dioramas," in which sub-Saharan African people are "confined to the 'Heart of Darkness' jungles and plains, alongside the great African animals." See Monique Scott, "Museums Matter in the Current Climate of Anti-Black Racism," *Anthropology News* 60, no. 2 (March 2019), https://onlinelibrary.wiley.com/doi/abs/10.1111/AN.1119.

8 As Michel Foucault explains in *Madness and Civilization*: "Madness had become a thing to look at; no longer a monster inside oneself, but an animal with strange mechanisms, a bestiality from which man had long since

been suppressed." Michel Foucault, *The Foucault Reader*, ed. Paul Rabinow (New York: Pantheon, 1984), 70. The classical period encompassed the years roughly from Descartes to the end of the Enlightenment.

9 Steven Mullaney, "Strange Things, Gross Terms, Curious Customs: The Rehearsal of Cultures in the Late Renaissance," *Representations*, no. 3 (1983): 45; Cited in Tony Bennett, *The Birth of the Museum: History, Theory, Politics* (Routledge, 2013), 187.

10 A sense of longing and nostalgia surrounded Native people and open space—symbols of freedom and wilderness at odds with the pervasive systems that railroads factories, cities and commercial agriculture represented. As the writer Rebecca Solnit writes, Americans "loved buffalo and Indians, or at least loved what they represented in the romantic art and literature, even as their government's policies were annihilating them." See Rebecca Solnit, *River of Shadows: Eadweard Muybridge and the Technological Wild West* (Viking, 2003), 73.

11 In her research on Kini's life, theorist Adria L. Imada draws upon oral history interviews conducted by anthropologist Joann Wheeler Kealiinohomoku. In one interview, Kini describes her delight upon encountering the Street of Cairo: "We went to this big building, Egypt. Everything Egypt. Land of Egypt. River running and all that. Stalls, the people, the camels, everything big, big, big." Joann Wheeler Kealiinohomoku, "A Court Dancer Disagrees with Emerson's Classic Book on the Hula," *Ethnomusicology* 8, no. 2 (1964): 161–64; Cited in Imada, "Transnational Hula as Colonial Culture," 163.

12 W.E.B. Du Bois, "The American Negro at Paris," *The American Monthly Review of Reviews* XXII, no. 5 (November 1900): 575–77; Cited in Hua Hsu, "What W. E. B. Du Bois Conveyed in His Captivating Infographics," The New Yorker, accessed April 13, 2021, https://www.newyorker.com/books/page-turner/what-web-du-bois-conveyed-in-his-captivating-infographics.

13 Peter Greenhalgh, "Education, Entertainment and Politics: Lessons from the Great International Exhibitions," in *New Museology*, ed. Peter Vergo (Reaktion Books, 1989), 87.

14 See l'Estoile, "From the Colonial Exhibition to the Museum of Man. An Alternative Genealogy of French Anthropology," 348.

15 Stephen Jay Gould, "The Hottentot Venus," *Natural History* 91, no. 10 (1982): 20; Bennett, *The Birth of the Museum*, 205.

16 The emphasis fell on the size and shape of the more "highly evolved brain of European man" compared to the obsession over the female's pelvis. Bennett explains that this hierarchized construction was centered on the female genitals in that it depended on the idea that female reproductive organs were an inversion, and therefore inferior, version of the male reproductive organs. See Gould, "The Hottentot Venus"; Bennett, *The Birth of the Museum*, 203–5.

17 One reason for this differential treatment might be the ways in which Native American identity has been racialized in the U.S., where, according to Eve Tuck and K. Wayne Yang, "contemporary Indigenous generations [is portrayed] to be less authentic, less indigenous than every prior generation in order to ultimately phase out indigenous claims to land and usher in settler claims to property." Eve Tuck and K. Wayne Yang, "Decolonization Is Not a Metaphor," *Decolonization: Indigeneity, Education & Society* 1, no. 1 (September 8, 2012): 12.

18 In 1850-51, Agassiz wrote a series of articles for the Unitarian *Christian Examiner*, in which he argued that the different races had been created separately, each in its own center of creation. See John P. Jackson and Nadine M. Weidman, *Race, Racism, and Science: Social Impact and Interaction* (Rutgers University Press, 2006), 52.

19 Author Evelyn Brooks Higginbotham coined the term "respectability politics" in her 1993 book *Righteous Discontent: The Women's Movement in the Black Baptist Church, 1880-1920*. As writer Damon Young explains, "it's a concept that has existed within black America since black people have been in America—the idea that if we walk a little straighter and write a little neater and speak a little clearer, then white people will treat us better." See Evelyn Brooks Higginbotham, *Righteous Discontent: The Women's Movement in the Black Baptist Church, 1880–1920*, Revised edition (Cambridge, Mass.: Harvard University Press, 1994); Damon Young, "The Definition, Danger and Disease of Respectability Politics, Explained," The Root, March 21, 2016, https://www.theroot.com/the-definition-danger-and-disease-of-respectability-po-1790854699.

20 Pitt-Rivers considered the working man to be an agent of progress, with women only being the passive beneficiaries of male-driven evolution. He placed non-Europeans on an ever lower rank, writing that "civilization" was "confined to particular races," who could either spread it to surrounding nations or "exterminate those whose low state of mental culture rendered them incapable of receiving it." See Augustus Henry Lane-Fox Pitt-Rivers, *The Evolution of Culture: And Other Essays* (Clarendon Press, 1906), 49. For more on his vision of concentric circles, see Augustus Henry Lane-Fox Pitt-Rivers, "Address as President of the Anthropological Section of the British Association," Report of the British Association for the Advancement of Science (Bath, September 6, 1888), https://web.prm.ox.ac.uk/rpr/index.php/primary-documents-index/14-general/728-baas-september-1888-1888.html.

21 Originally, the French method of rule was based on the idea of assimilation, which gave France the responsibility of absorbing its colonies administratively and culturally. By the turn of the twentieth century, in response to the rise of nationalism and anti-colonial movements, the French pivoted to rule based on association. See Benoît de l'Estoile, "From the Colonial Exhibition to the Museum of Man. An Alternative Genealogy of French Anthropology," *Social Anthropology* 11, no. 3 (October 2003): 341–61.

22 This story is recounted by Rebecca Solnit. See Solnit, *River of Shadows*, 74.

23 As she writes, "What happens if, instead of assuming that Reynolds was in total control, we recognize that Mai was making a creative choice in performing his freigness, deliberately constructing himself as Other by taking off his British costume and dressing in *tapa* [Pacific barkcloth]? See Procter, *The Whole Picture*, 96.

Chapter 3: Rewriting the Narrative

1 From the Met's collection, Monkman models Thomas Crawford's 1846 sculpture *Mexican Girl Dying*, as well as Eugène Delacroix's painting "The Natchez." For a full exploration of the paintings' references, see Holland Cotter, "A Cree Artist Redraws History," *The New York Times*, December 19, 2019, sec. Arts, https://www.nytimes.com/2019/12/19/arts/design/kent-monkman-metropolitan-museum.html.

2 The term "new museology" is often attributed to Peter Vergo, whose book by the same name called for a "radical re-examination of the role of museums in society." See Peter Vergo, "Introduction," in *New Museology*, ed. Peter Vergo (Reaktion Books, 1989), 3.

3 This is the argument put forward by Gaëlle Crenn in "Reformulation of the Museum's Discourse in Reflexive Ethnographic Exhibitions. Limits and Ambivalences at the Museum Der Kulturen (Basel) and the Neuchâtel Ethnography Museum," *ICOFOM Study Series*, no. 45 (September 17, 2017): 37–46.

4 For full, comparative descriptions of the exhibits *Fluffs and Feathers* and *Intro the Heart of Africa* see Henrietta Riegel, "Into the Heart of Irony: Ethnographic Exhibitions and the Politics of Difference," *The Sociological Review* 43 (May 1, 1995): 83–104.

5 Cited in Jerry Mitchell, "See the Photo Emmett Till's Mother Wanted You to See — the One That Inspired a Generation to Join the Civil Rights Movement.," Mississippi Center for Investigative Reporting, August 28, 2020, https://www.mississippicir.org/news/see-the-photo-emmett-tills-mother-wanted-you-to-see-the-one-that-inspired-a-generation-to-join-the-civil-rights-movement.

6 During the event surrounding the Schutz controversy, artist Lyle Ashton Harris grabbed the microphone said: "I don't want to have a 'kumbaya' moment.'" Weinberg's description of the museum as a "safe space for unsafe ideas" came a year later, when the Whitney was embroiled in another controversy surrounding its ties to one of its board's vice-chairs. See Caroline Goldstein, "The Whitney 'Cannot Right All the Ills of an Unjust World': Adam Weinberg Responds to Staff Protests Over a Board Member," Artnet News, December 3, 2018, https://news.artnet.com/art-world/whitney-protest-adam-weinberg-response-1409164; D'Souza, *Whitewalling*, 36.

7 As *Artforum* explains, the six other scaffolds that comprise the structure reference "those used to execute abolitionist John Brown (1859); the Lincoln Conspirators (1865), which included the first woman executed in US history; the Haymarket Martyrs (1886), which followed a labor uprising and bombing in Chicago; Rainey Bethea (1936), the last legally conducted public execution in US history; Billy Bailey (1996), the last

execution by hanging (not public) in the US; and Saddam Hussein (2006), for war crimes at a joint Iraqi/US facility." See "Dakota Nation Demands Removal of Sculpture at Walker Art Center," Artforum, May 29, 2017, https://www.artforum.com/news/dakota-nation-demands-removal-of-sculpture-at-walker-art-center-68759.

8 Cited in Amy Lonetree, *Decolonizing Museums: Representing Native America in National and Tribal Museums* (Univ of North Carolina Press, 2012), 101-102.

9 Archeologist Claire Smith, for example, wrote that the NMAI "exemplifies decolonisation in practice … reversing the impact of colonialism." See Smith, "Decolonizing the Museum: The National Museum of the American Indian in Washington, D.C.," 437; Cited in Lonetree, *Decolonizing Museums*, 120.

10 Huey Copeland and Frank Wilderson III, "Red, Black, and Blue: The National Museum of African American History and Culture and the National Museum of the American Indian," Artforum, September 2017, https://www.artforum.com/print/201707/red-black-and-blue-the-national-museum-of-african-american-history-and-culture-and-the-national-museum-of-the-american-indian-70457.

11 Some historians argue that Gorée Island was never actually a shipping point for slaves. But the power of the symbolism remains. See John Murphy, "Powerful Symbol, Weak in Facts," Daily Press, June 30, 2004, https://www.dailypress.com/dailypress/bal-slavery0630-story.html; For more on the emotional experiences of African Americans who visit these sites, see David G. Nicholls, "African Americana in Dakar's Liminal Spaces," in *Monuments of the Black Atlantic: Slavery and Memory*, ed. Frances L. and Edwin L. Cummings Professor of American Studies and English Joanne M. Braxton and Joanne M. Braxton (LIT, 2004), 141–51.

12 At a joint meeting of the UNWTO and the United Nations Educational Scientific and Cultural Organization (UNESCO) held in Accra (Ghana) in April 1995, participating countries committed to "foster economic and human development and to rehabilitate, restore and promote the tangible and intangible heritage handed down by the slave trade for the purposes of cultural tourism, thereby throwing into relief the common

nature of the slave trade in terms of Africa, Europe, the Americas and the Caribbean." See World Tourism Organization and UNESCO, "Accra Declaration on the WTO-UNESCO Cultural Tourism Programme 'The Slave Route'" (Madrid, 1995); Sevil Sönmez, Ercan Sirakaya-Turk, and Victor Teye, "Heritage Tourism in Africa: Residents' Perceptions of African-American and White Tourists," *Tourism Analysis*, June 2011.

13 See for example Kwaku Nti, "Slave Heritage Is Big Business, Tainting the Diaspora's Bonds with Africa," The Conversation, January 9, 2017, http://theconversation.com/slave-heritage-is-big-business-tainting-the-diasporas-bonds-with-africa-70062.

14 Mawere and Mubaya, "'A Shadow That Refuses to Leave': The Enduring Legacy of Colonialism in Zimbabwean Museum Governance," 141.

15 At the time, many scientists objected to the tour, claiming that transporting the skeleton would damage it. Richard Leakey called the exhibit a "form of prostitution" and a "gross exploitation of the ancestors of humanity." See Sandi Doughton, "Lucy on Display with Controversy," The Seattle Times, October 2, 2008, https://www.seattletimes.com/seattle-news/lucy-on-display-with-controversy/.

16 Nigussu Mekonnen Abay, "Stakeholder Engagement at the 'National Museum of Ethiopia'" (Addis Ababa University, 2016).

17 Take the Museum on the Seam, a socio-political contemporary art museum that was built in the home of Palestinian architect Andoni Baramki. Like many Palestinians, Baramki's family was forced to flee Jerusalem during the 1948 Arab-Israeli War, known as the Palestinian *nakba* ("catastrophe" in Arabic). Likewise, the Janco Dada Museum was built by Jewish settlers in the 1950s in the ruins of the depopulated Palestinian village of Ein Houd. In recent years, the planned Museum of Tolerance in Jerusalem has faced controversy concerning its location on an ancient Muslim cemetery. See Mary Pelletier, "'They Tell Lies': Israel's 'museum of Coexistence' Erases Palestinian History," Middle East Eye, June 6, 2017, http://www.middleeasteye.net/features/they-tell-lies-israels-museum-coexistence-erases-palestinian-history; Rory McCarthy, "Row over Plan to Build Jewish Museum of Tolerance on Site of Muslim Cemetery," The Guardian, February 10, 2010, http://www.theguardian.com/world/2010/feb/10/jewish-museum-tolerance-muslim-cemetery;

Susan Slyomovics, "Discourses on the Pre-1948 Palestinian Village: The Case of Ein Hod/Ein Houd," *Traditional Dwellings and Settlements Review* 4, no. 2 (1993): 27–37.

18 This is the argument put forward by Lila Abu-Lughod in her article "Imagining Palestine's Alter-Natives: Settler Colonialism and Museum Politics," *Critical Inquiry* 47, no. 1 (September 1, 2020): 1–27.

19 As Susan Legêne, historian of the Tropenmuseum and curator of its historical section, explained that beginning in the 1960s, the Tropenmuseum "took as its principal theme [international] cooperation, development aid and daily life in the Third World. Just as had the old colonial museum, its new approach privileged the contemporary world. Thus, in no way was the presentation of the permanent collections supposed to make reference to the Dutch colonial empire, even though 90% of the collections in the Tropenmuseum found their provenance in colonial connections." Susan Legêne, "Identité nationale et 'cultures autres': Le musée colonial comme monde àpart aux Pays-Bas," in *Du musée colonial au musée des cultures du monde*, ed. Dominique Taffin (Paris: Maisonneuve et Larose, 2000), 101; Cited in Robert Aldrich, "Colonial Museums in a Postcolonial Europe," *African and Black Diaspora: An International Journal* 2, no. 2 (July 1, 2009): 143.

20 Chirac wrote in the preface to the museum's guidebook that MQB wishes to be inscribed "at the heart of the dialogue [between] cultures and civilizations," and insisted that this dialogue be made "possible by that which is universal in each." Chirac, preface to *Le guided musée du quai Branly*, 7. Cited in Caroline Ford, "Museums after Empire in Metropolitan and Overseas France," The Journal of Modern History 82, no. 3 (September 1, 2010): 643.

21 This is an argument made by Iris van Huis in Iris van Huis, "Contesting Cultural Heritage: Decolonizing the Tropenmuseum as an Intervention in the Dutch/European Memory Complex," in *Dissonant Heritages and Memories in Contemporary Europe*, ed. Tuuli Lähdesmäki et al., Palgrave Studies in Cultural Heritage and Conflict (Cham: Springer International Publishing, 2019), 215–48; See also Melissa F. Weiner, "The Ideologically Colonized Metropole: Dutch Racism and Racist Denial," *Sociology Compass* 8, no. 6 (2014): 731–44.

22 Online comments cited in Adam Hochschild, "The Fight to Decolonize the Museum," *The Atlantic*, accessed September 1, 2020, https://www.theatlantic.com/magazine/archive/2020/01/when-museums-have-ugly-pasts/603133/.

23 See Steve Hemming, "Audience Participation: Working with Local People at the Geffrye Museum, London," in *Cultural Diversity: Developing Museum Audiences in Britain*, ed. Eilean Hooper-Greenhill (Leicester University Press, 2001), 168–82.

24 Bayryam Mustafa Bayryamali, "Addressing the British Museum's Colonial History and Hollow Solidarity With Black Lives," Hyperallergic, June 16, 2020, https://hyperallergic.com/570591/letter-to-british-museum-hartwig-fischer/.

25 These groups include NYC Stands with Standing Rock, American Indian Community House, Black Youth Project 100, South Asia Solidarity Initiative, Chinatown Art Brigade, Take Back the Bronx, The People's Cultural Plan, and Working Artists and the Greater Economy (WAGE).

26 These are questions posed by Chip Colwell. See Colwell, "Repatriation and the Work of Decolonization," *National Council on Public History* (blog), June 18, 2019, https://ncph.org/history-at-work/repatriation-and-decolonization/.

27 Monument Removal Brigade, "Prelude to the Removal of a Monument."

Chapter 4: Follow The Money

1 Moacir dos Anjos et al., *Ernesto Neto: The Edges of the World*, ed. Cliff Lauson (London: New York: Hayward Gallery Publishing, 2010), 8. Cited in Paula Clemente Vega, "The 2017 Venice Biennale and the Colonial Other," *Third Text* (blog), November 1, 2018, http://thirdtext.org/vega-2017-venice-biennale#Txtn6.

2 Wenny Teo, "Neocolonialism as Multiculturalism at the Kenya Pavilion," The Art Newspaper, n.d., (link no longer active); Cited in Lorena Muñoz-Alonso, "'Shame in Venice': Italian-Chinese Line-up for Kenya's Biennale Pavilion Sparks Outrage," artnet News, March 25, 2015, https://news.artnet.com/exhibitions/outrage-kenyan-pavilion-venice-biennale-281137.

3 Cited in Hans Haacke, "Museums: Managers of Consciousness," in *Hans Haacke: For Real: Works 1959-2006*, ed. Matthias Flügge and Robert Fleck (Düsseldorf: Richter, 1983), 273–281.

4 See Kareem Estefan, "Introduction," in *Assuming Boycott: Resistance, Agency and Cultural Production*, ed. Kareem Estefan, Carin Kuoni, and Laura Raicovich (New York: OR Books, 2017), 17.

5 Kanishk Tharoor, "The Louvre Comes to Abu Dhabi," *The Guardian*, December 2, 2015, sec. News, https://www.theguardian.com/news/2015/dec/02/louvre-abu-dhabi-guggenheim-art.

6 See Yu-Chien Chang, Victoria Rodner, and Chloe Preece, "Country Branding through the Arts," in *Museum Marketization: Cultural Institutions in the Neoliberal Era*, ed. Karin M. Ekström, 1st Edition (Routledge, 2019), 179.

7 Kassim is quoting Sri Lankan and British novelist and activist Ambalavaner Sivanandan. In reference to post-colonial migration, he famously wrote, "We are here because you were there." Sumaya Kassim, "The Museum Will Not Be Decolonised," *Media Diversified* (blog), November 15, 2017, https://mediadiversified.org/2017/11/15/the-museum-will-not-be-decolonised/.

SHIMRIT LEE is a writer, educator, and curator based in Philadelphia. An interdisciplinary scholar working at the intersection of visual culture, performance, and critical security studies, Shimrit's research interests relate to the cultural production of security narratives in Israel and the U.S. She holds a Ph.D. in Middle Eastern Studies from NYU, and teaches high school social studies as well as community-based adult education at the Brooklyn Institute for Social Research.

CPSIA information can be obtained
at www.ICGtesting.com
Printed in the USA
JSHW021145300523
42399JS00003B/3